Skyscapes

Jean Odermatt
Skyscapes

Scalo Zurich – Berlin – New York

The pictures in this book are part of the Gotthard Project Archives. The project, begun in 1983, represents years of intensive research into a landscape in the heart of the European Alps.

Special thanks to my wife, Gabriela Odermatt Wick, and my three children, Evamaria, Seraphin and Pamina. Without their patience I would never have been able to pursue my project with such single-minded determination.
Many thanks also to the designer, Hans Werner Holzwarth, and to Angelika Stricker, George Reinhart, and Erwin Stegmann, who introduced me to photography.

Jean Odermatt – Skyscapes

Translation: Catherine Schelbert | Design: Hans Werner Holzwarth, Berlin | Color separations: Gert Schwab / Steidl, Schwab Scantechnik, Göttingen | Printing: Steidl, Göttingen
© 1997 for photographs and texts: Jean Odermatt | © 1997 for this edition: Scalo Zurich – Berlin – New York
Head office: Weinbergstrasse 22a, CH-8001 Zurich / Switzerland, phone 41 1 261 0910, fax 41 1 261 9262. Distributed in North America by D.A.P., New York City; in Europe, Africa and Asia by Thames and Hudson, London; in Germany, Austria and Switzerland by Scalo.

First Scalo Edition 1997 | ISBN 3-931141-61-6 | Printed in Germany

I dedicate this book to my father, who in his youth cherished the dream of becoming a star-gazer.

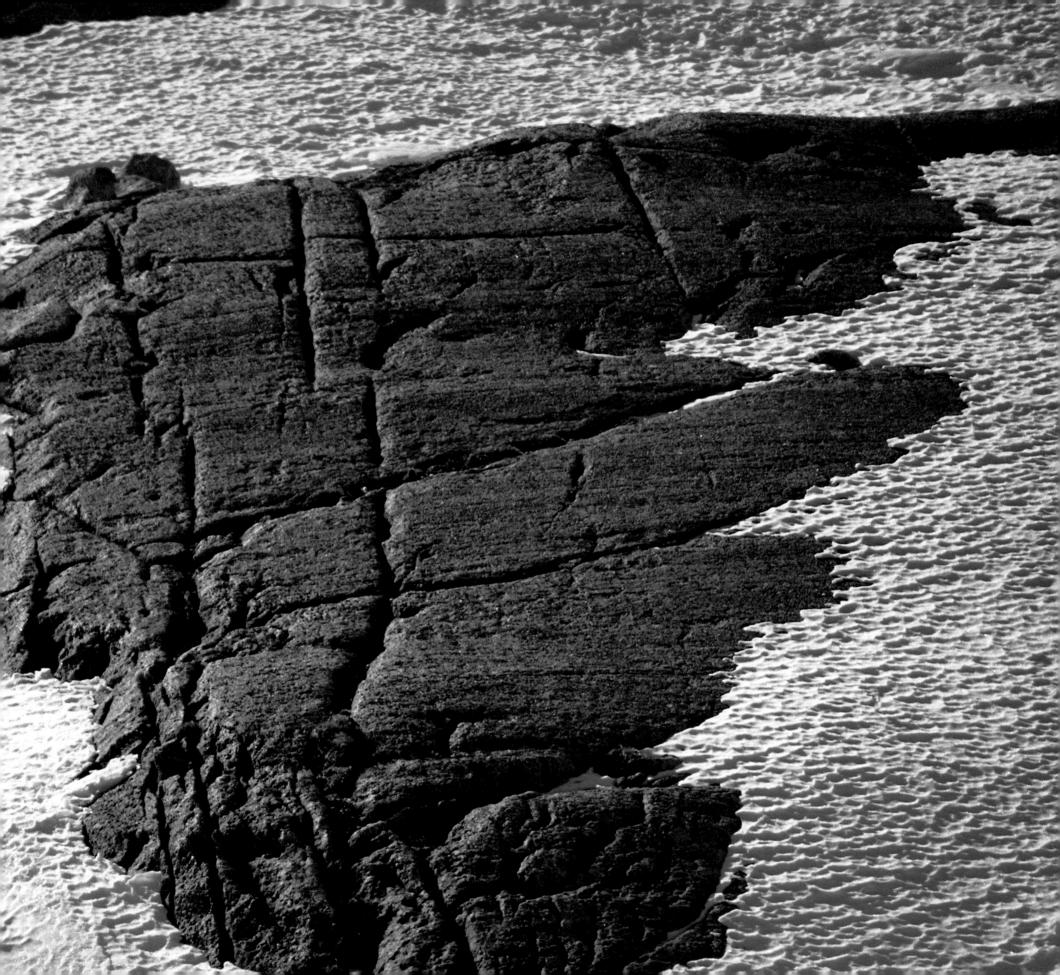

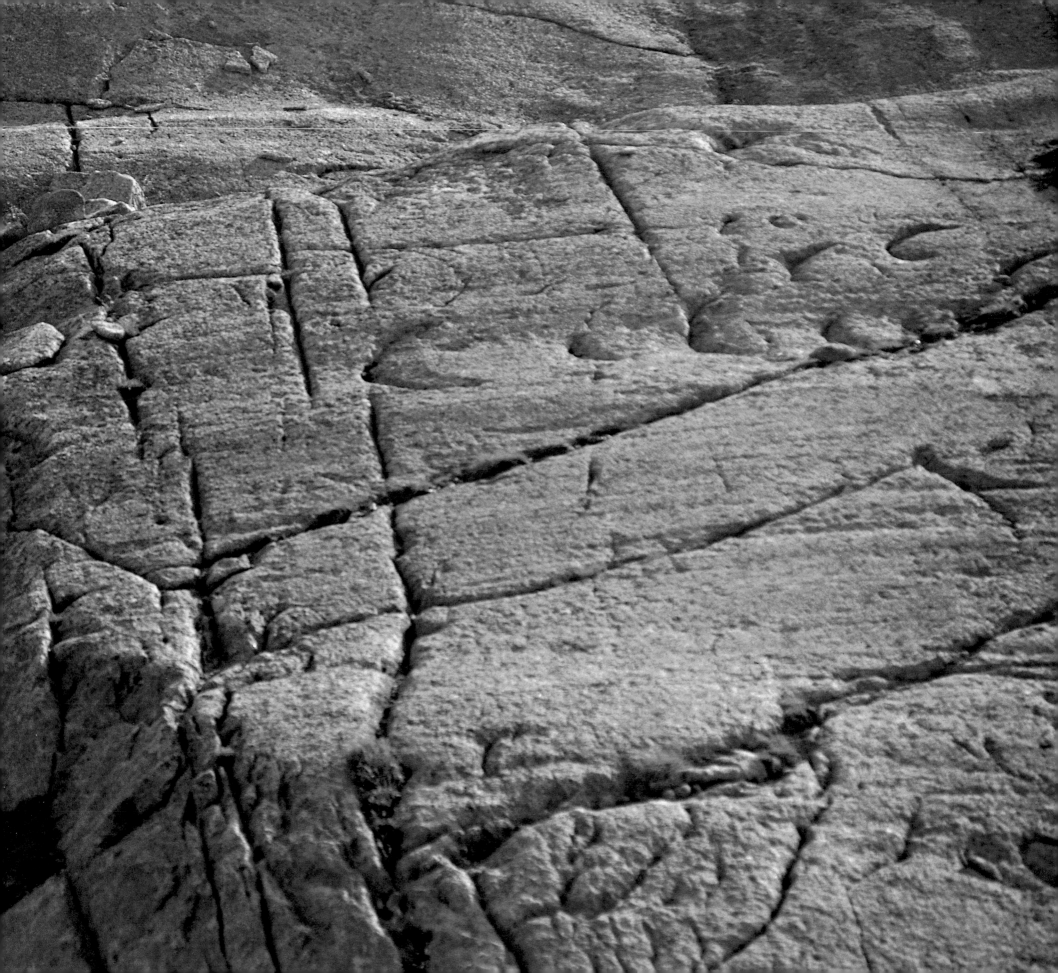

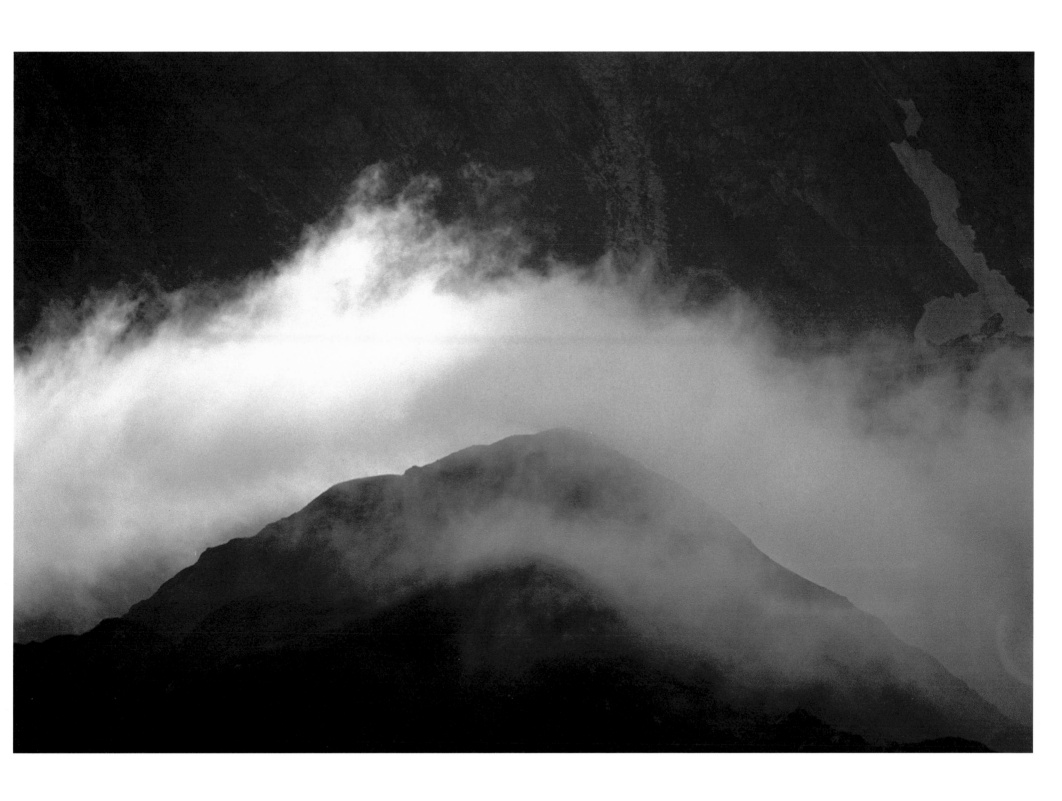

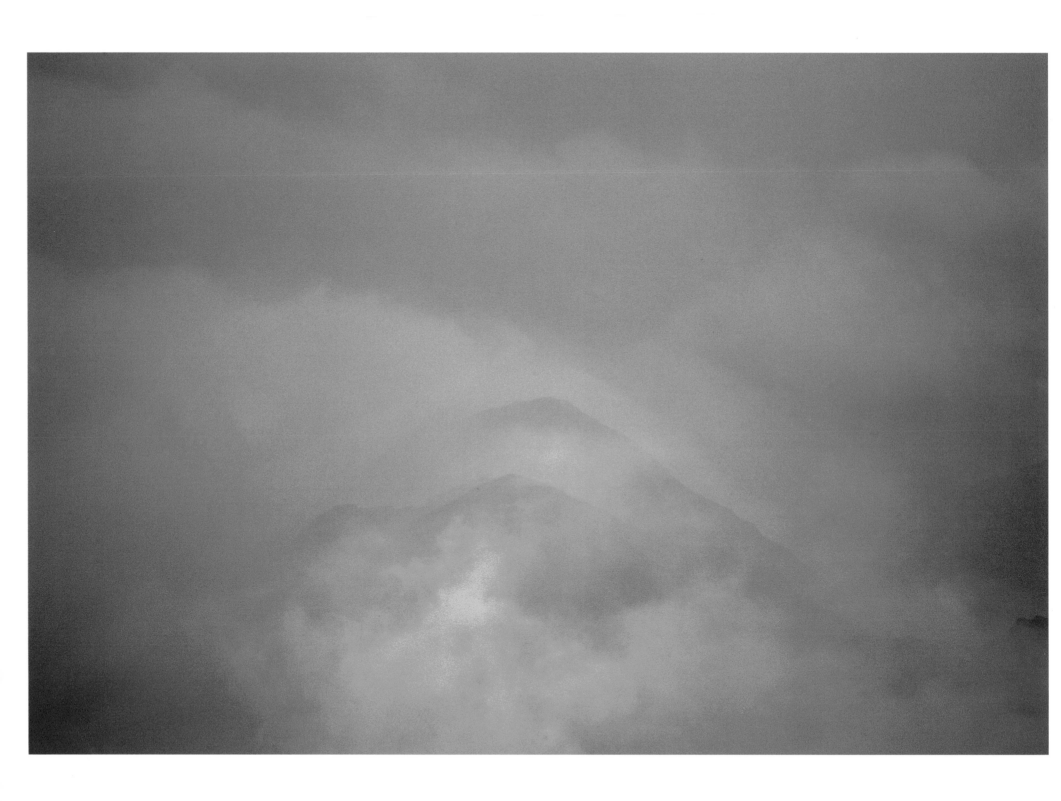

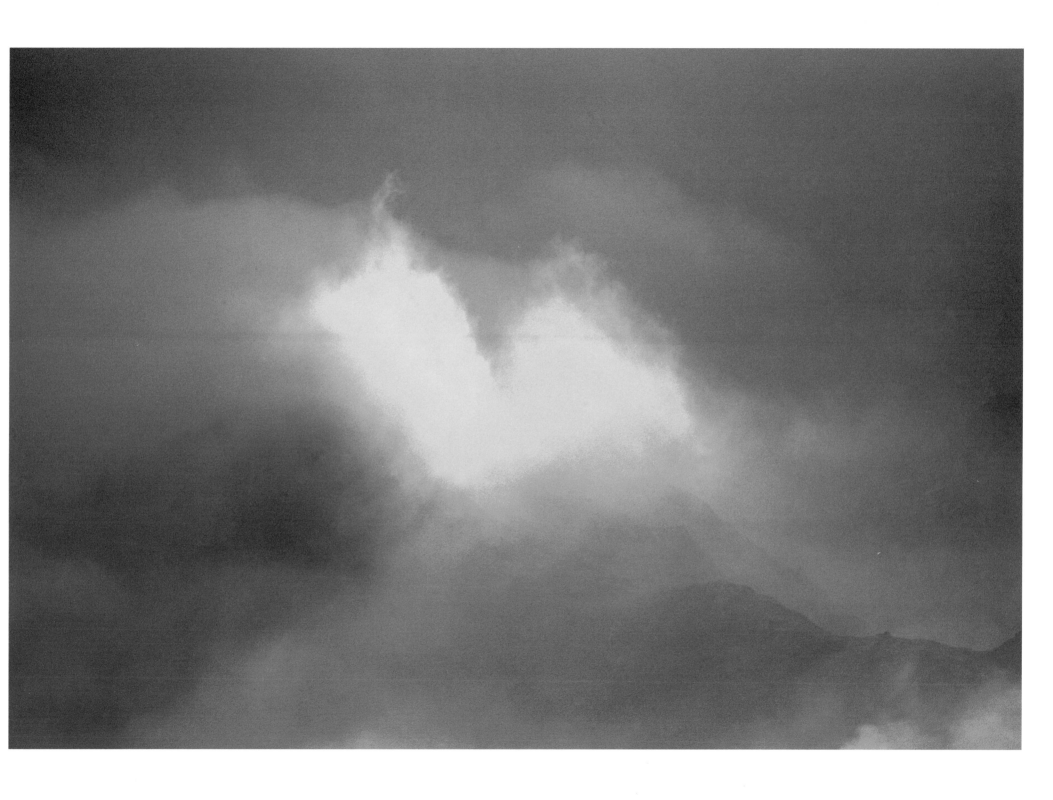

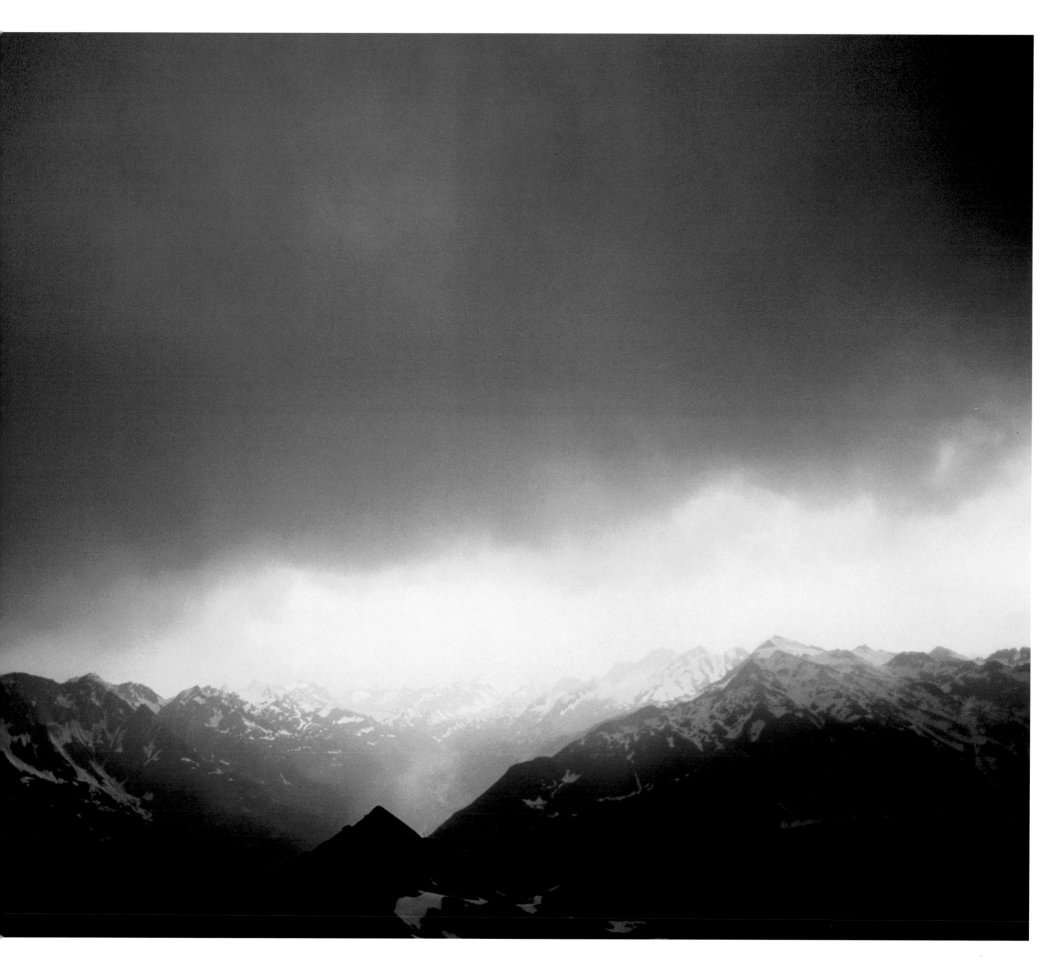

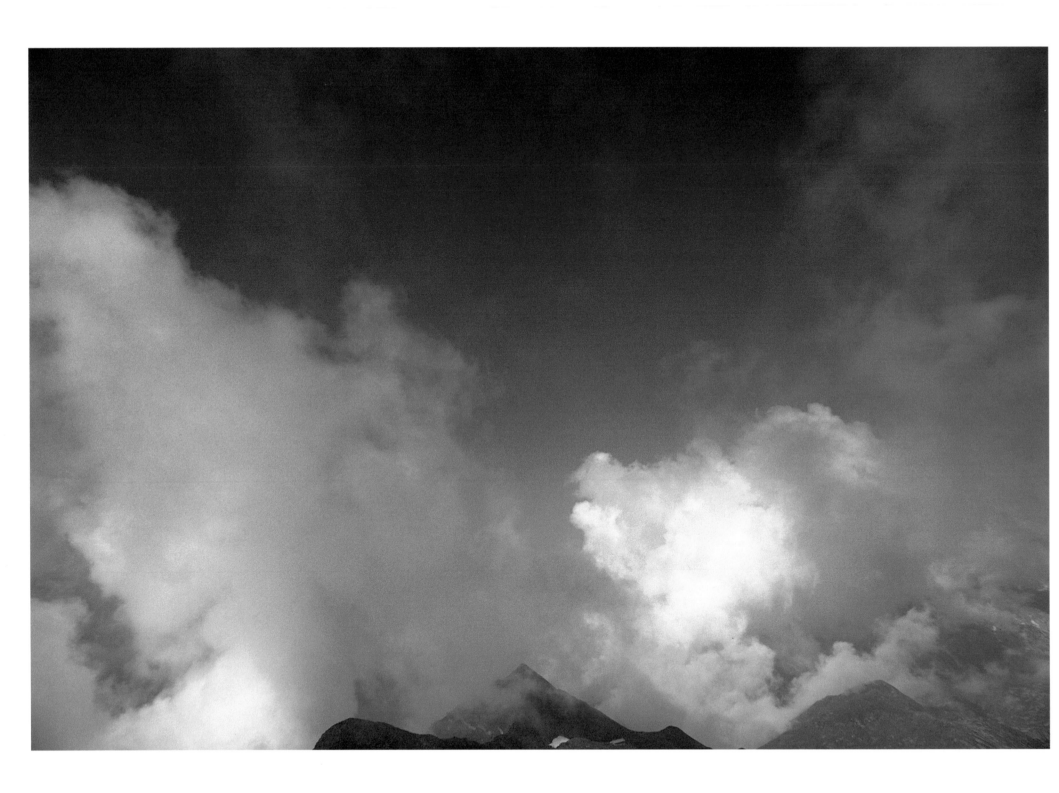

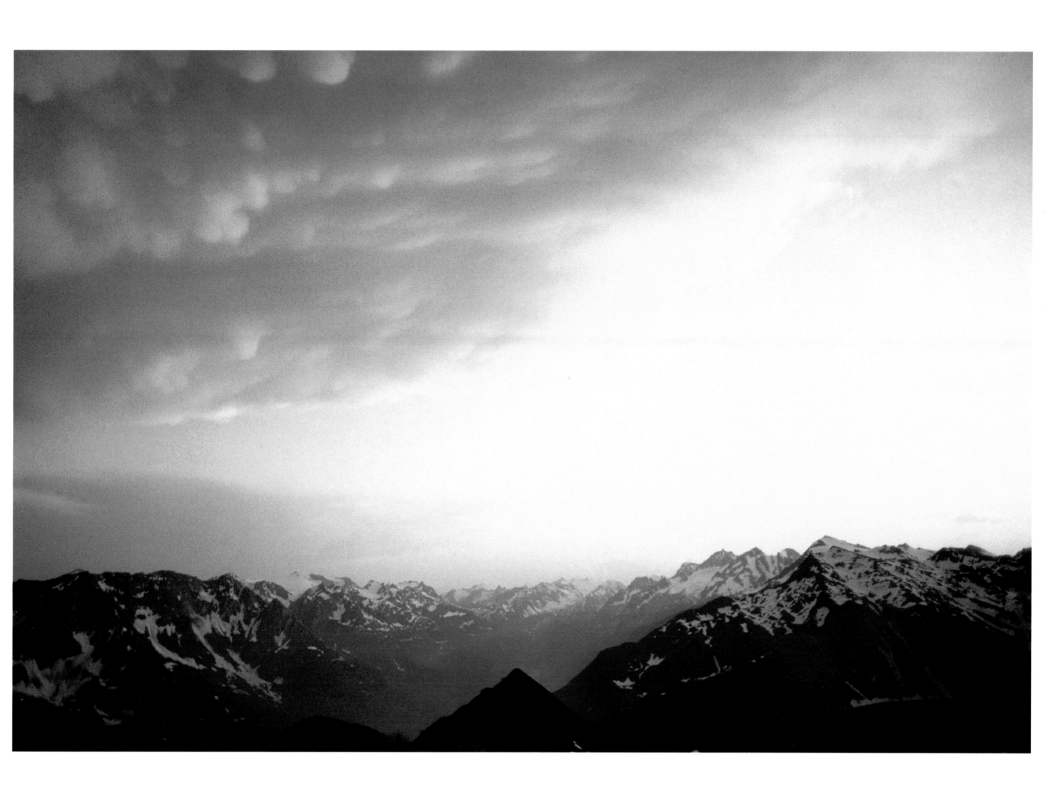

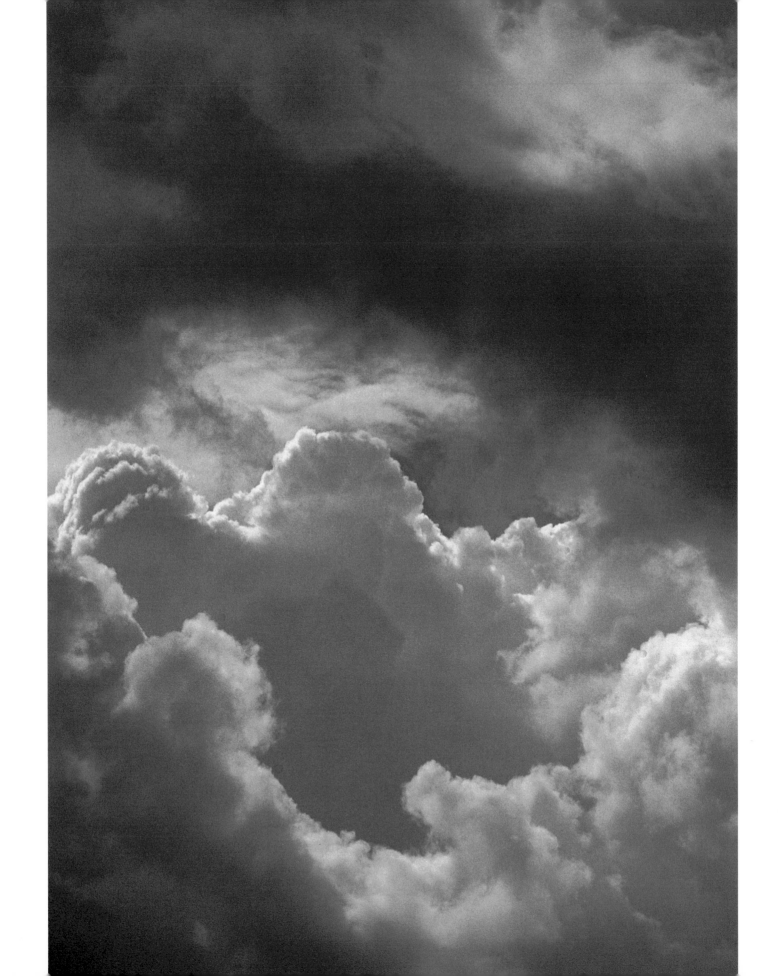

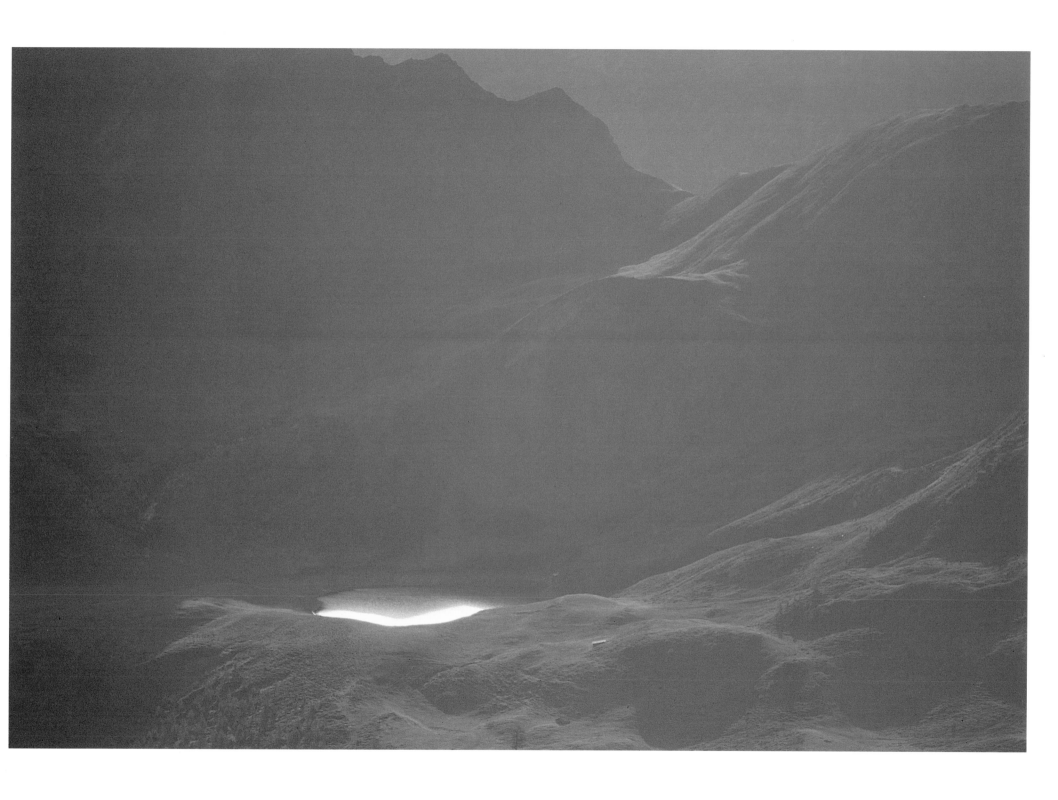

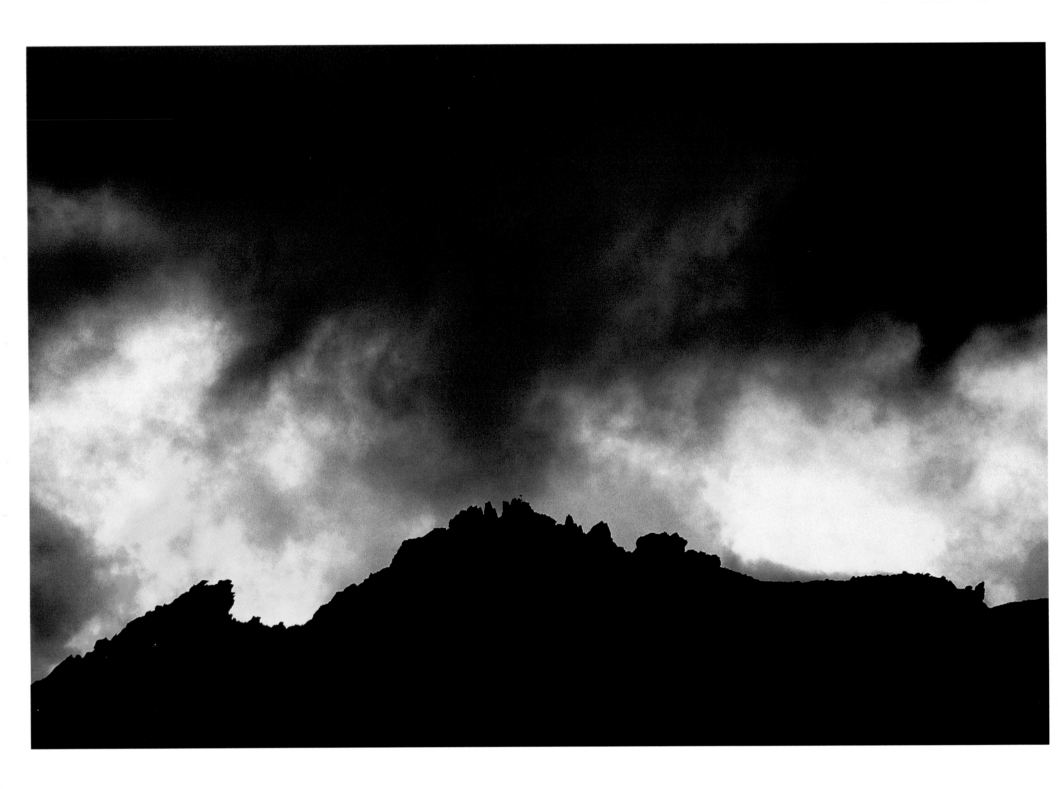

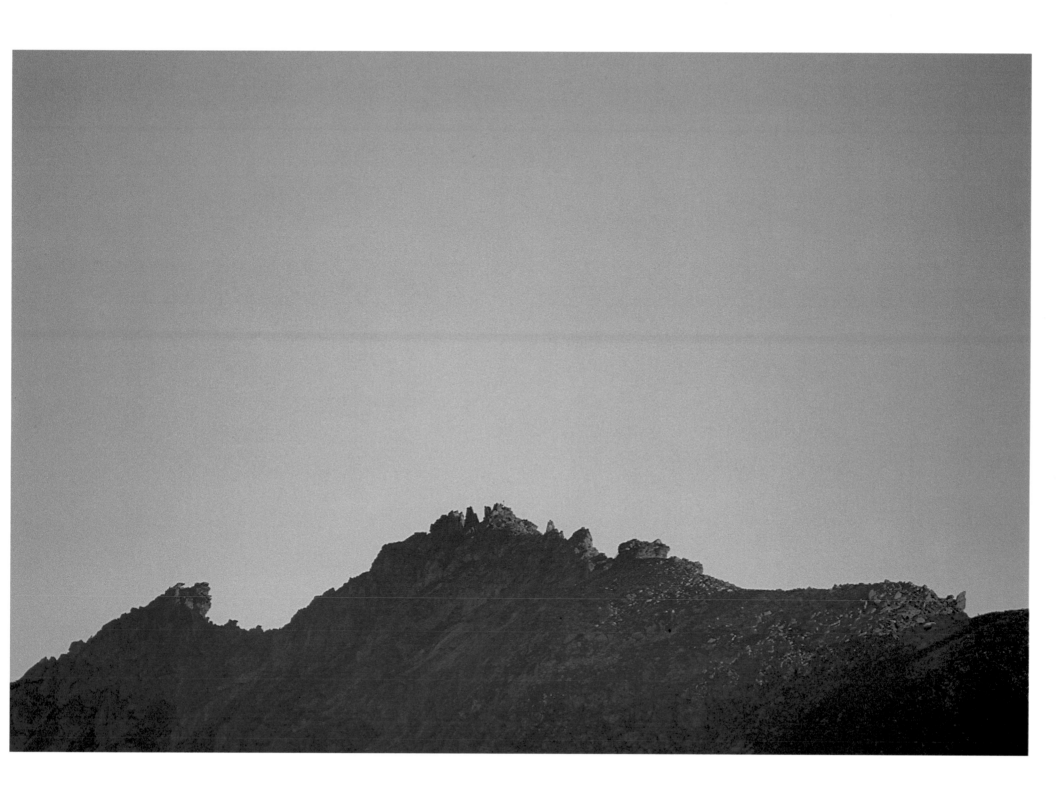

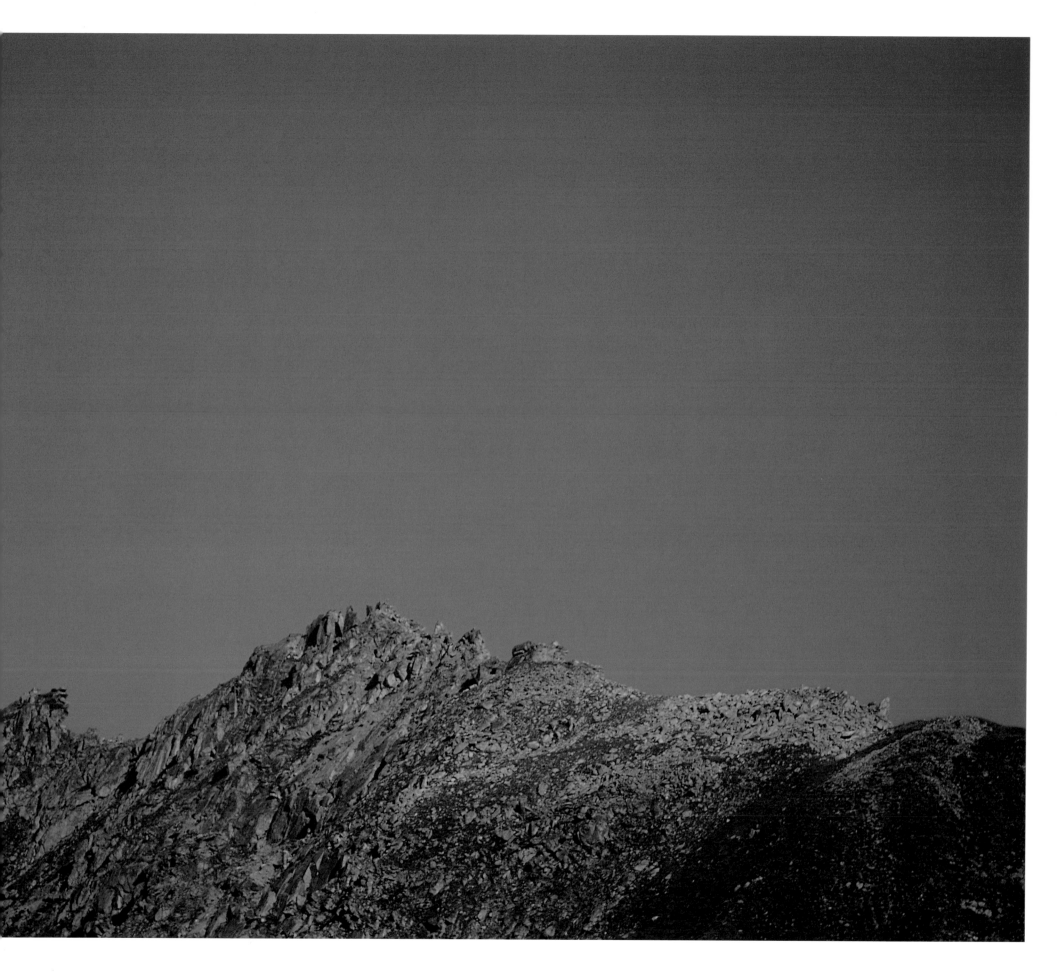

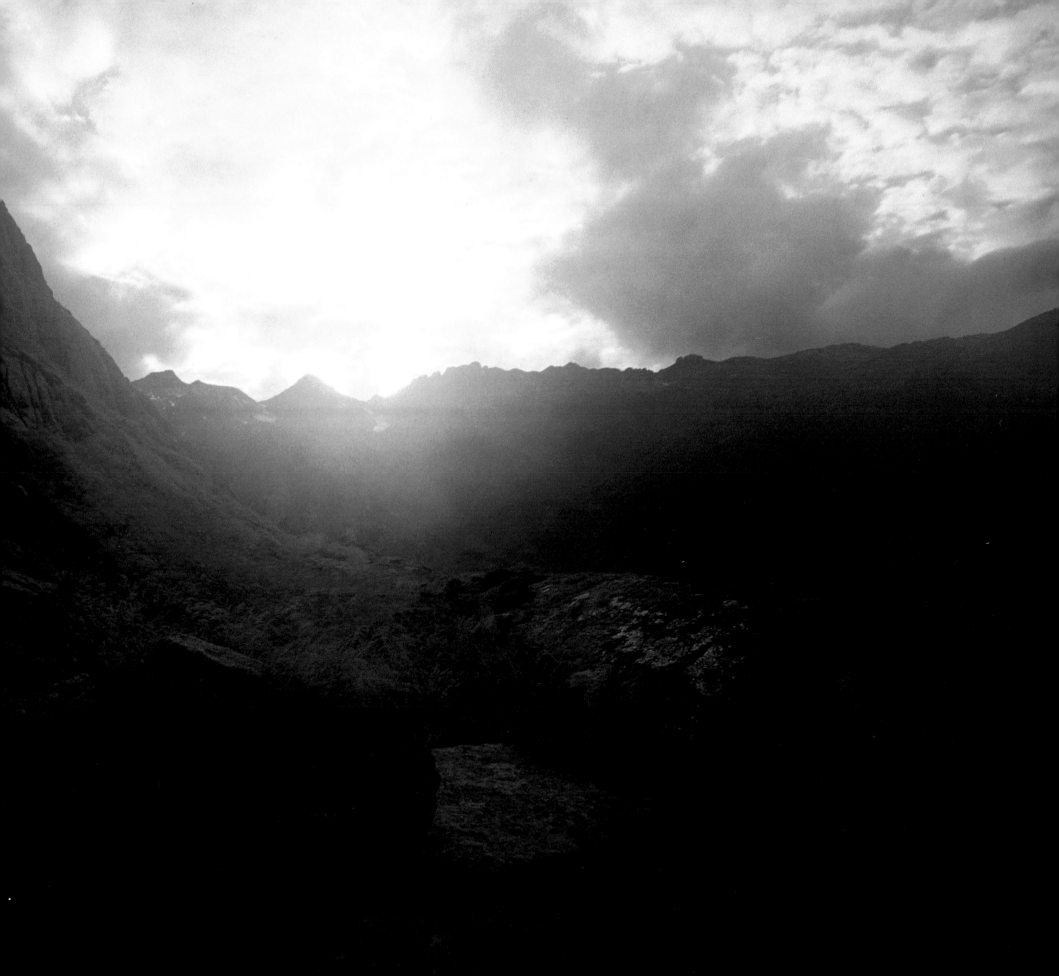

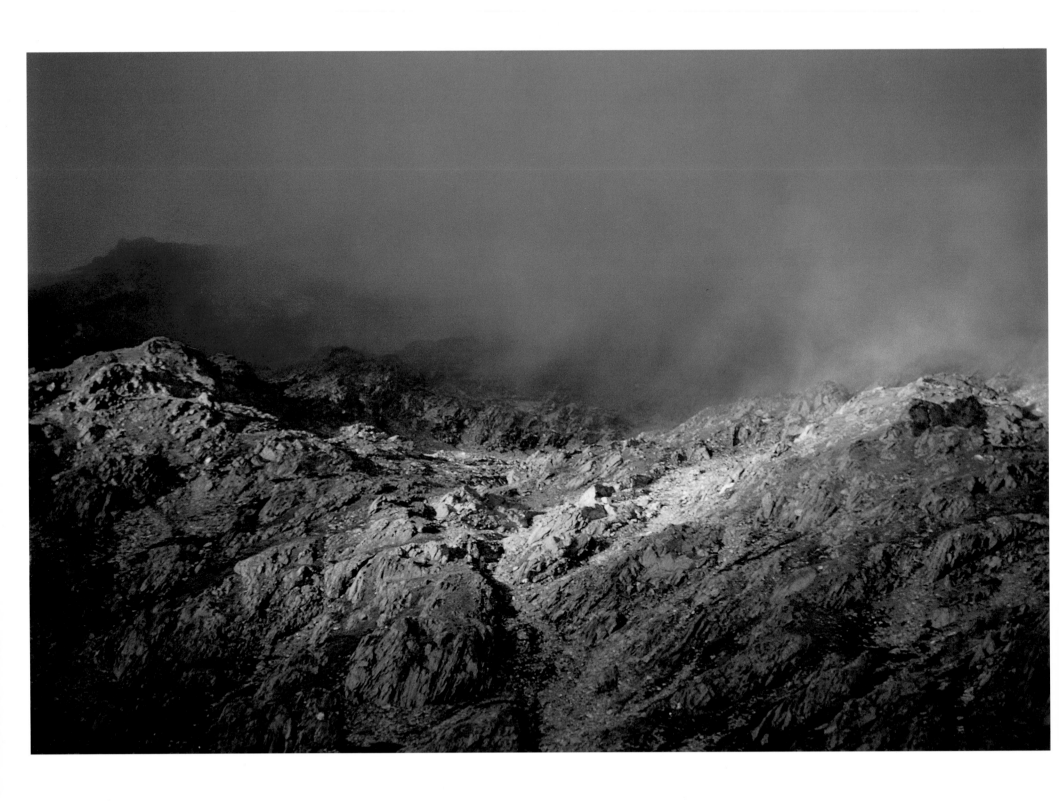

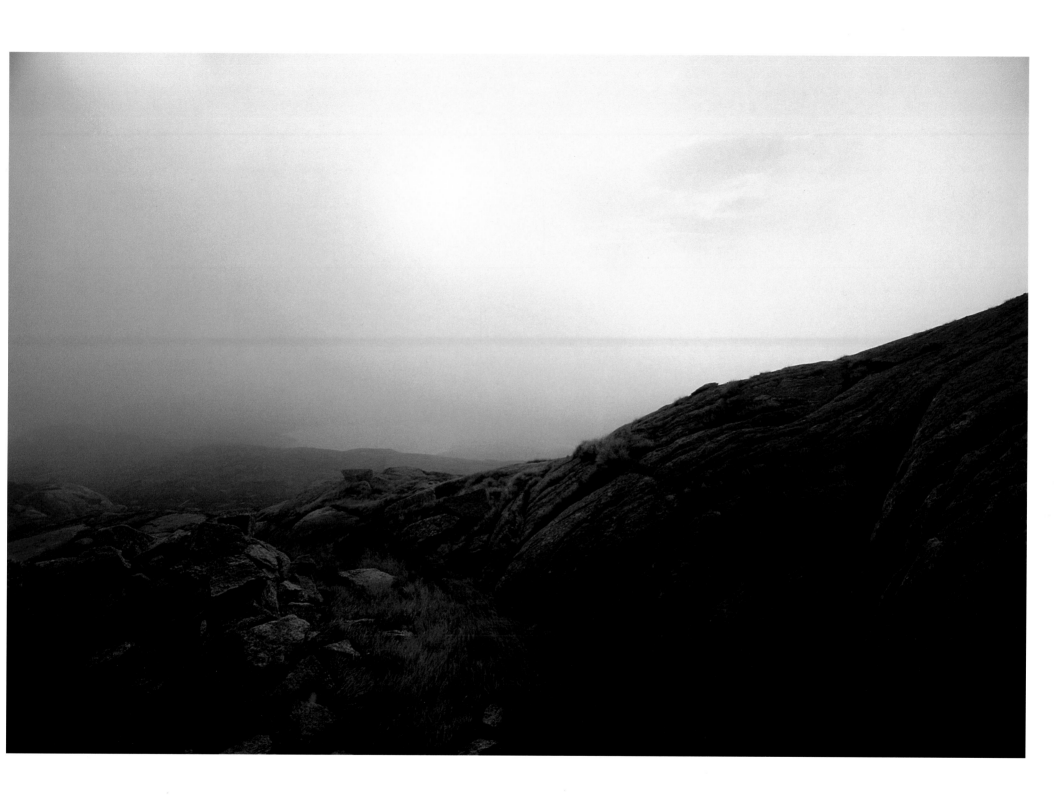

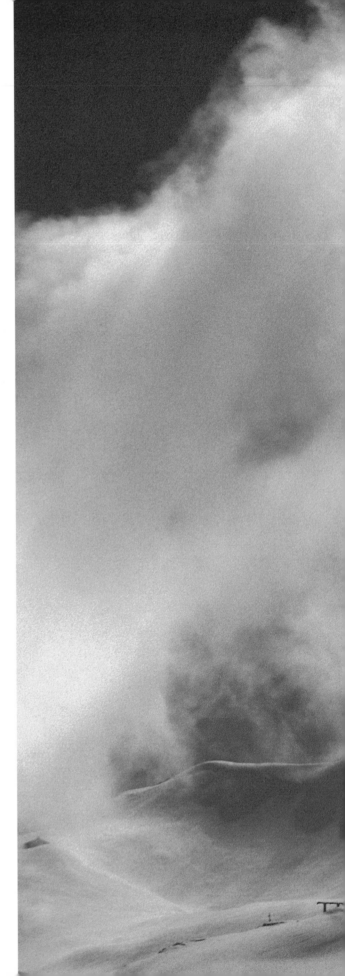

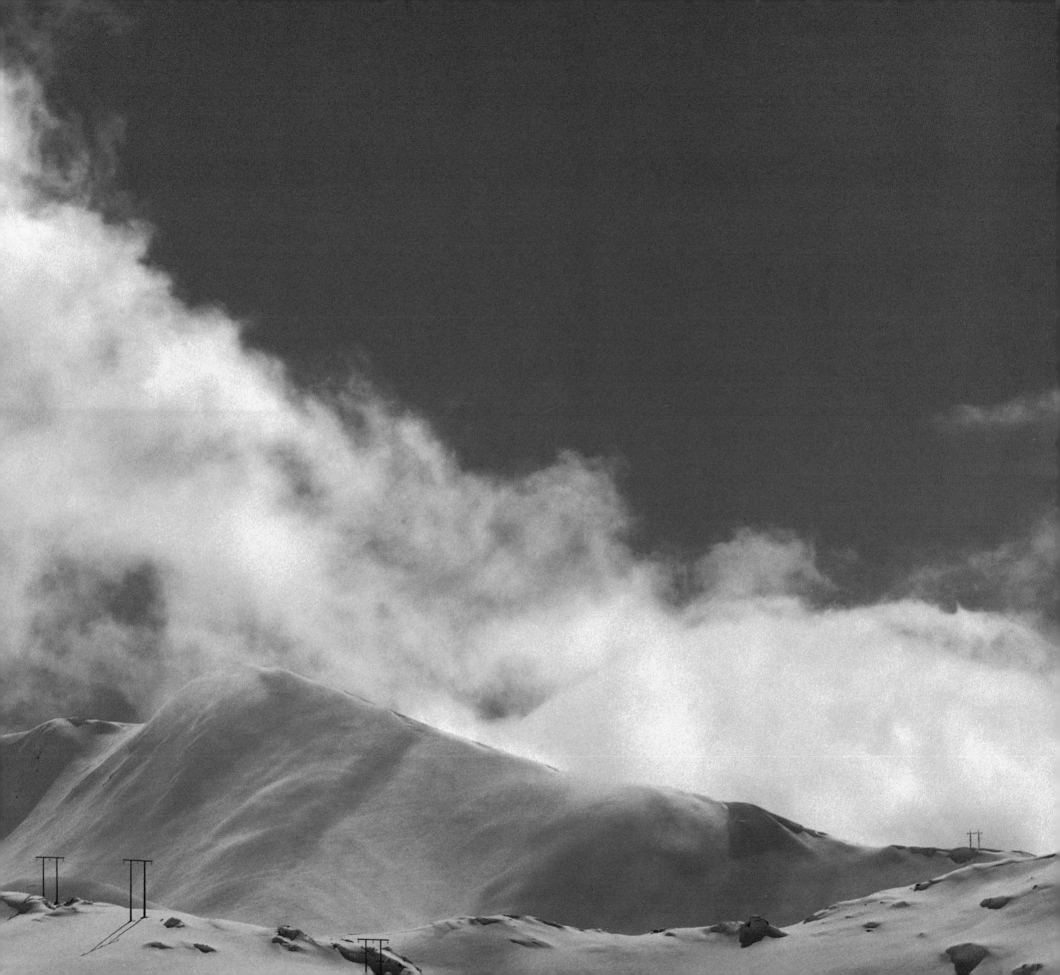

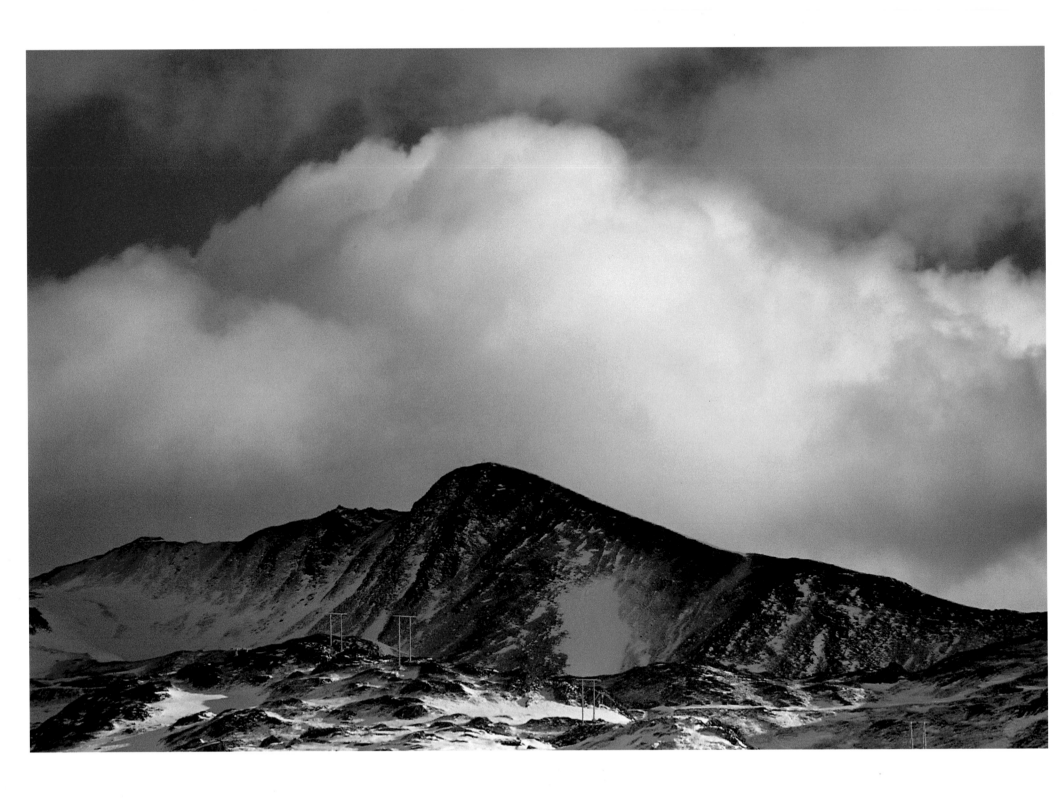

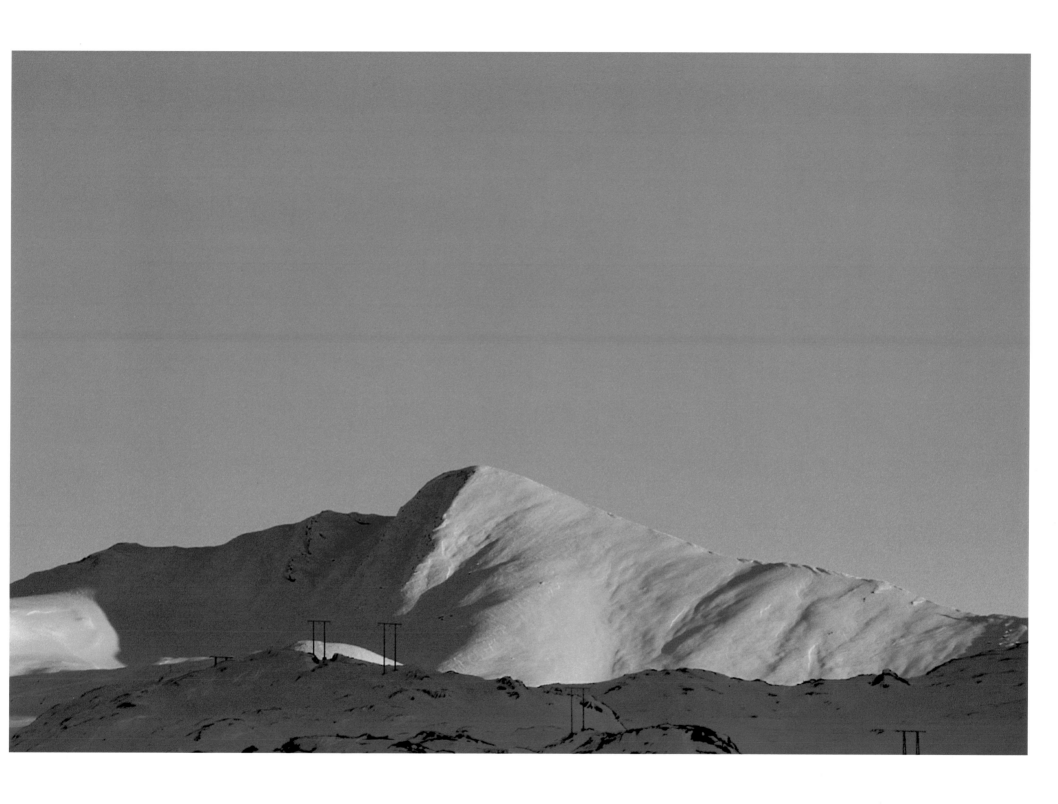

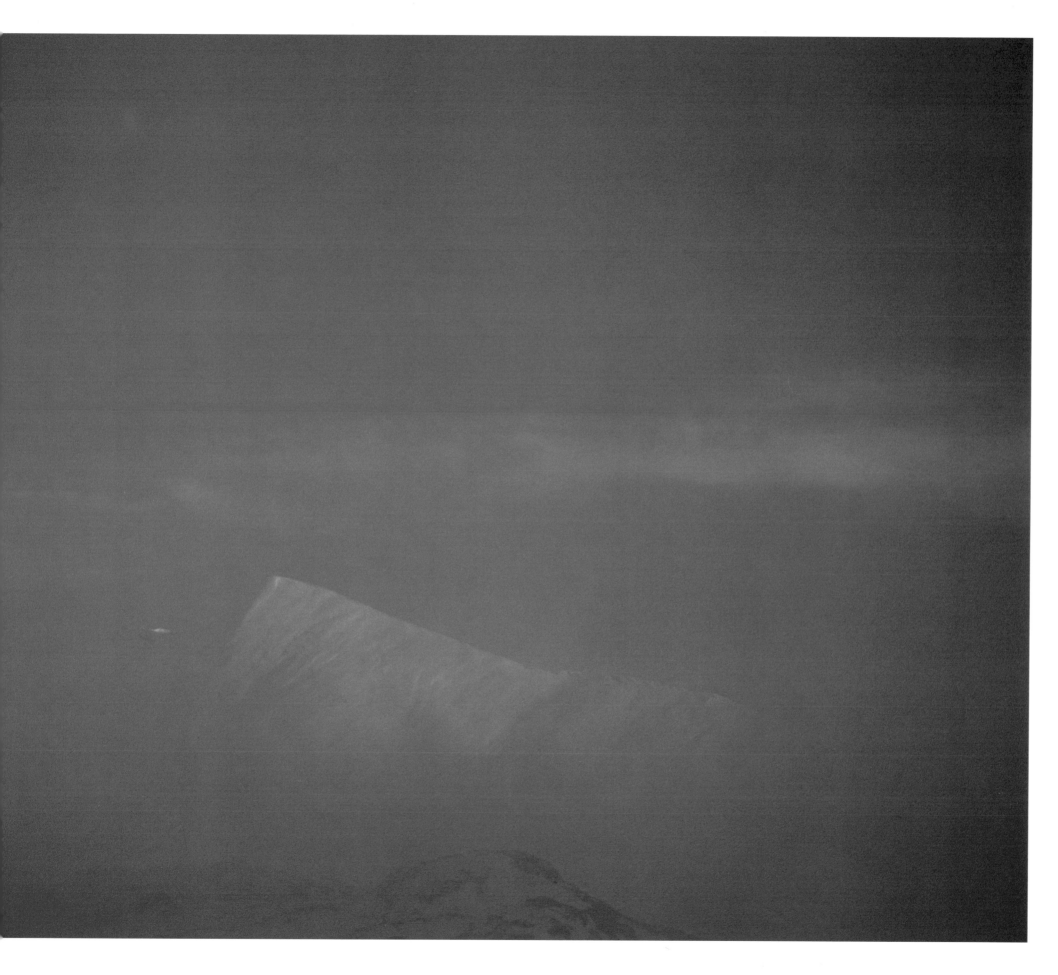

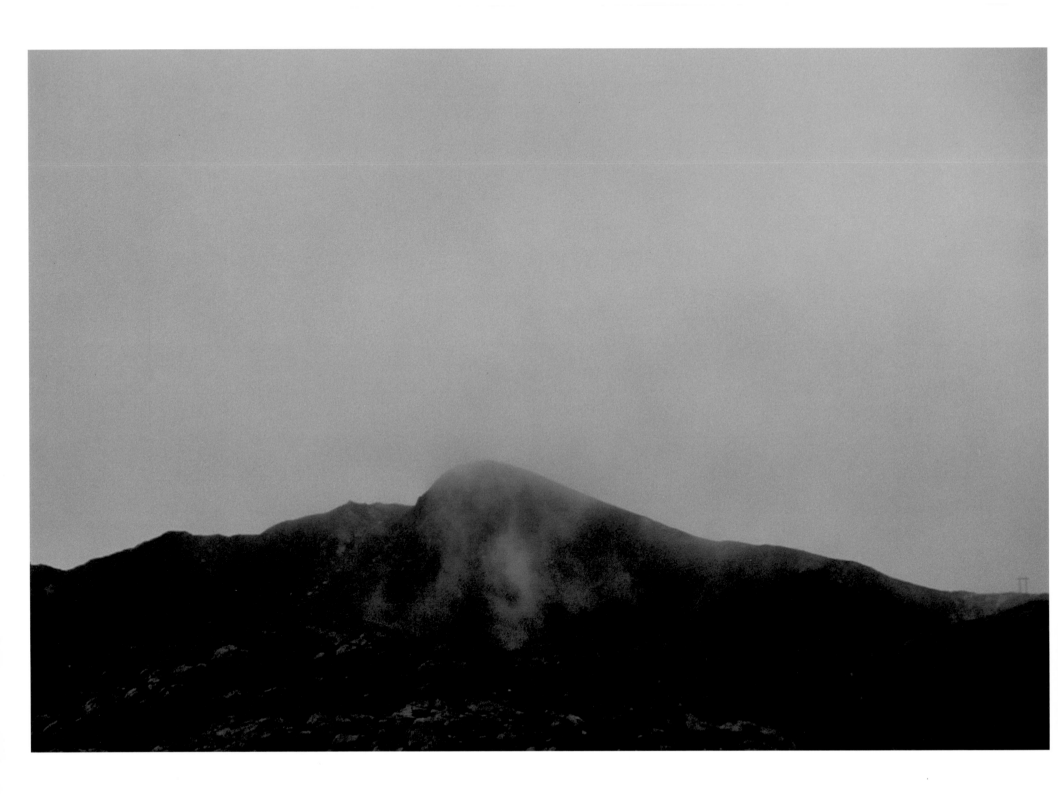

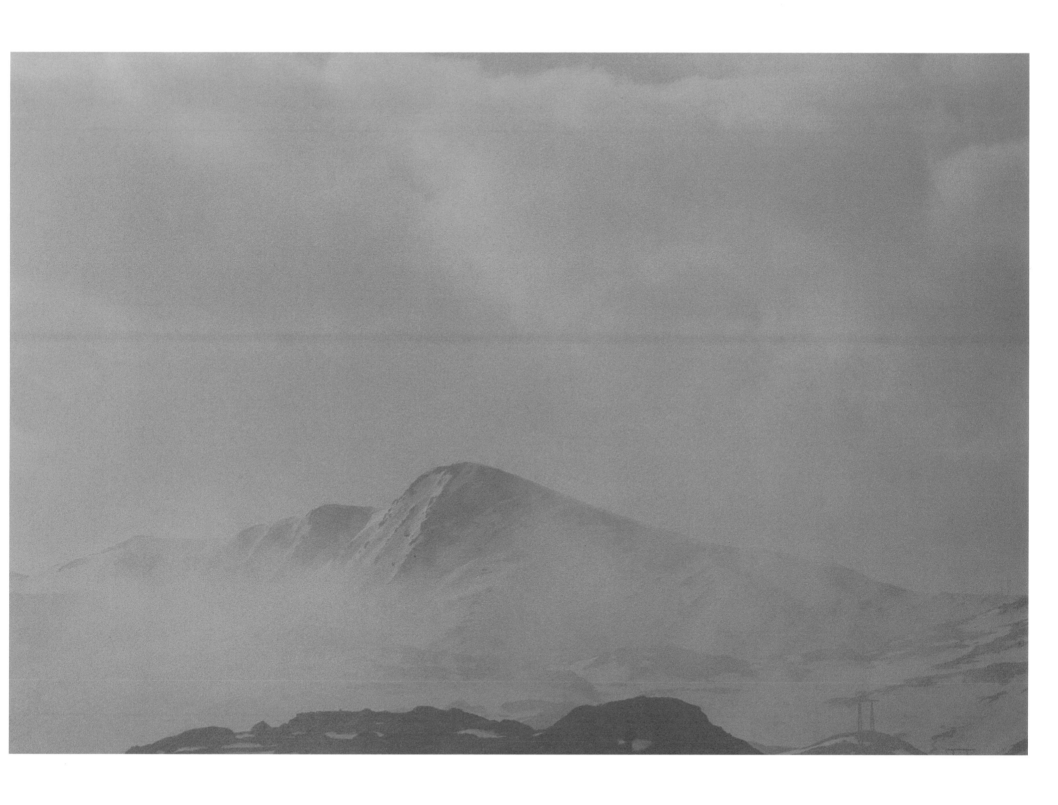

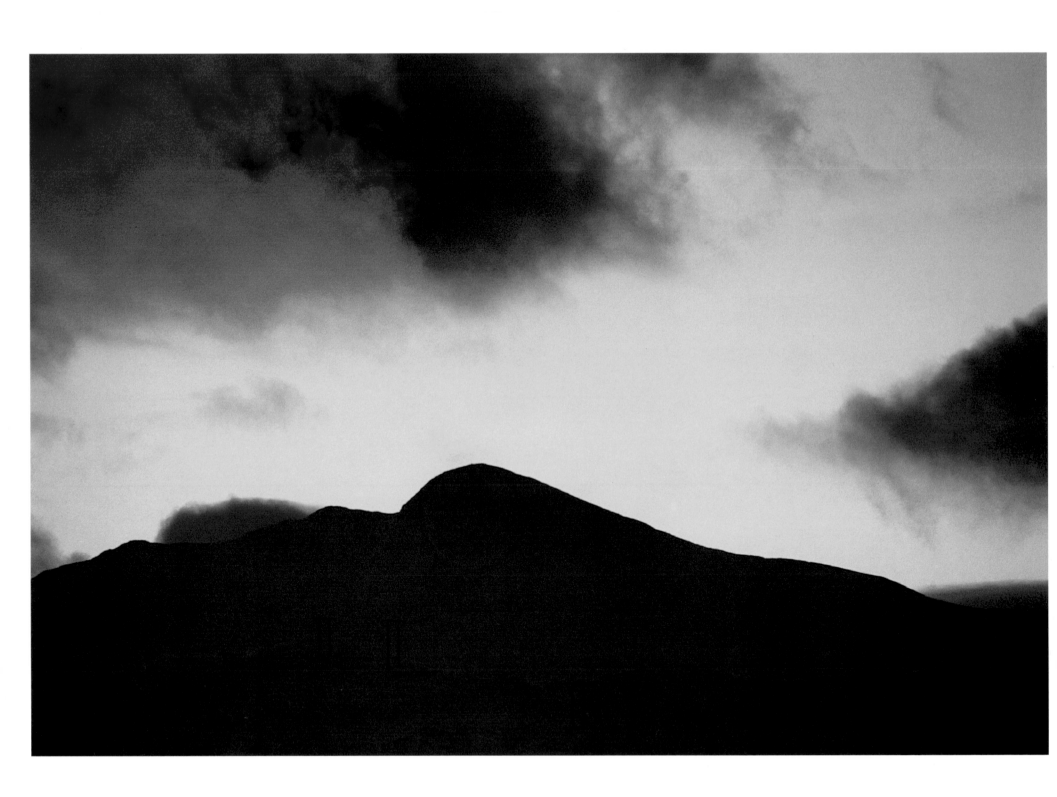

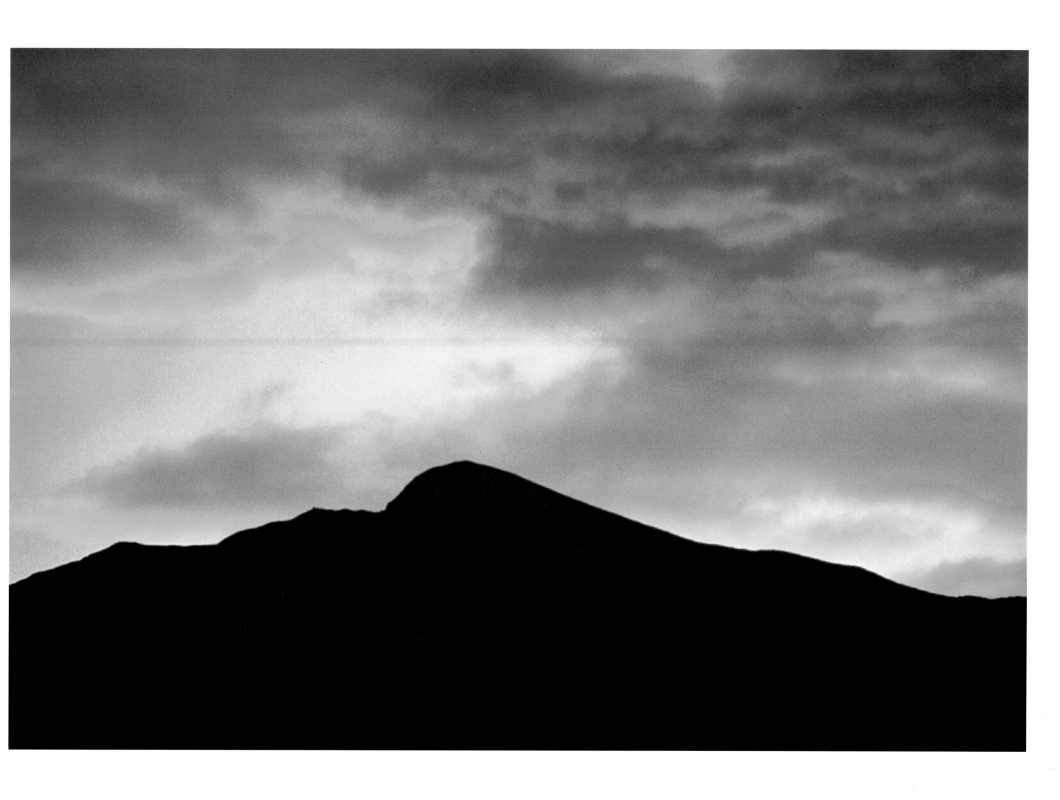

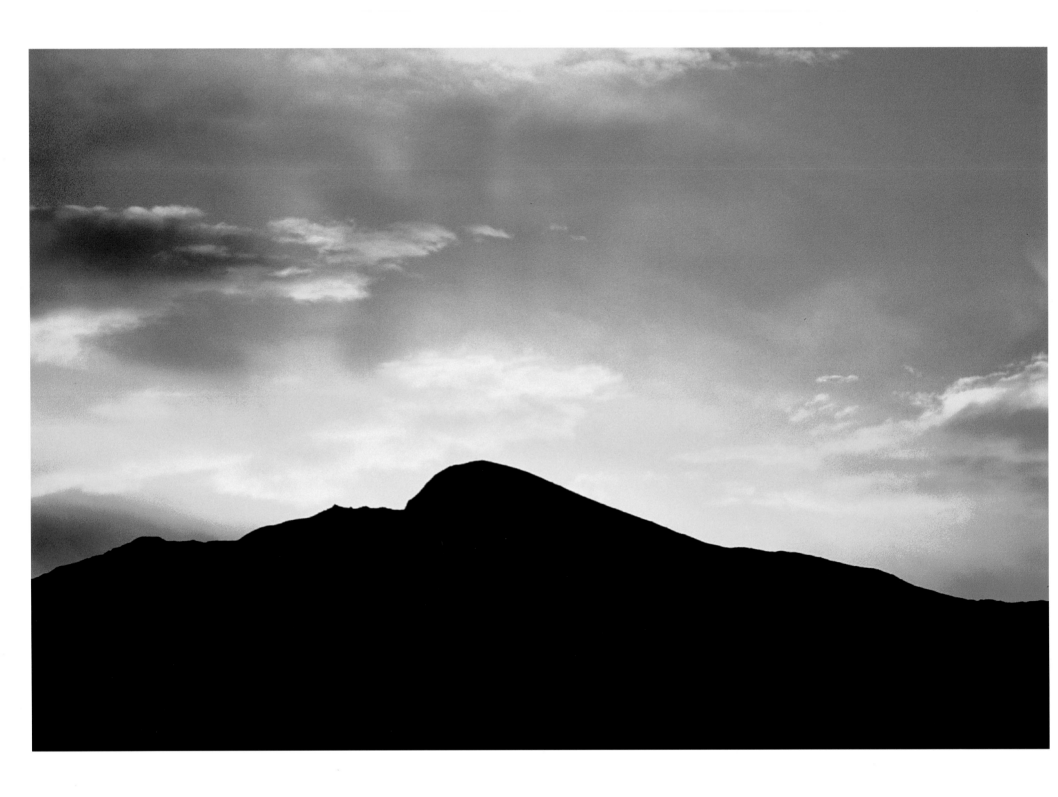

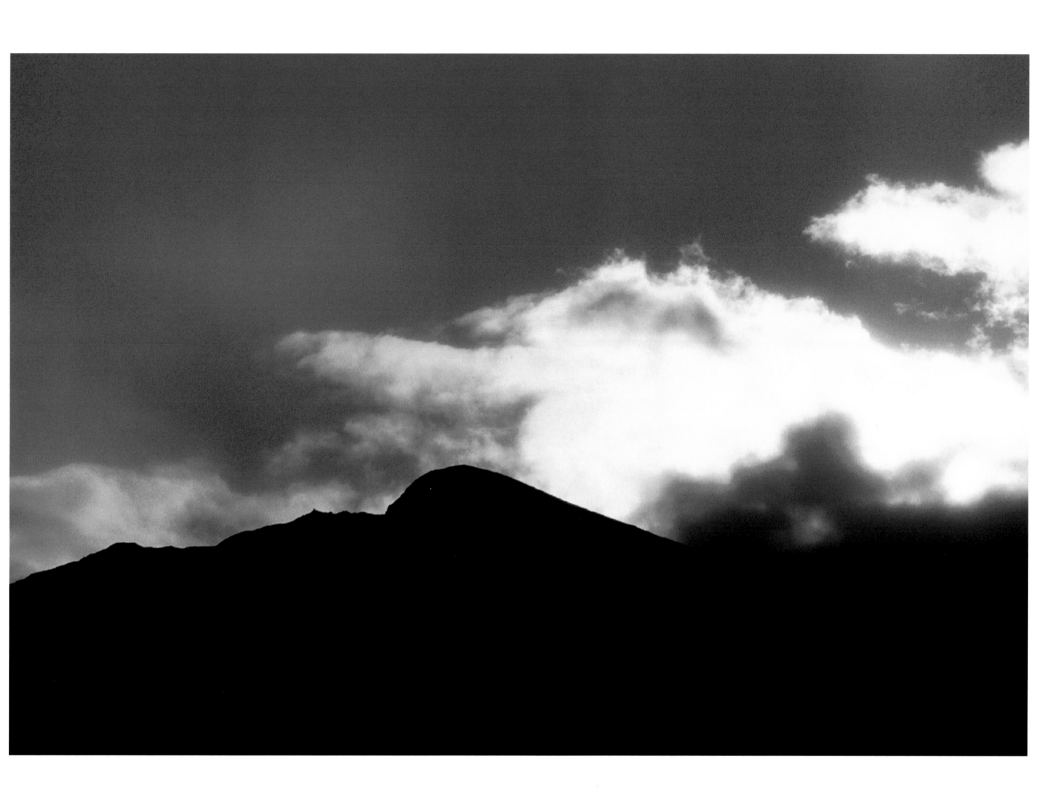

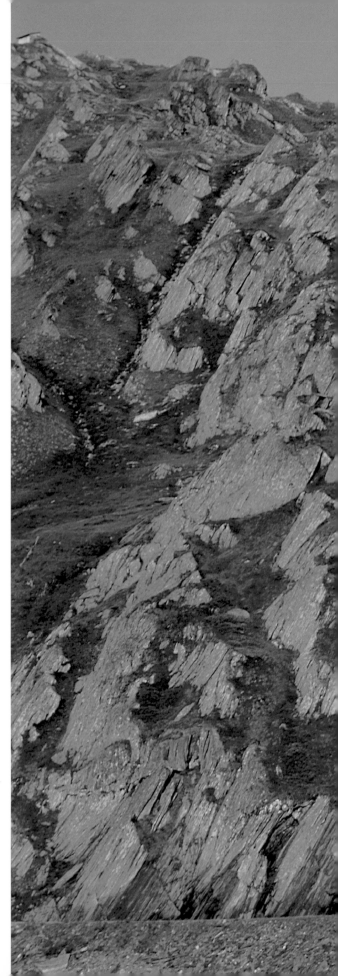

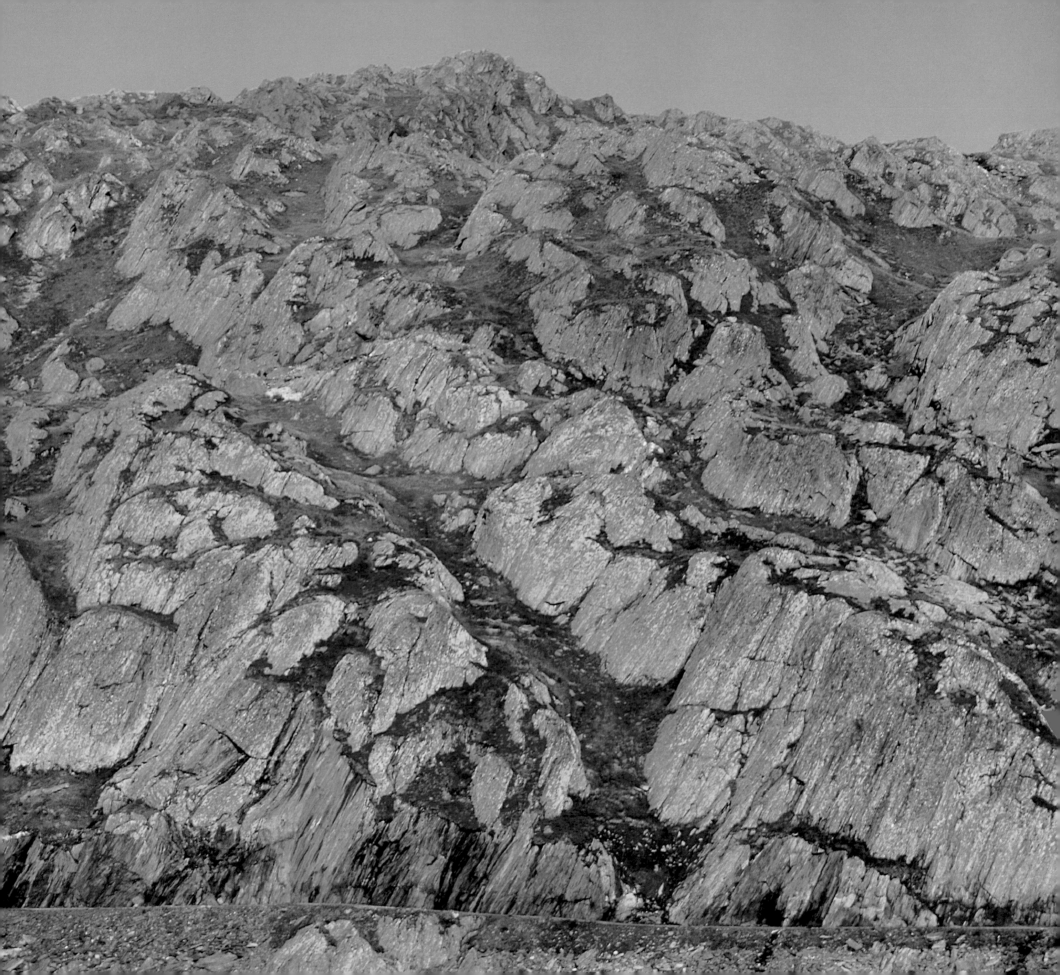

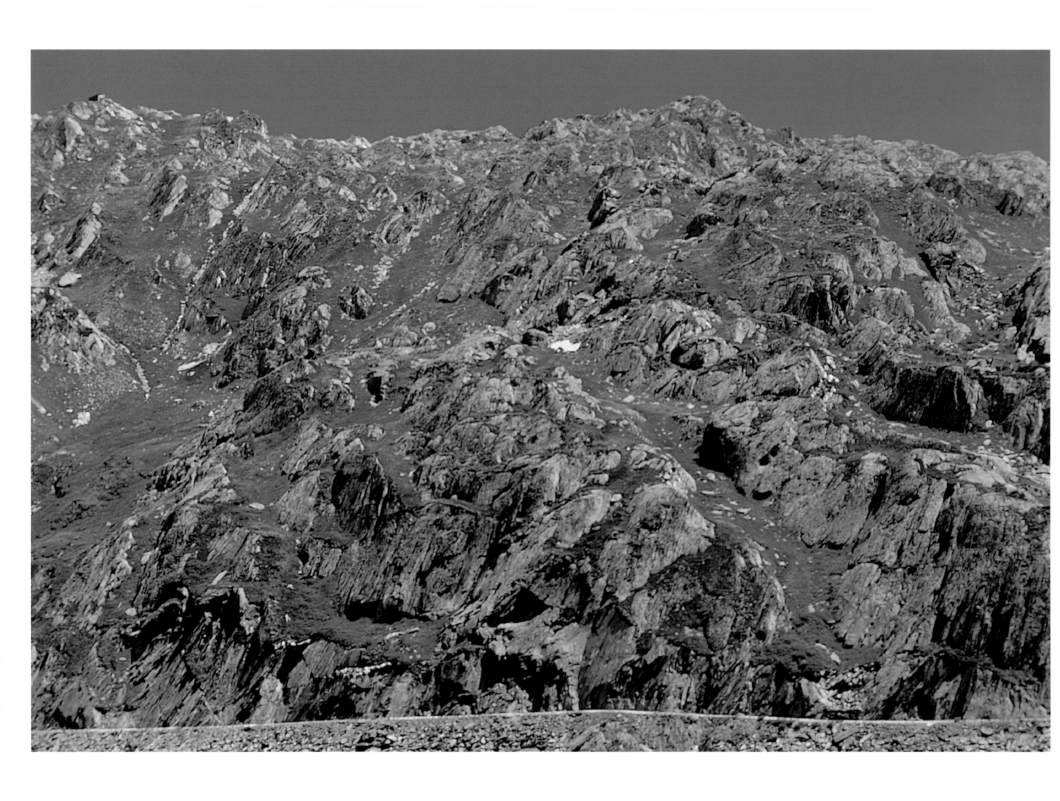

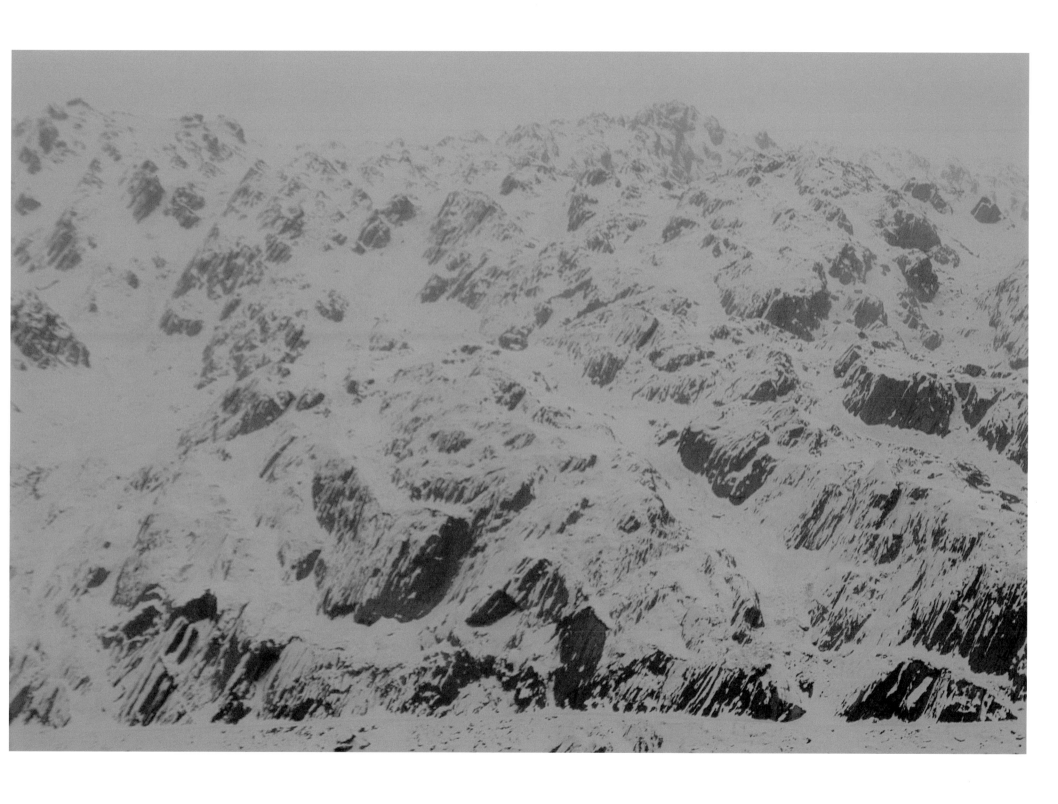

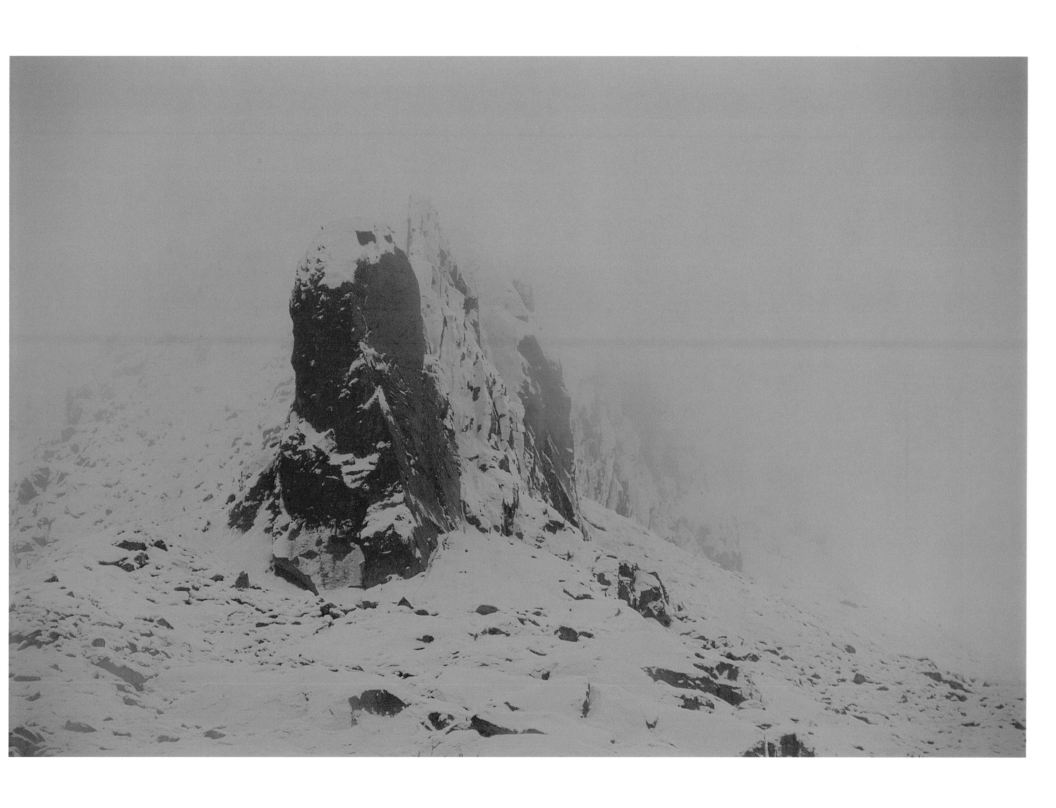

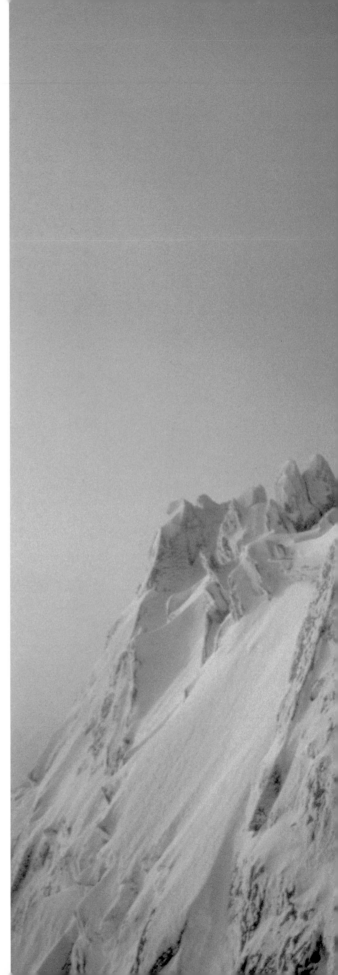

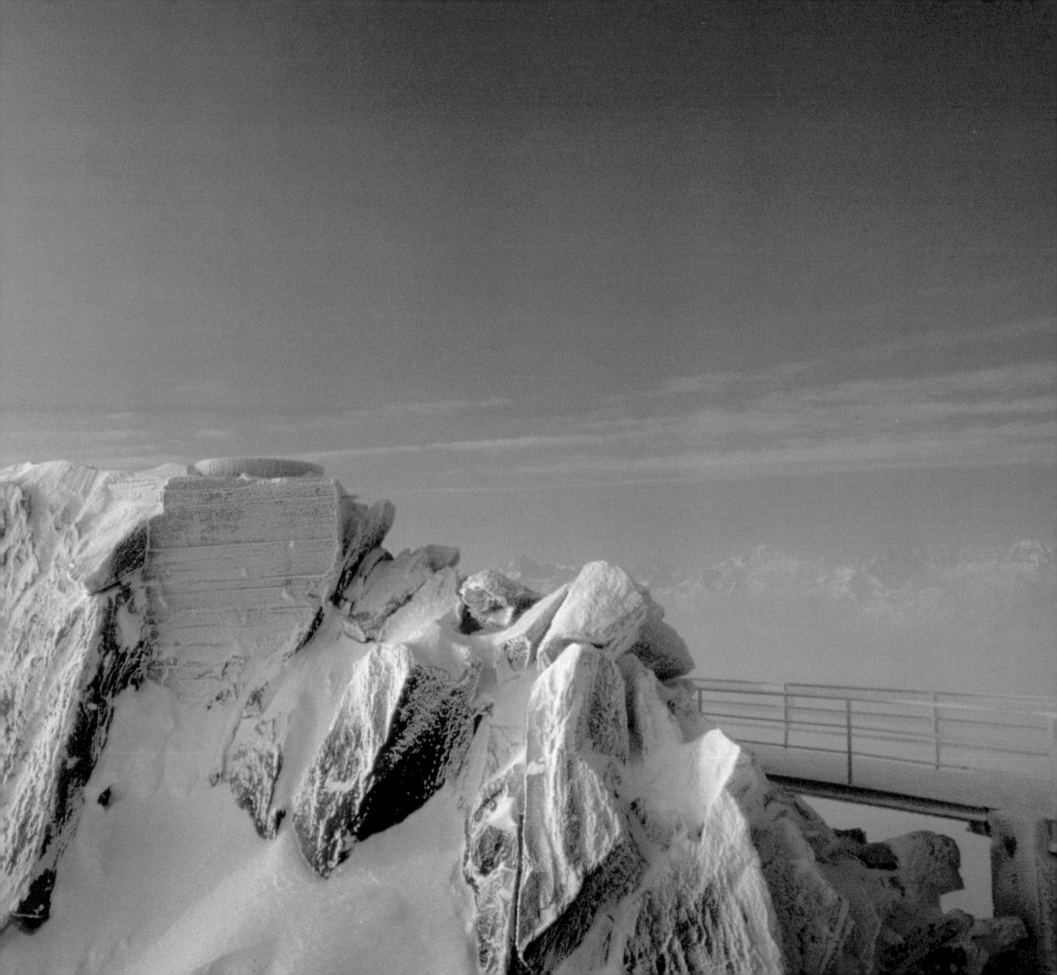

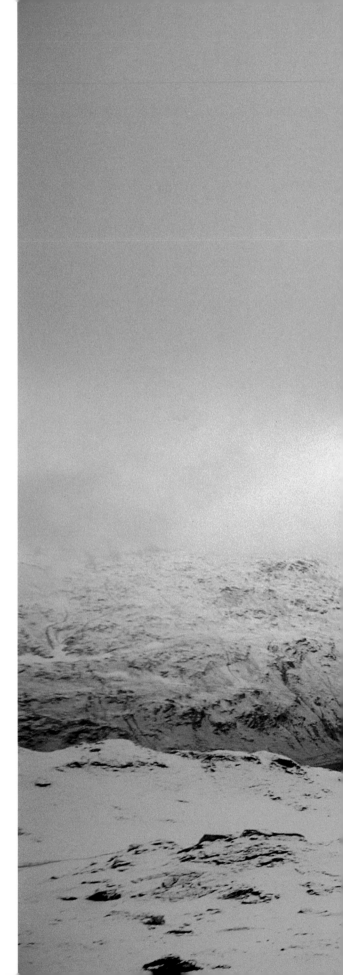

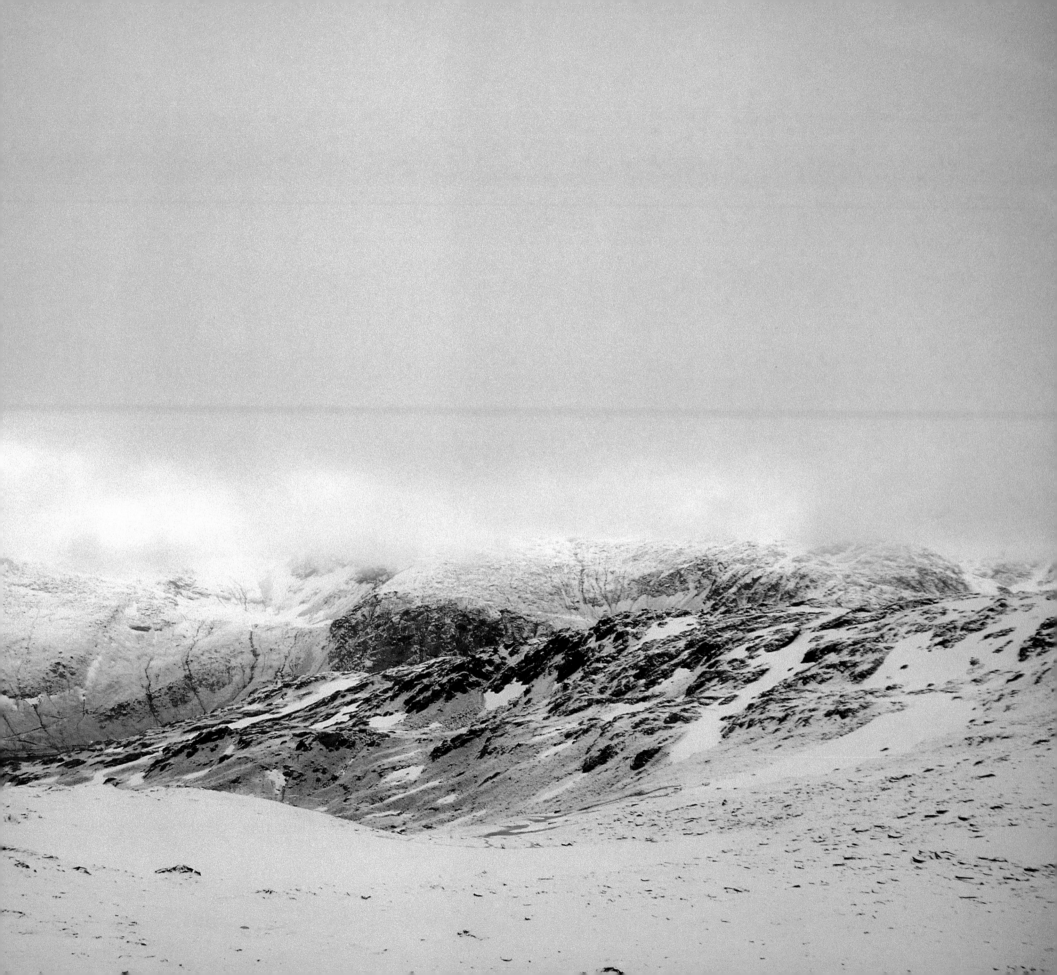

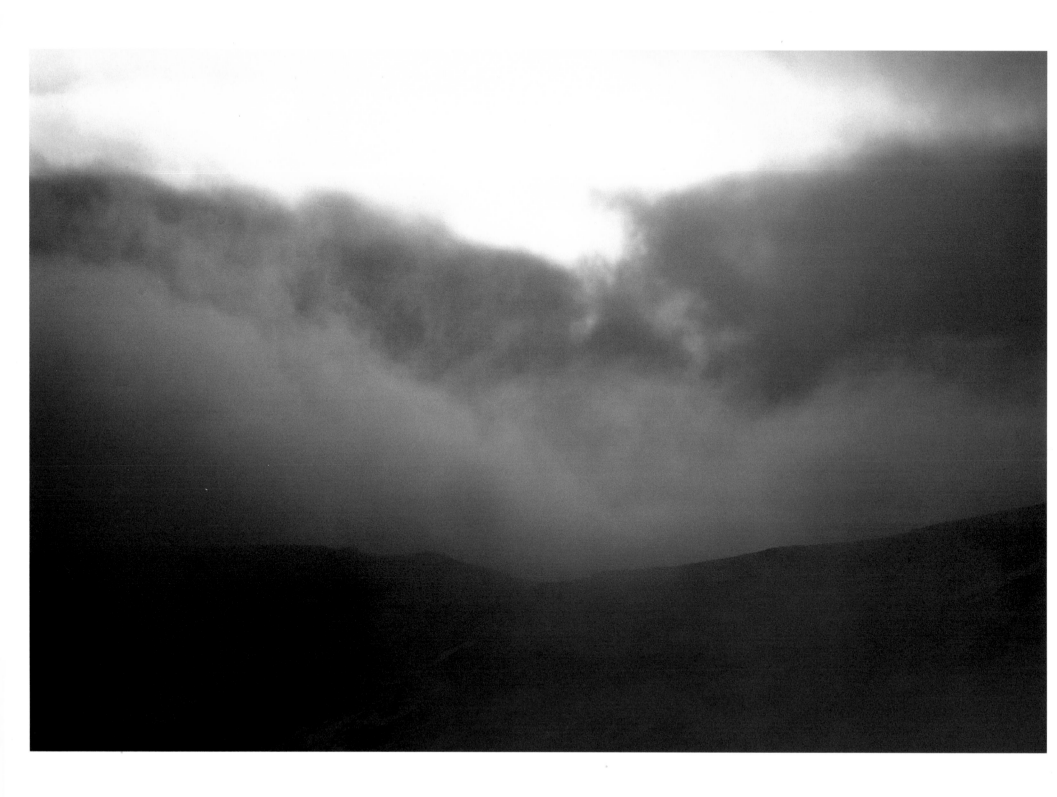

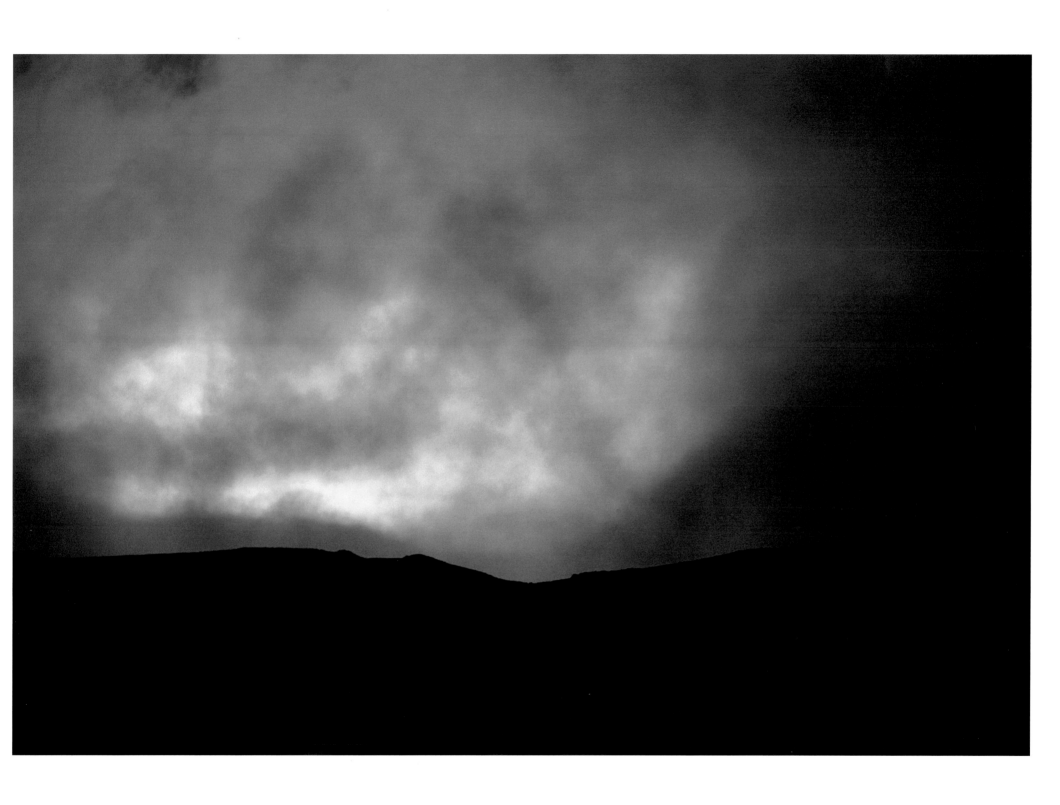

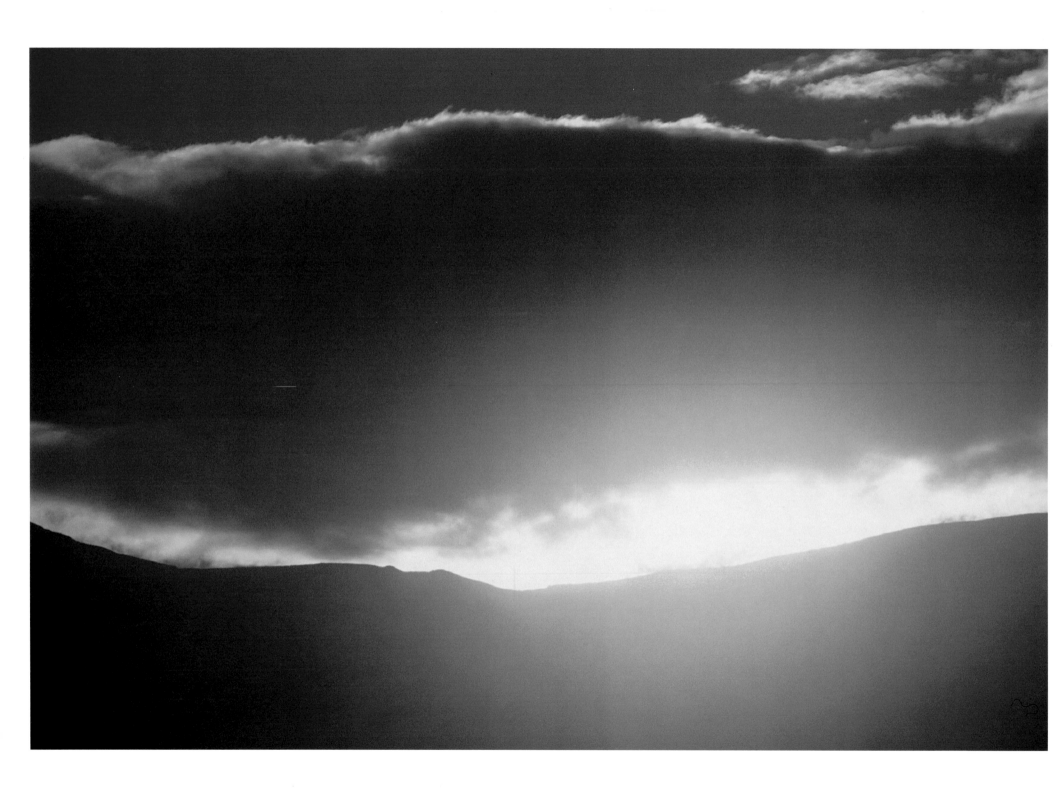

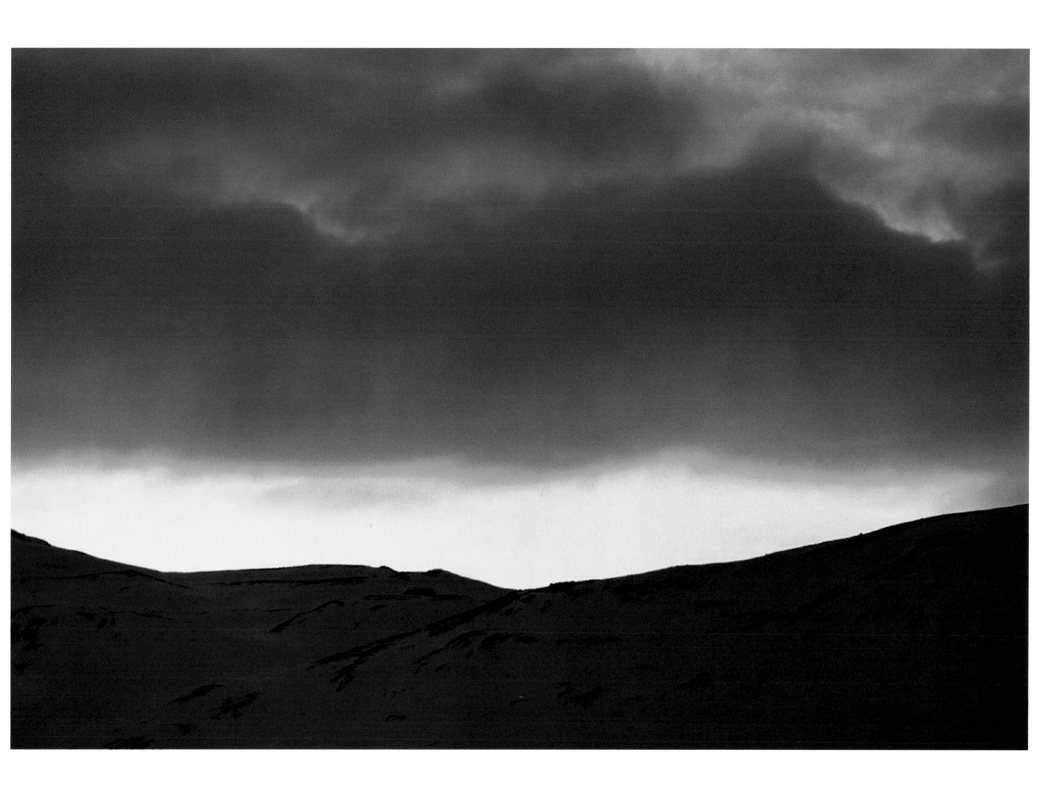

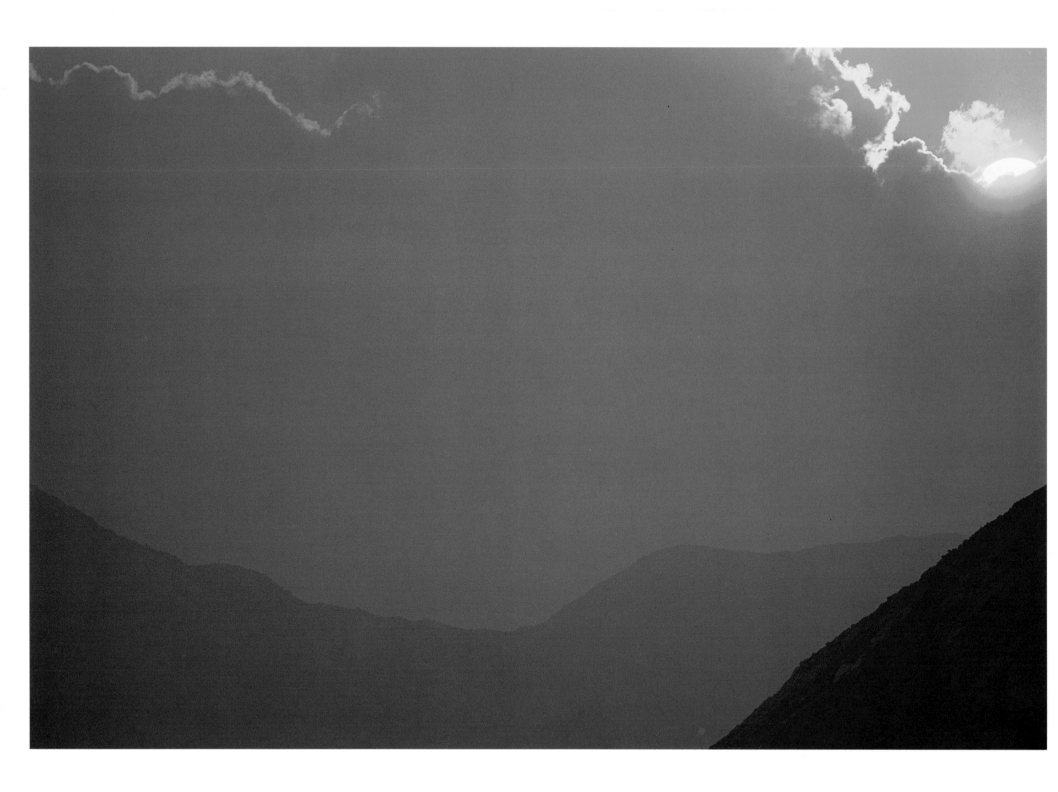

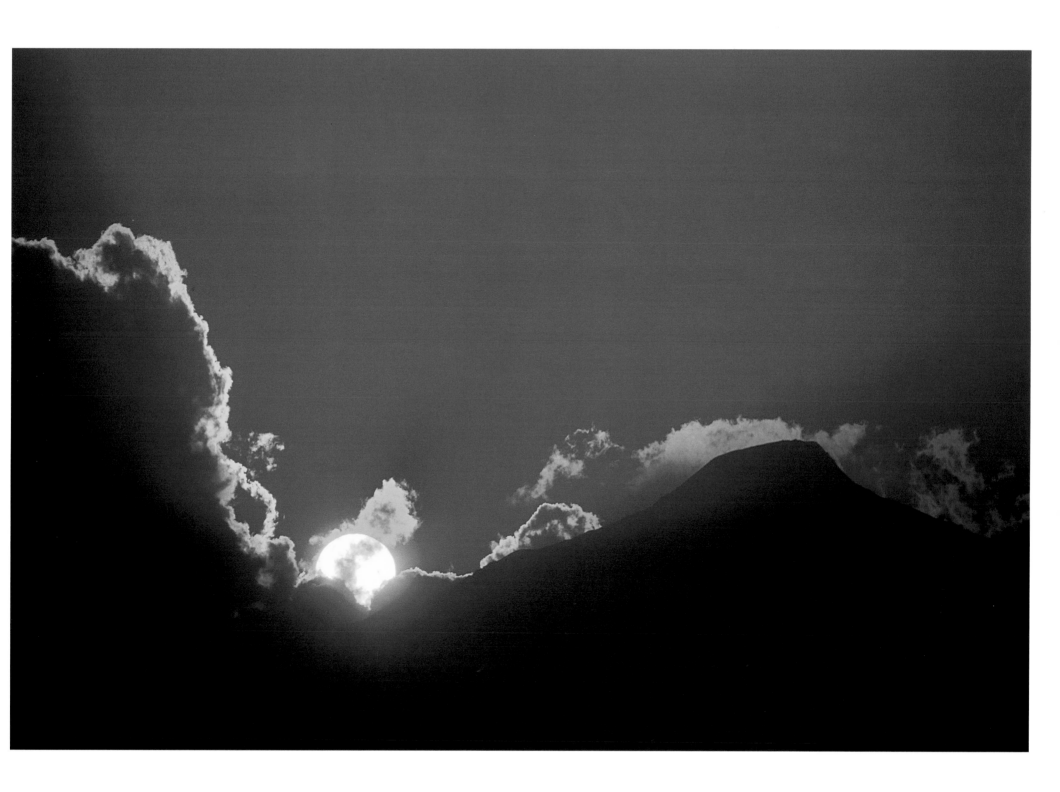

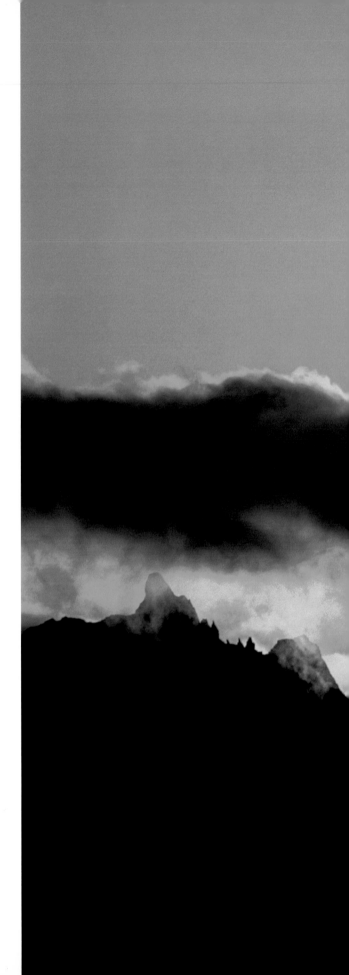

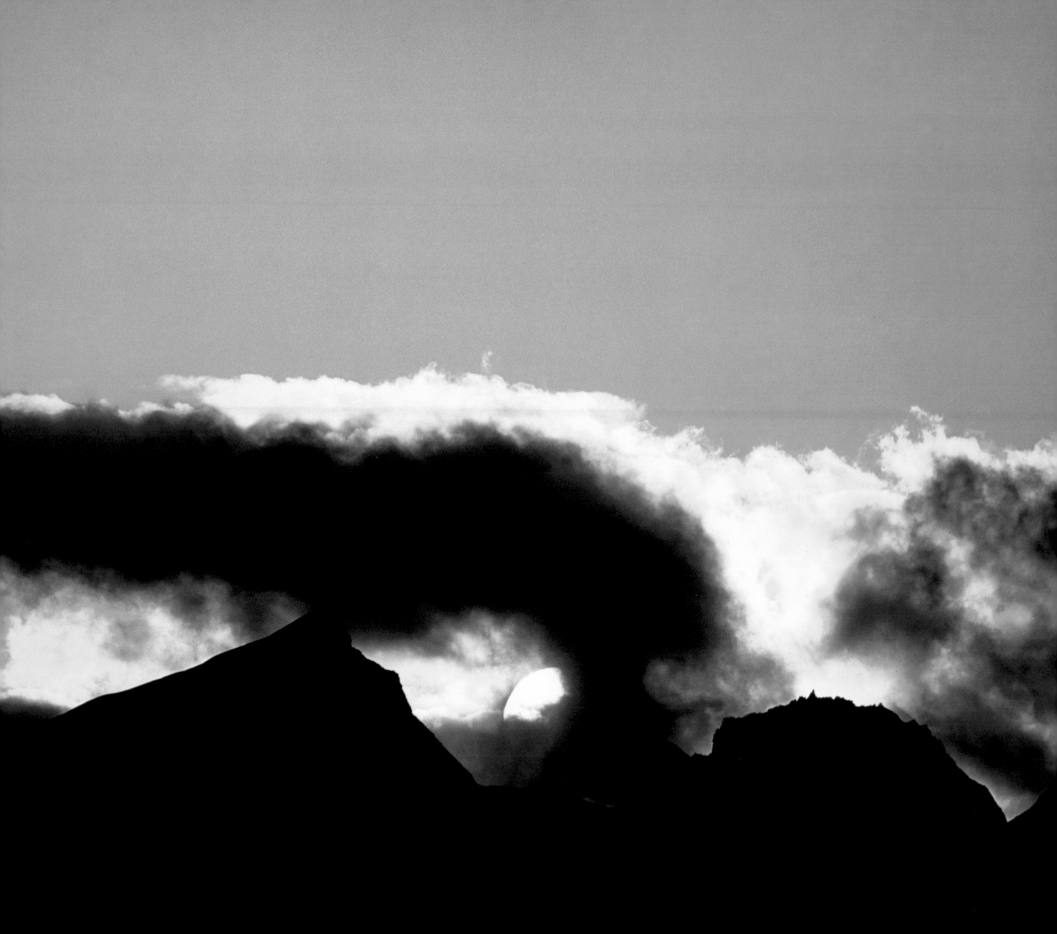

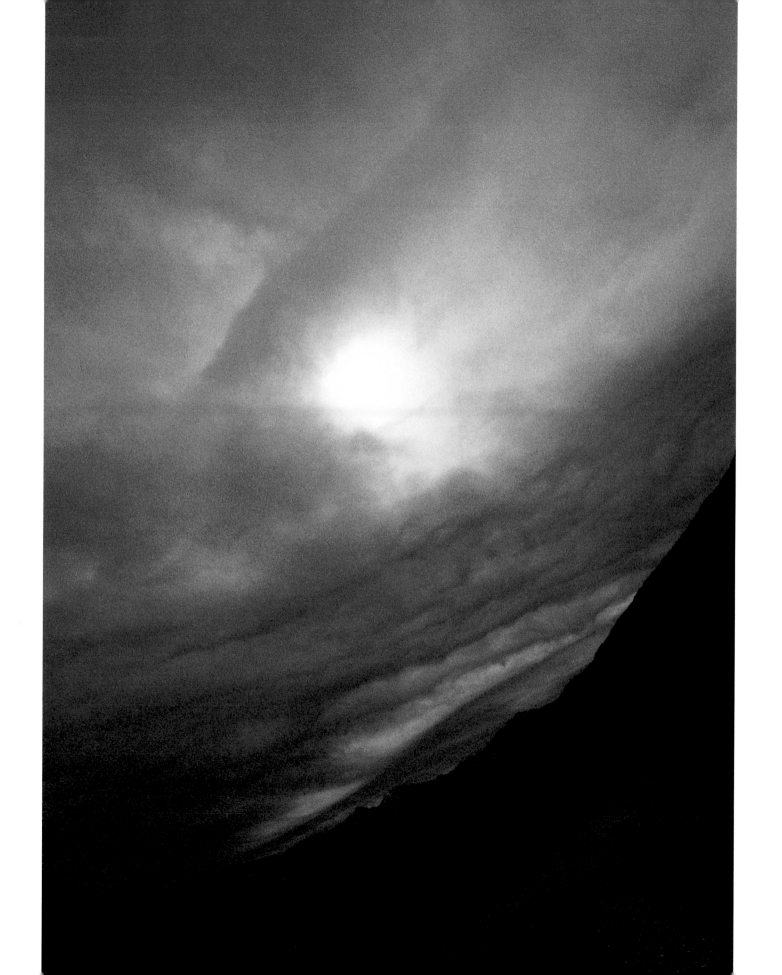

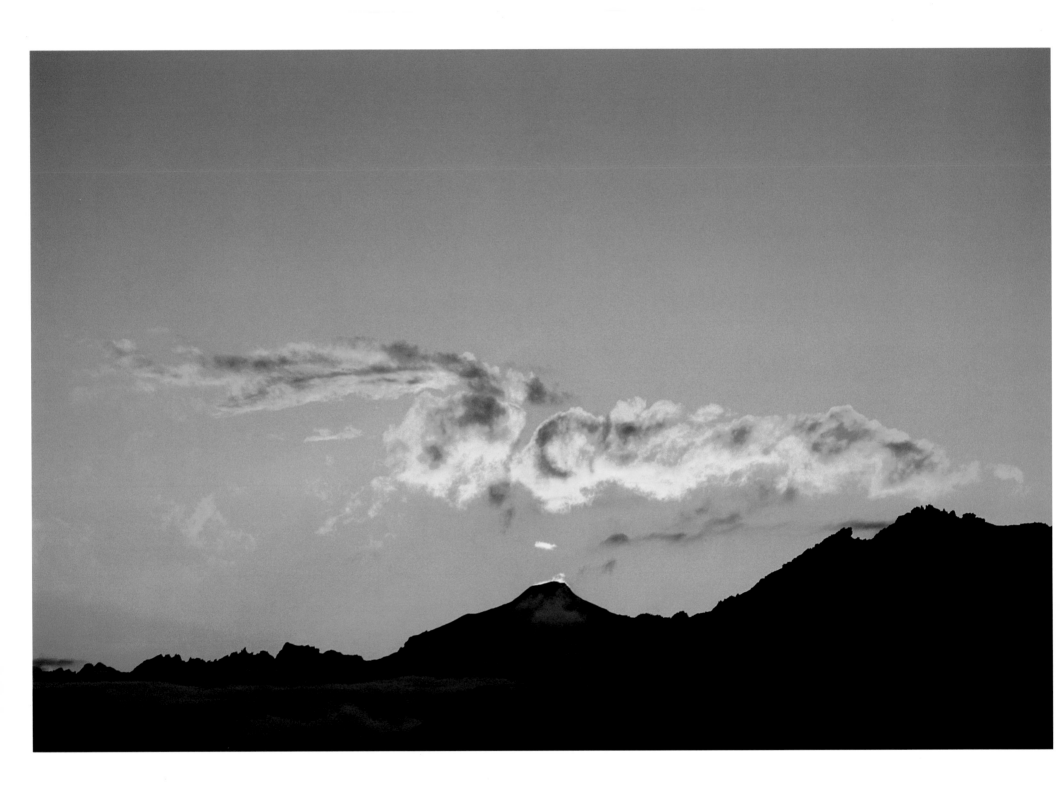

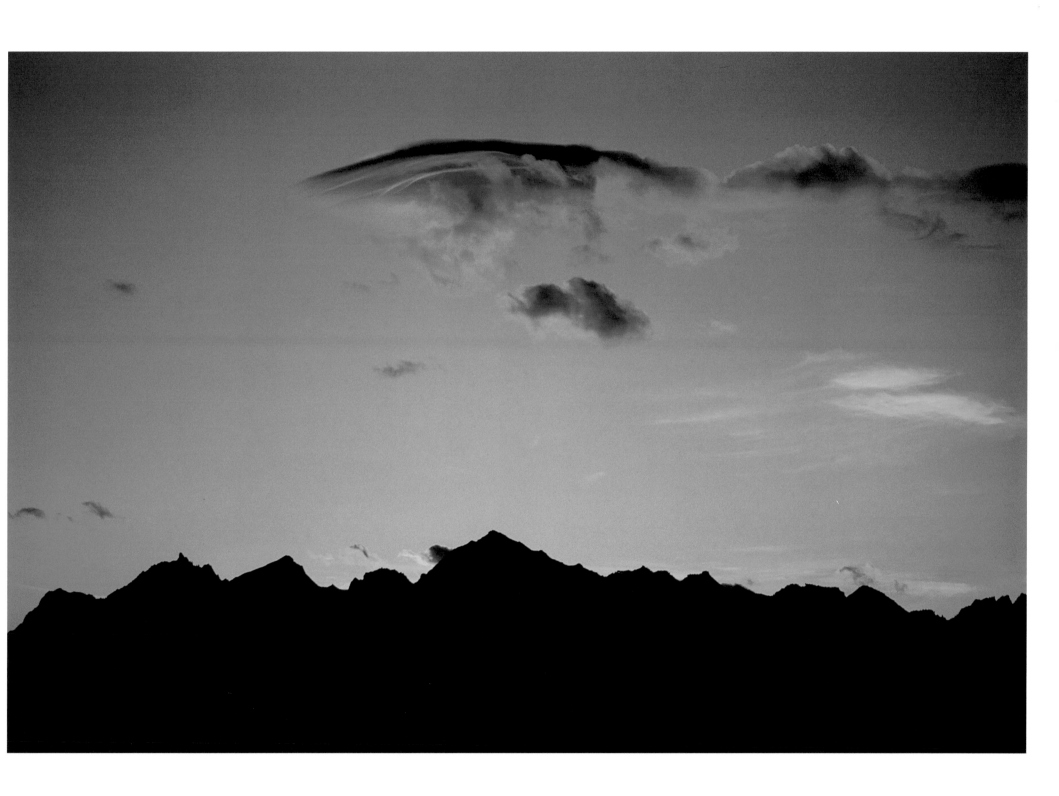

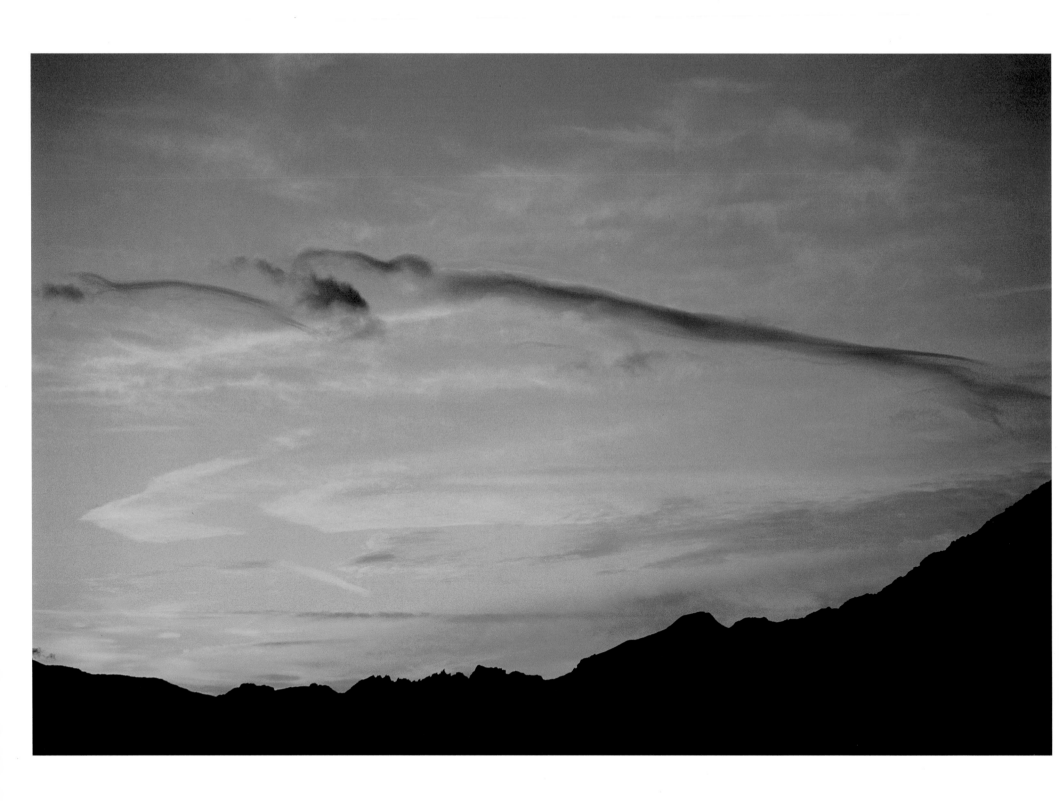

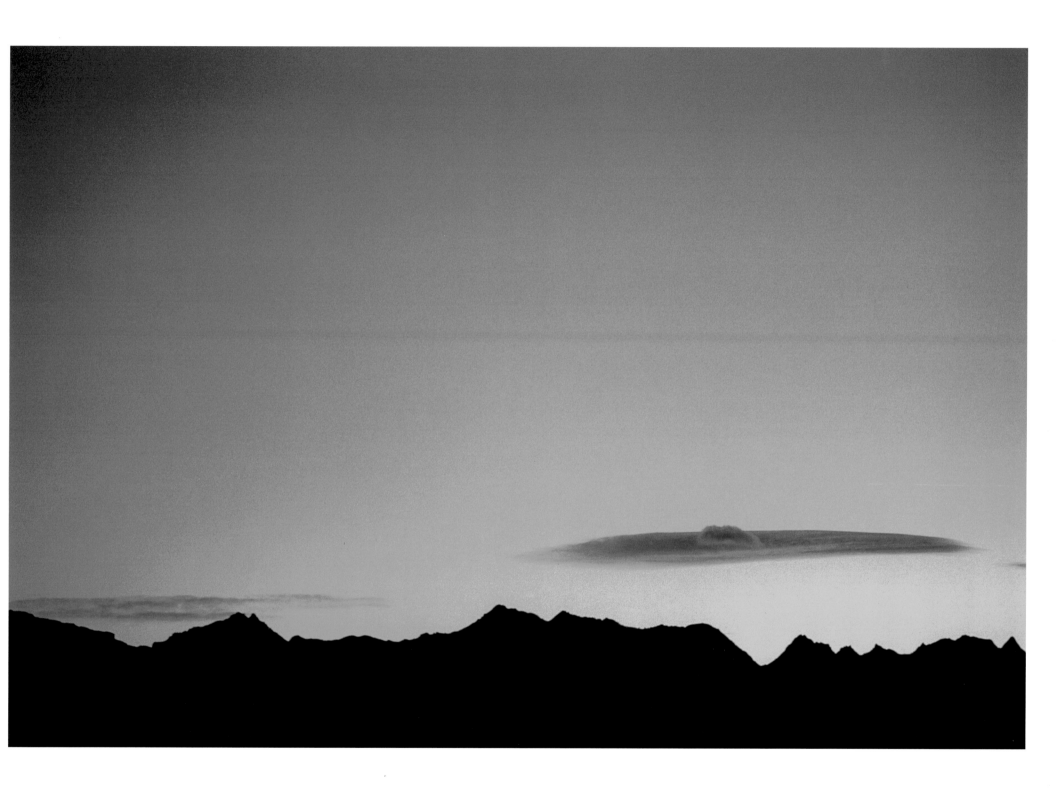

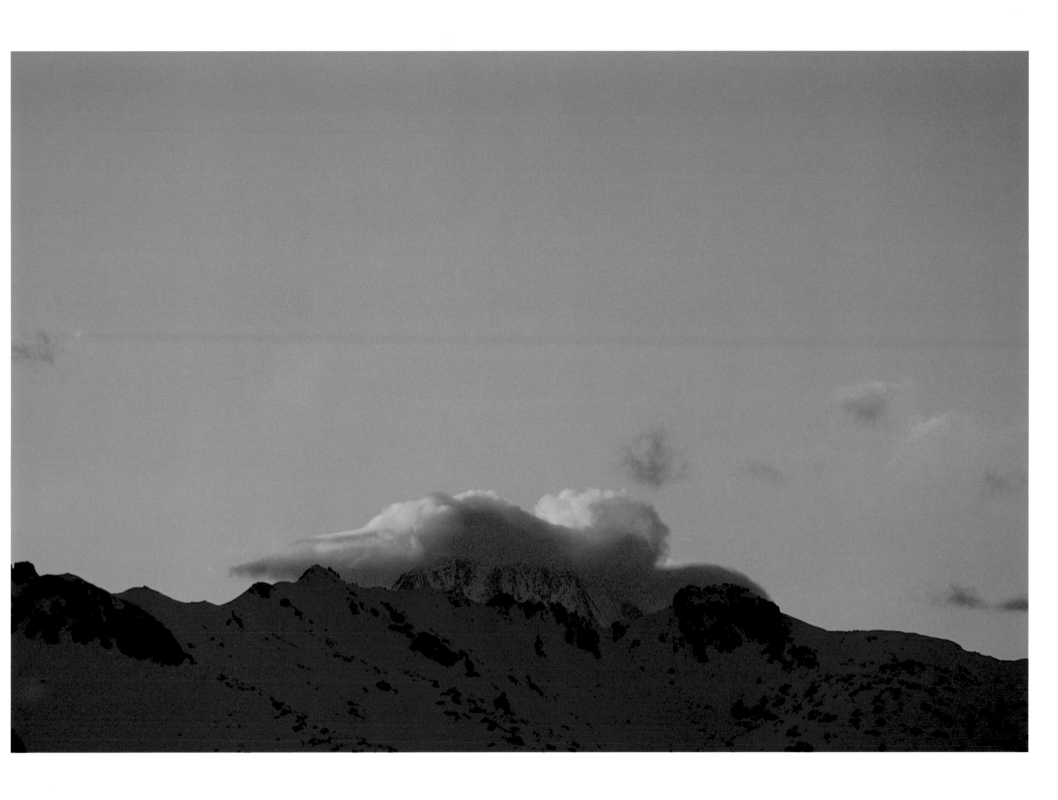

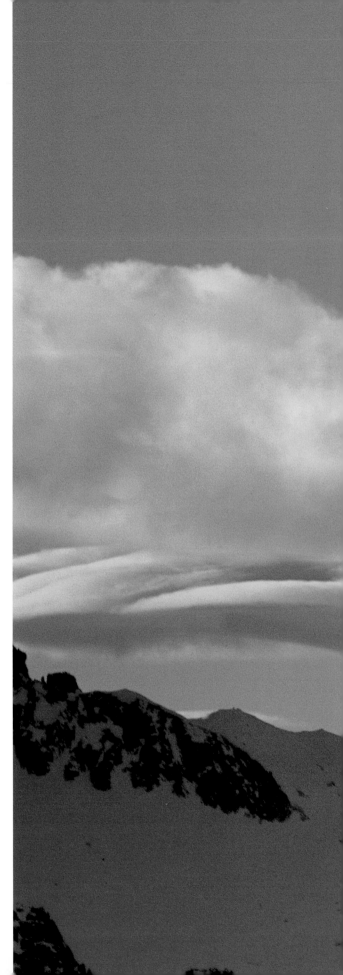

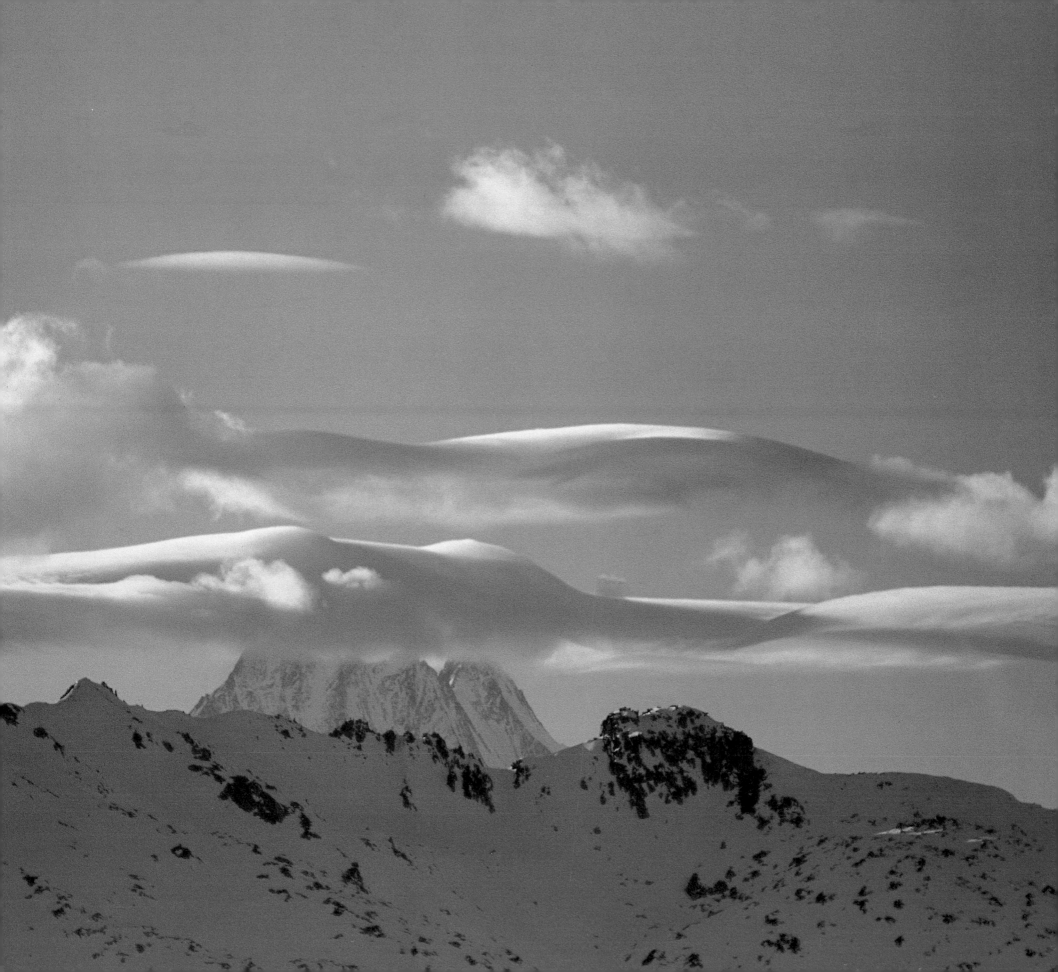

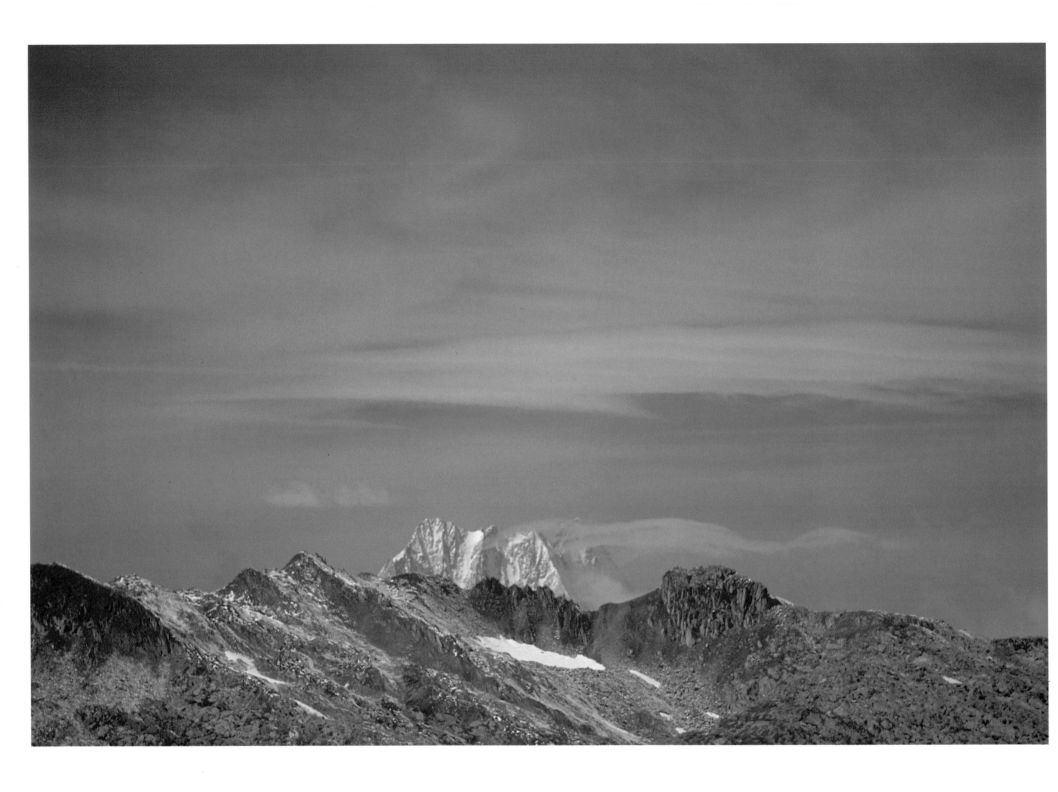

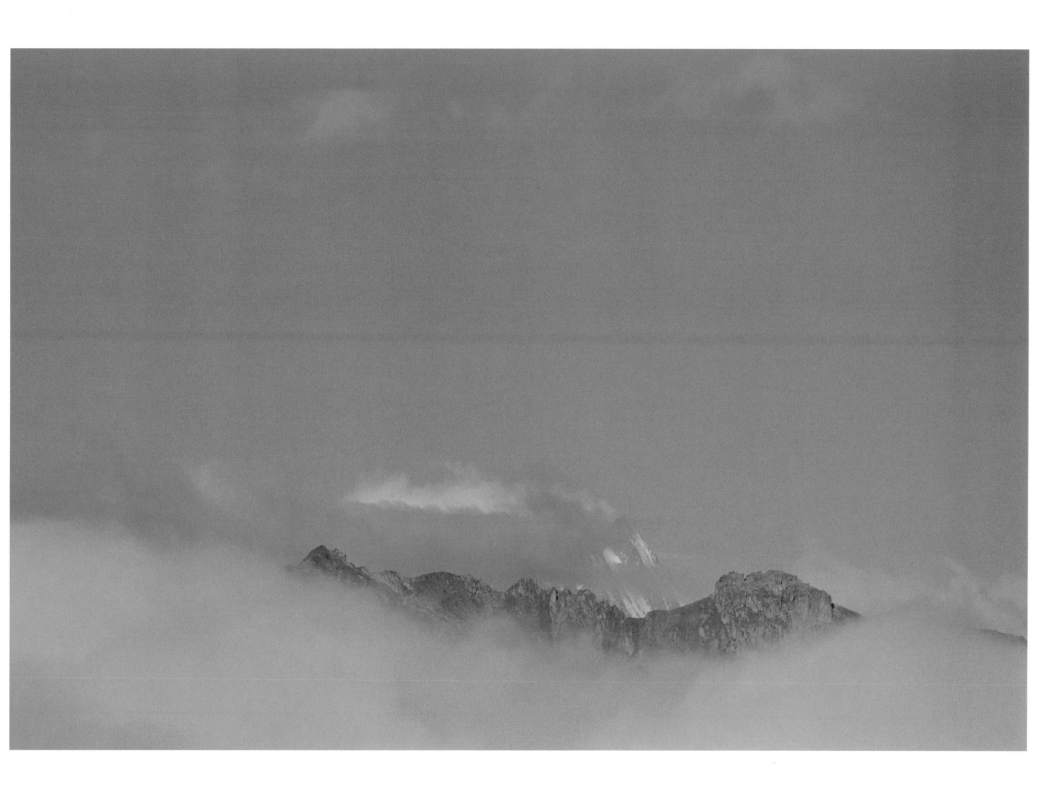

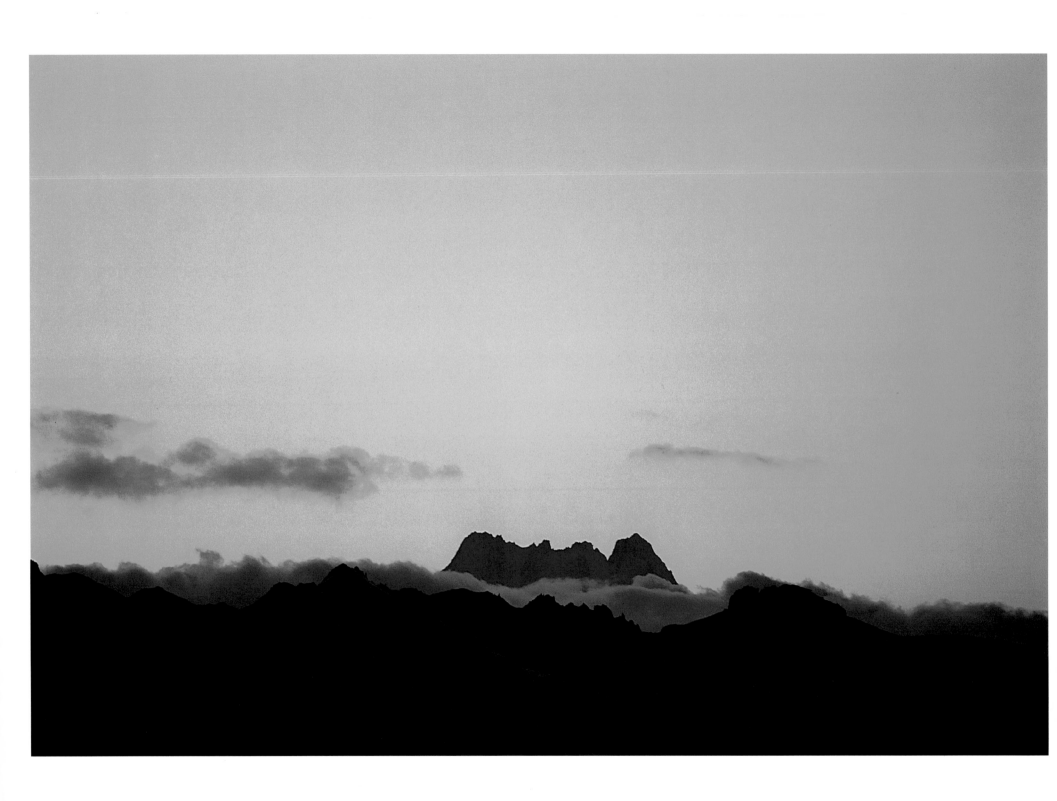

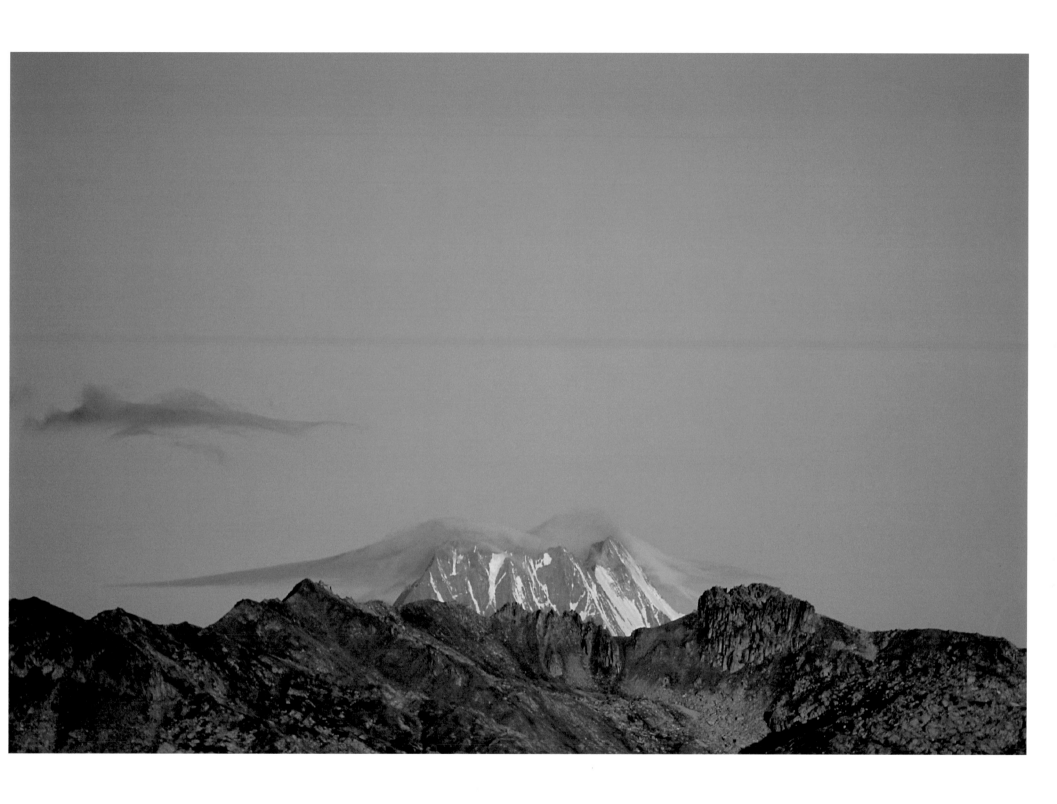

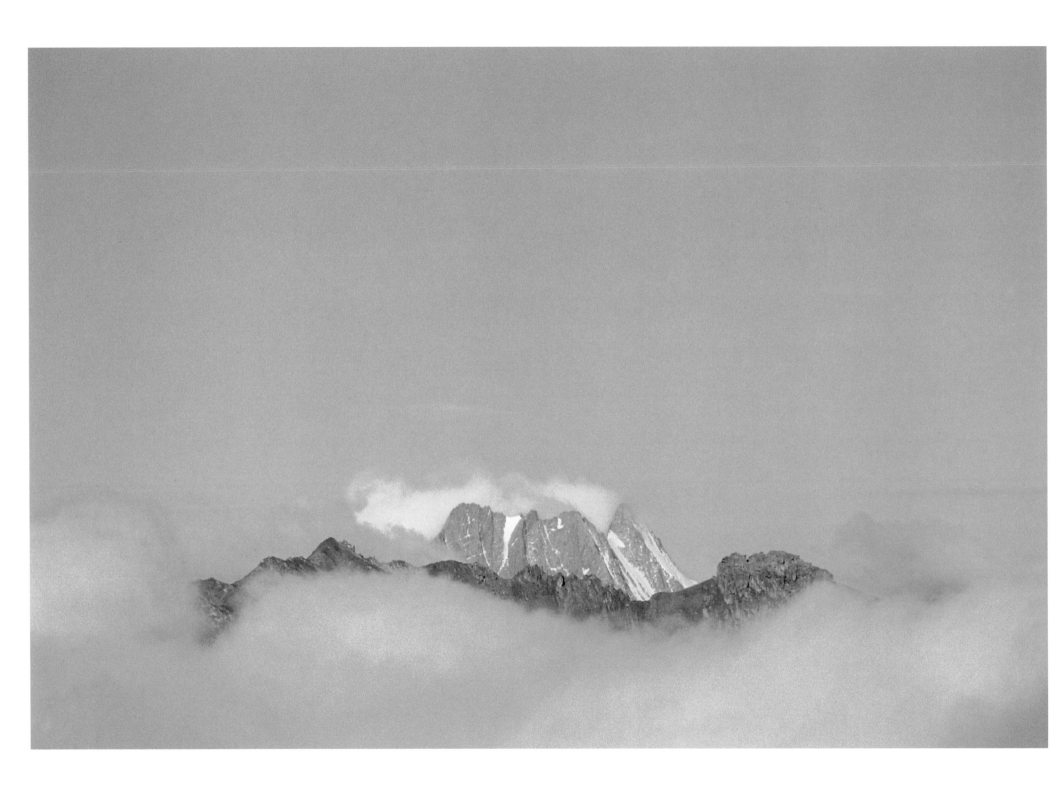

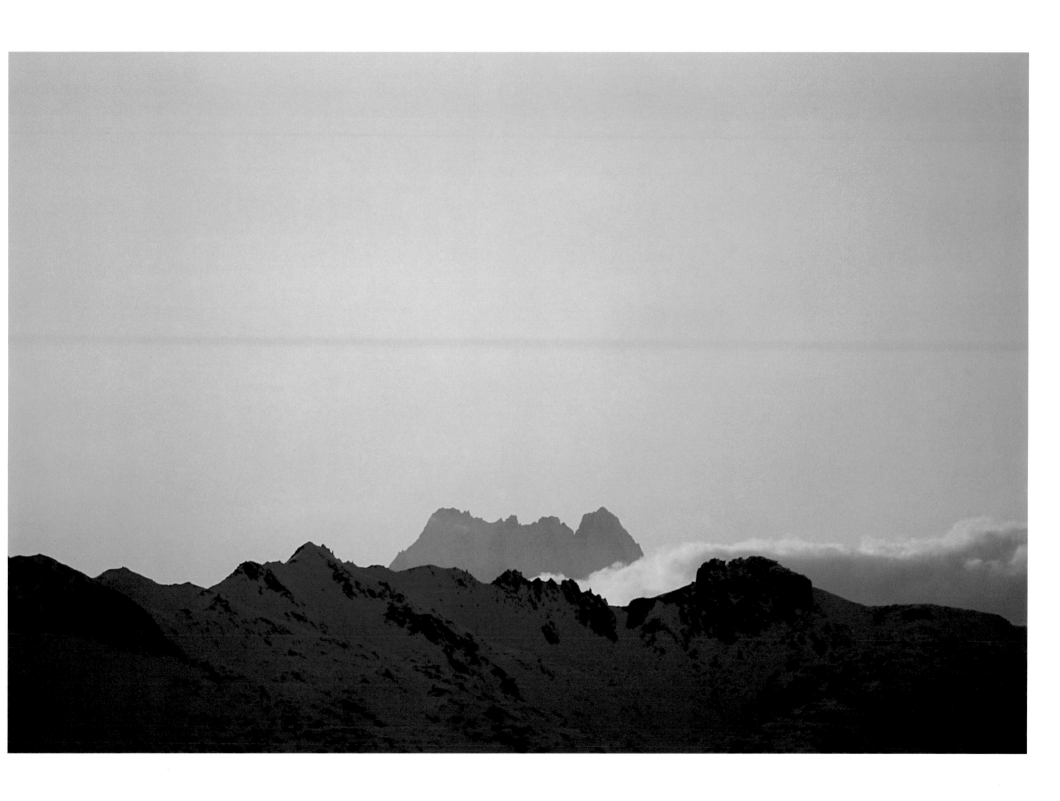

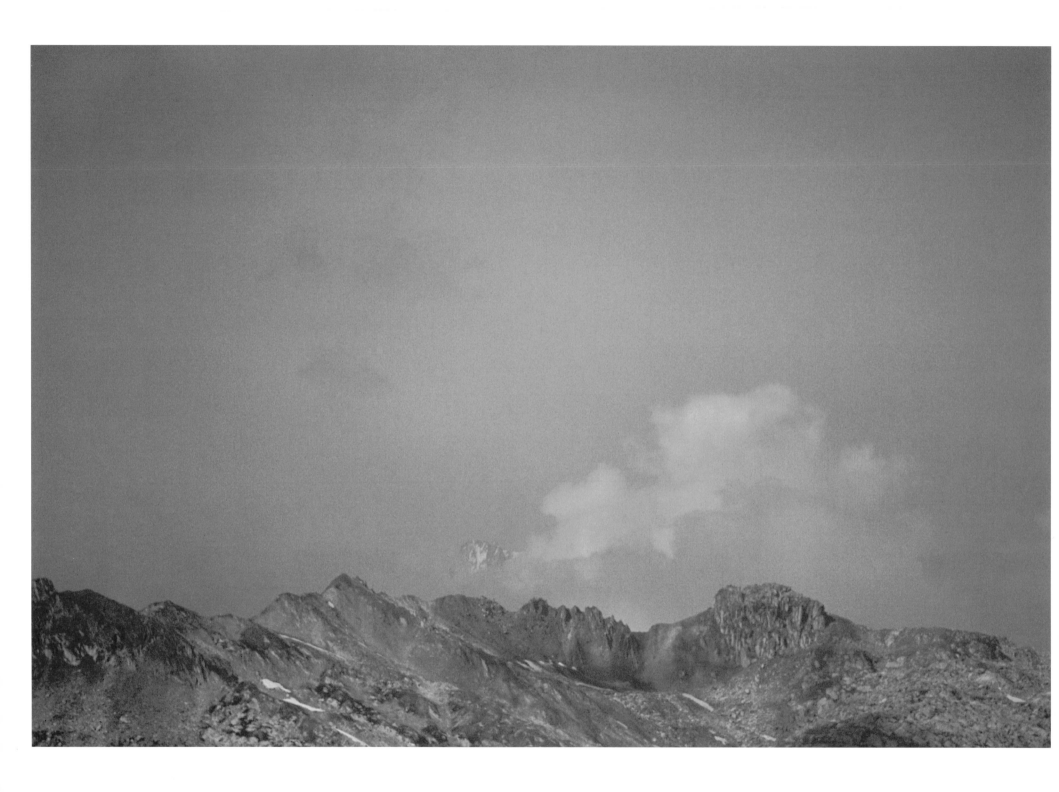

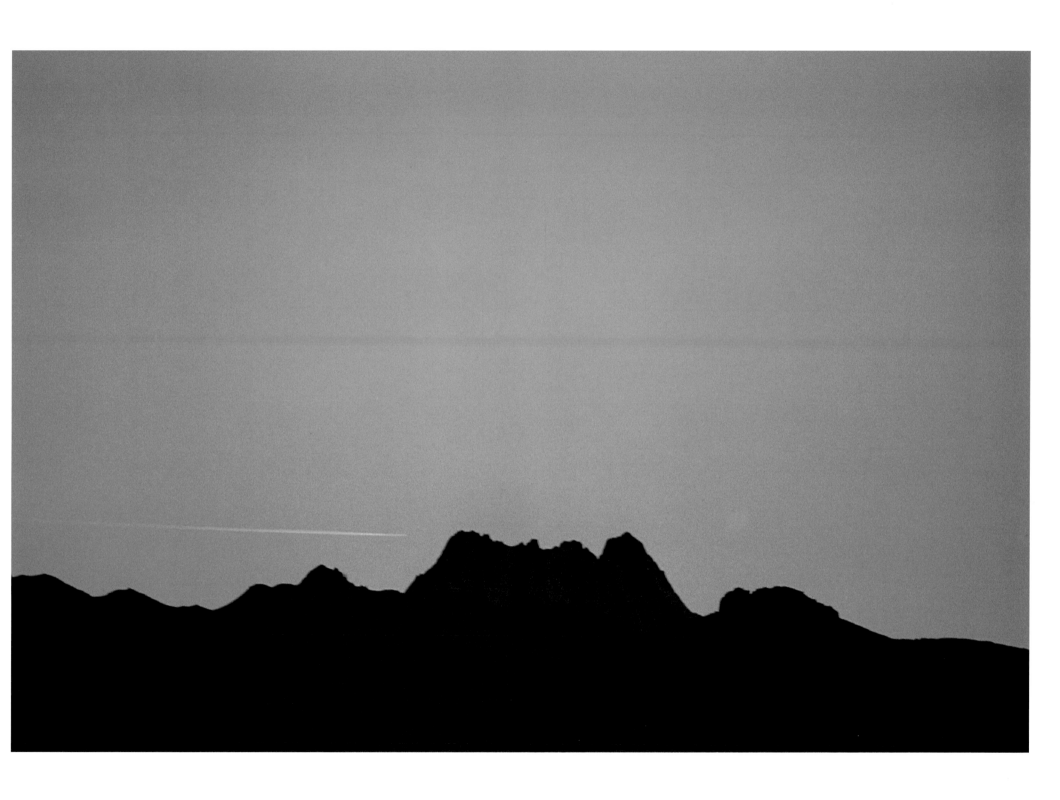

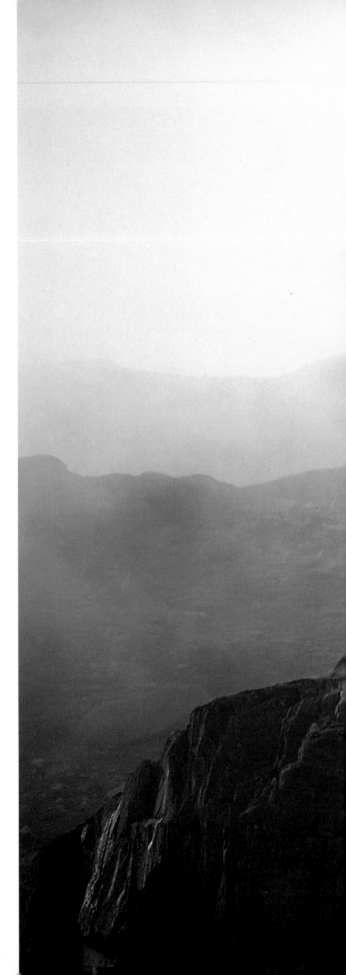

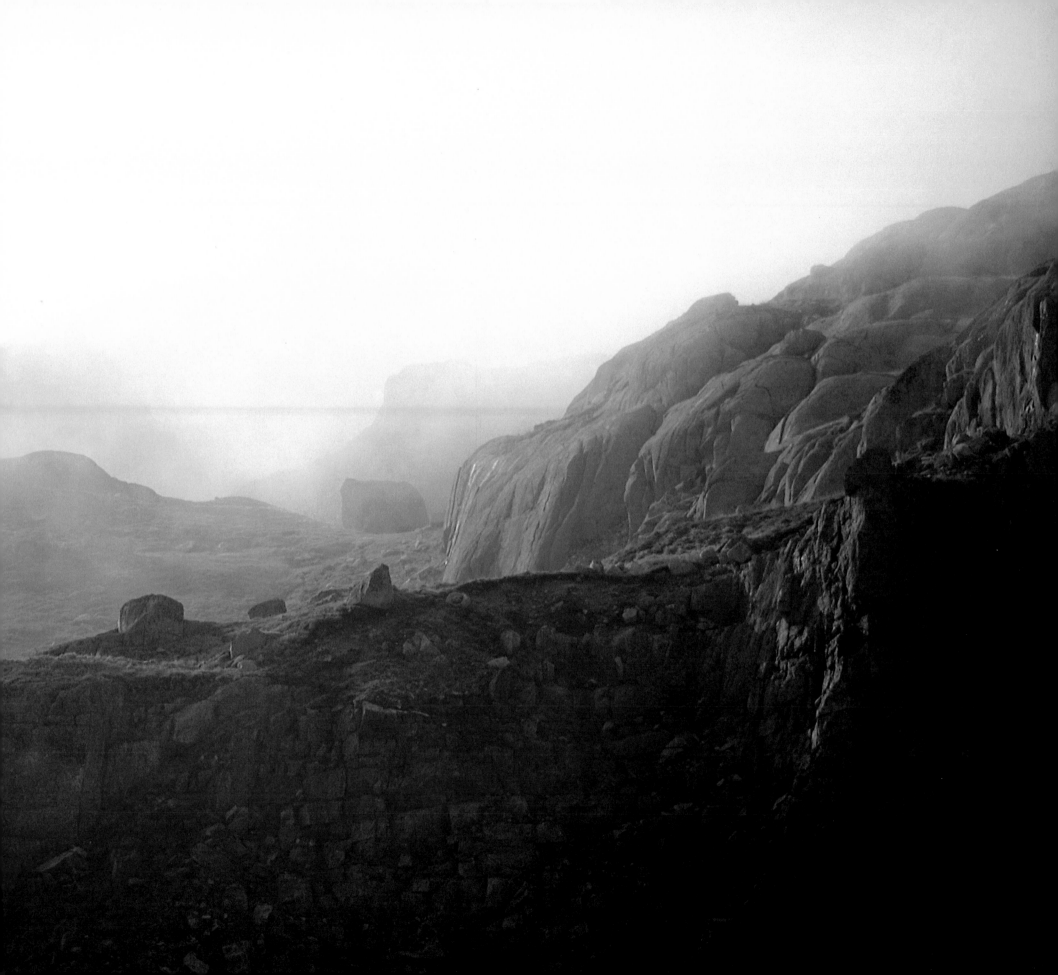

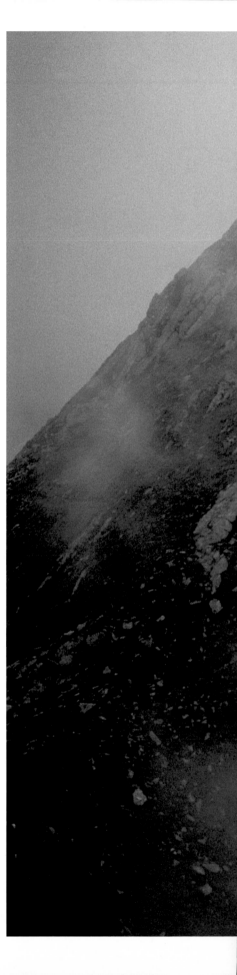

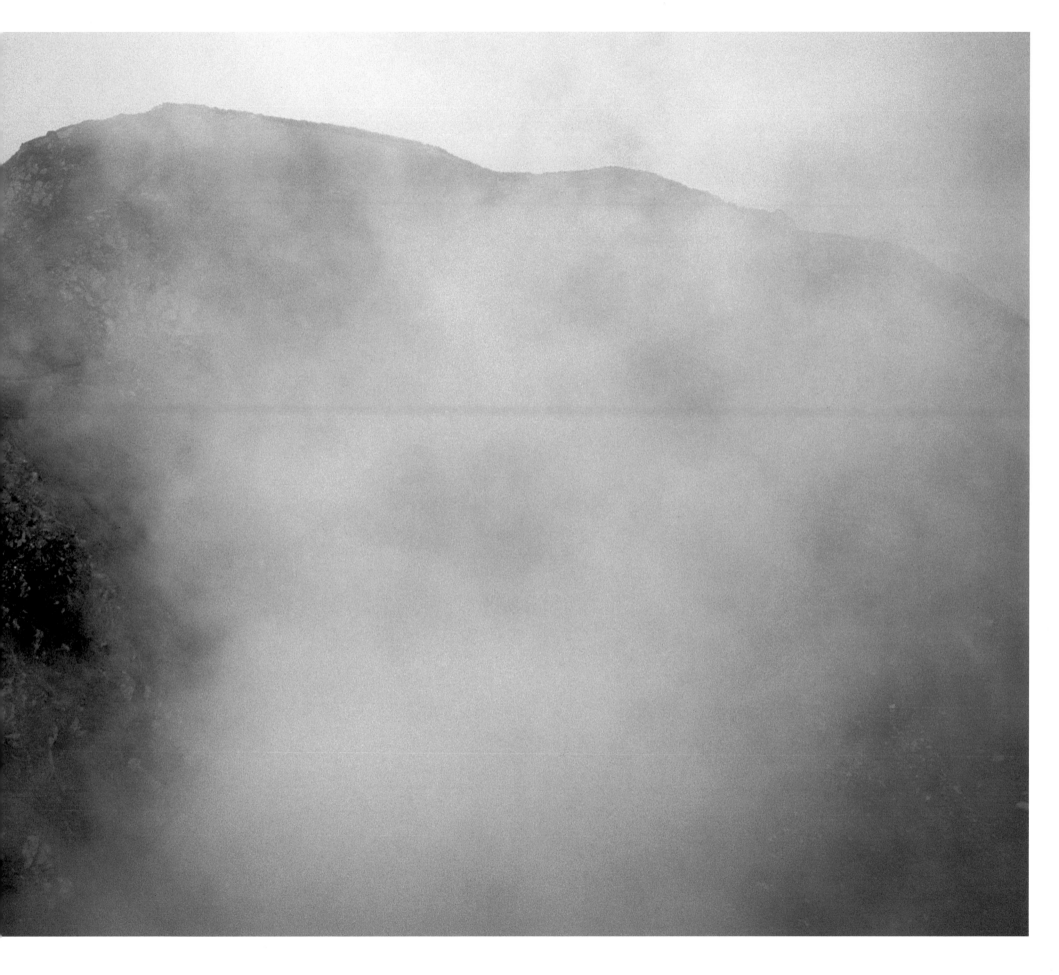

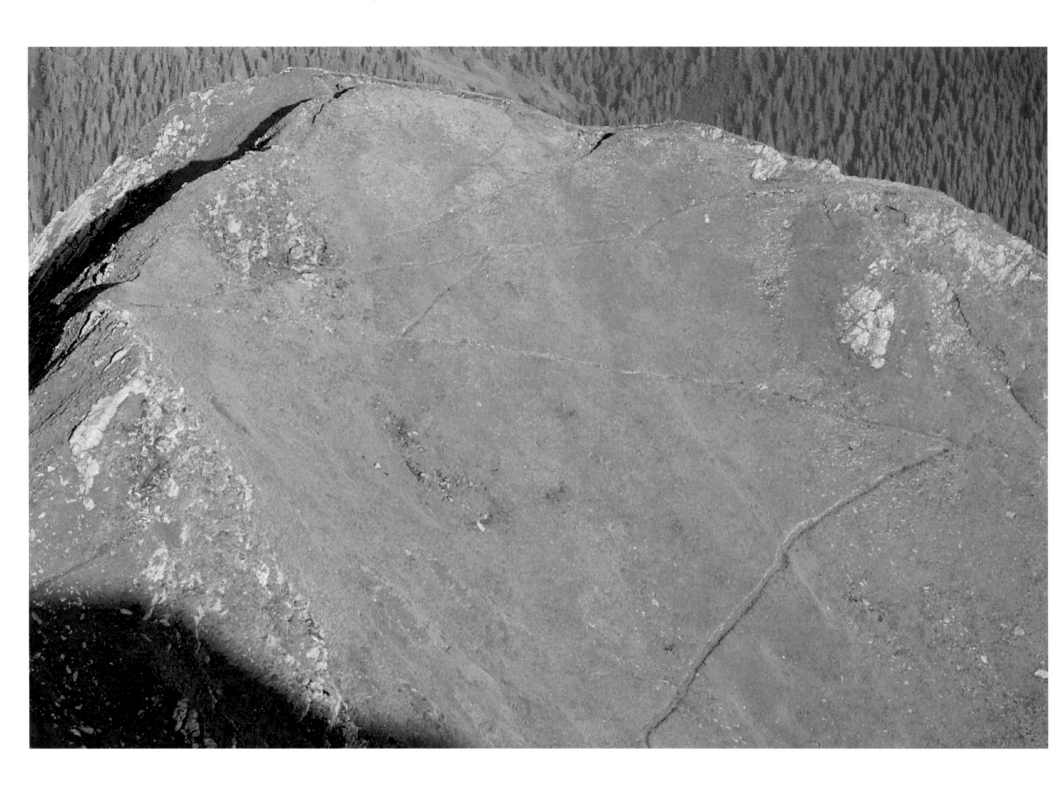

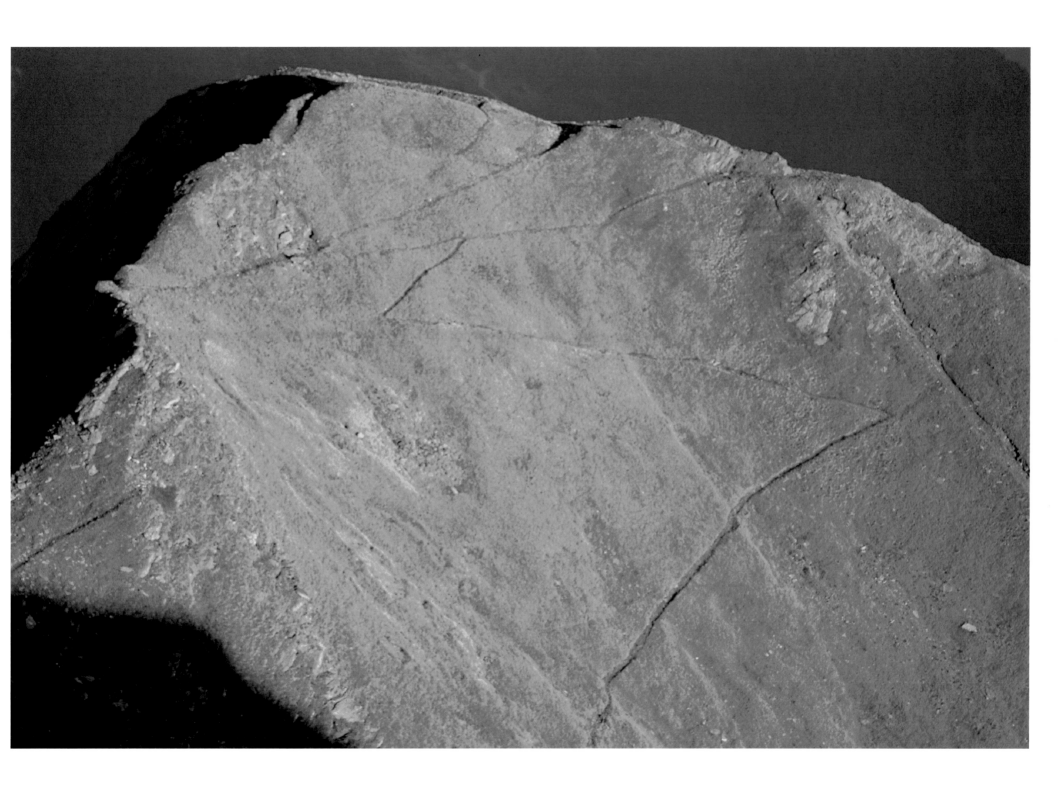

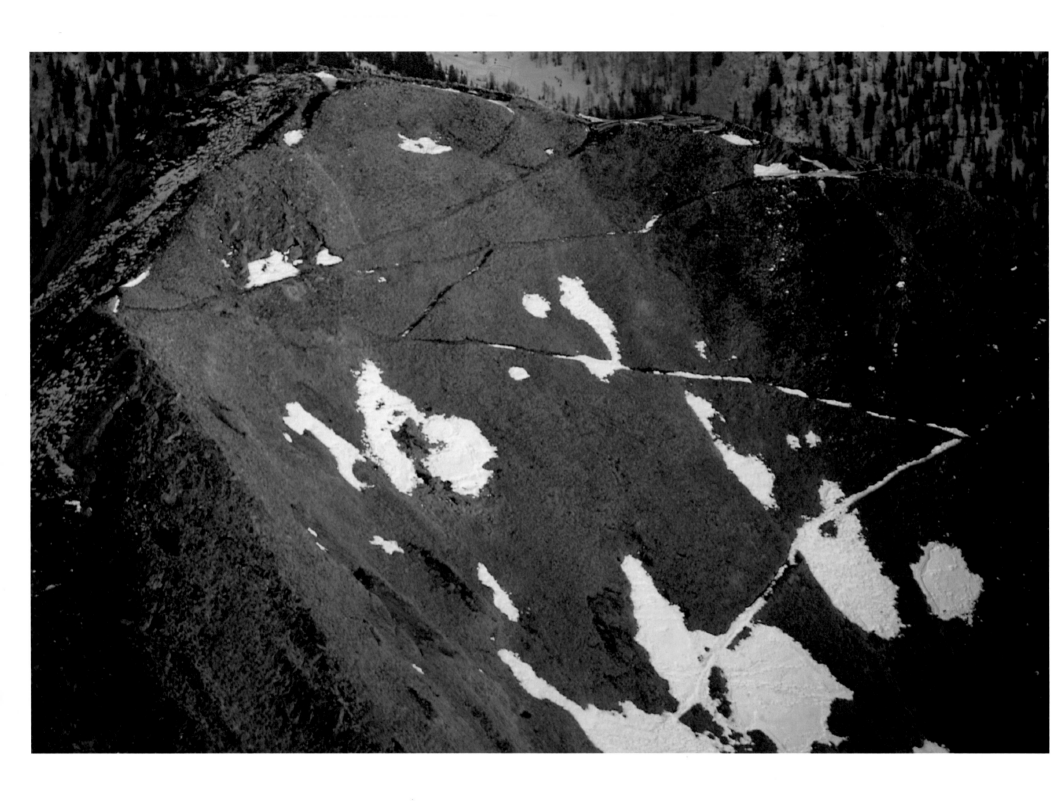

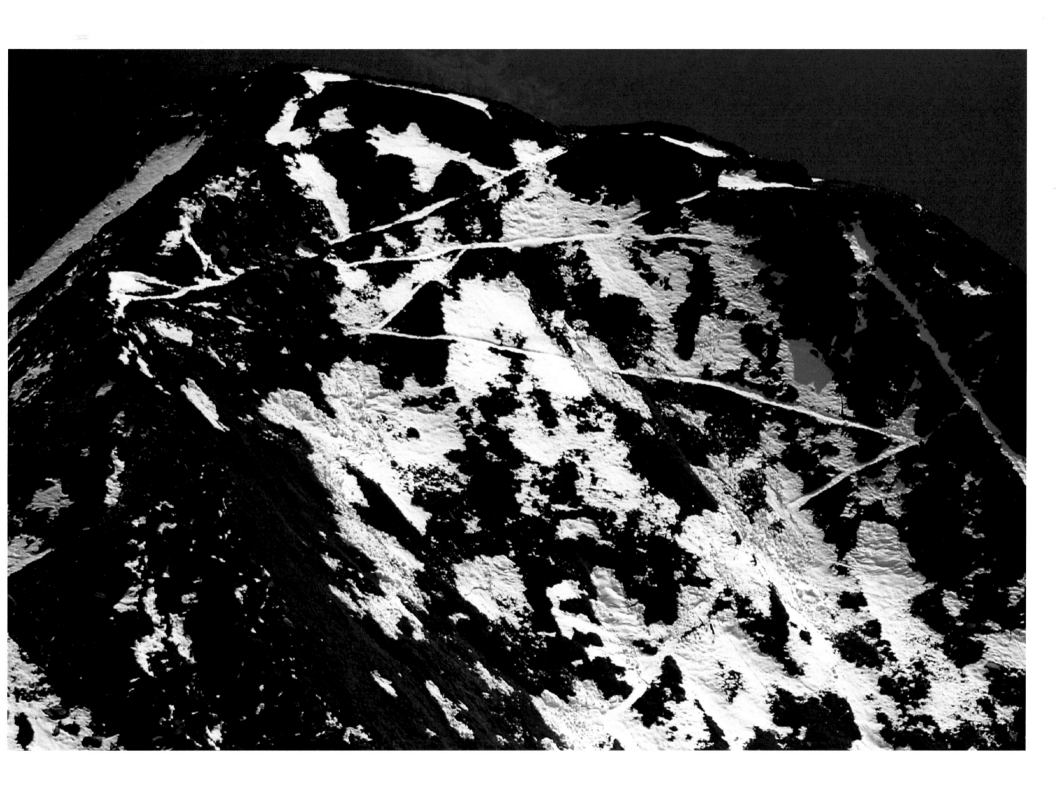

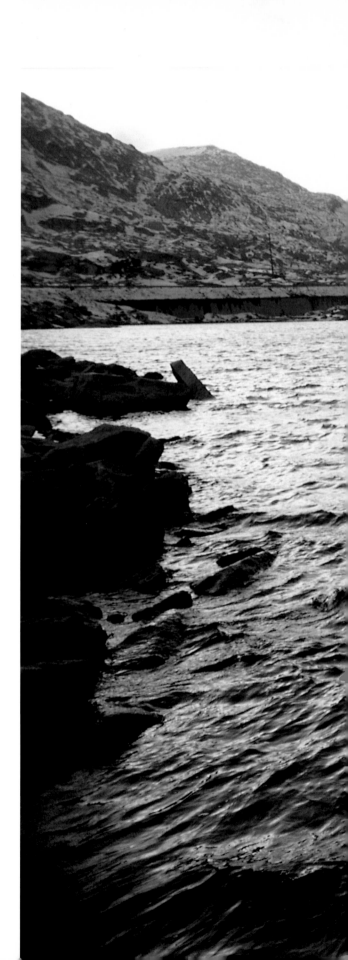

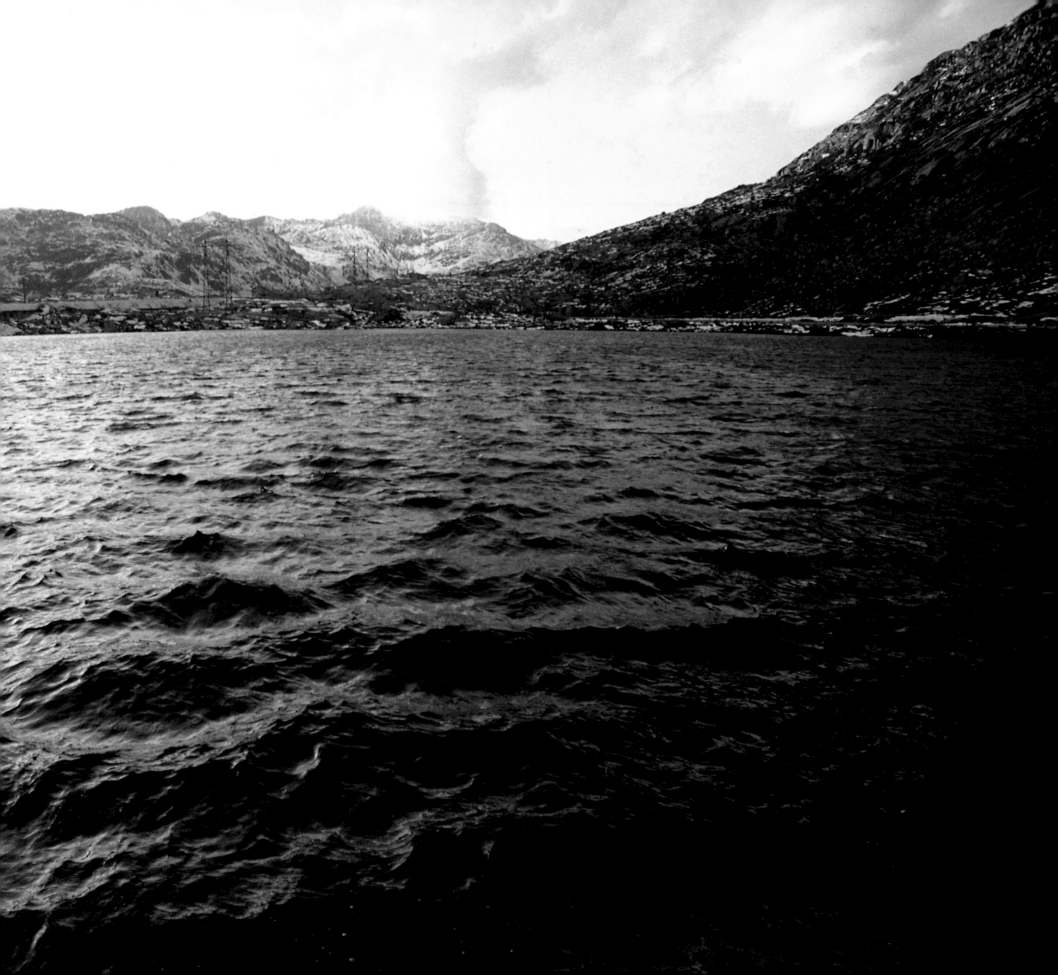

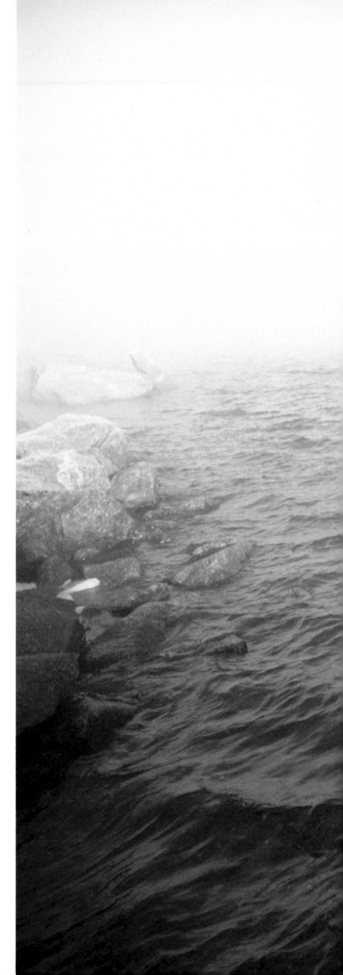

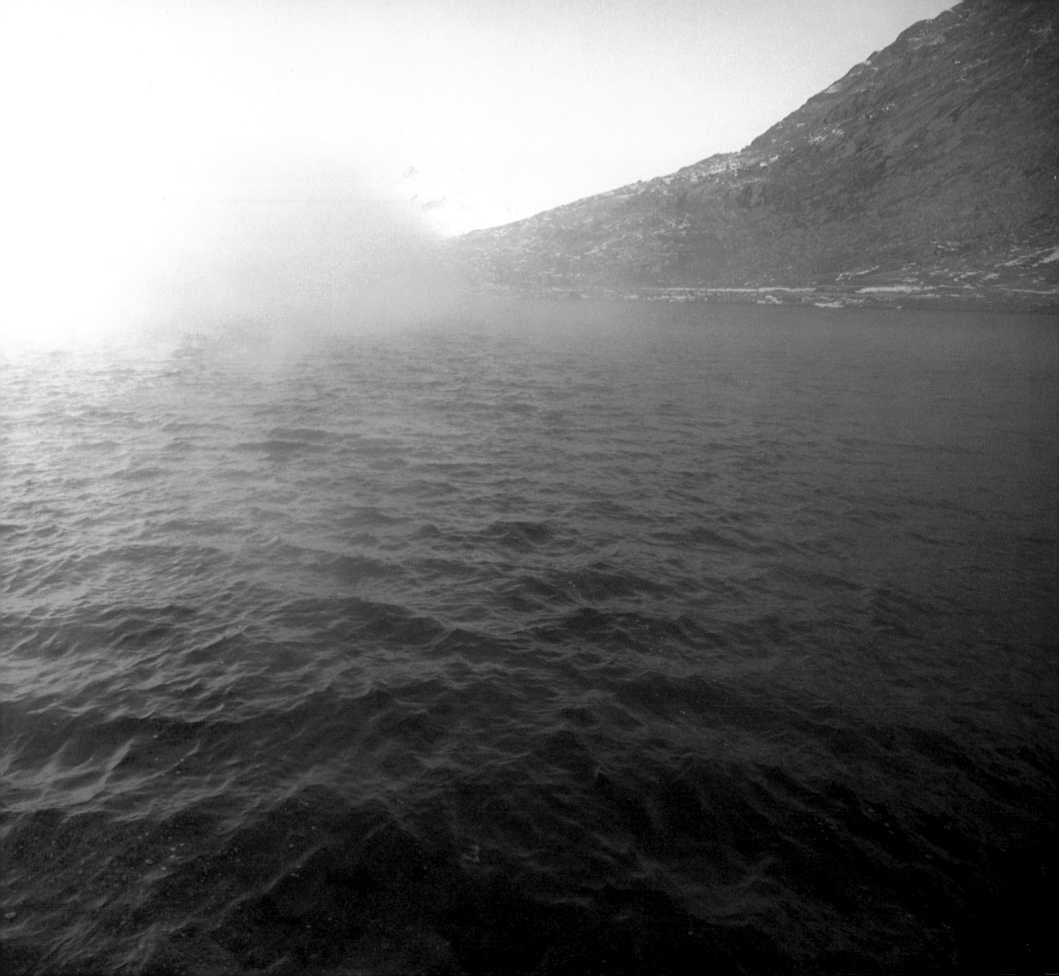

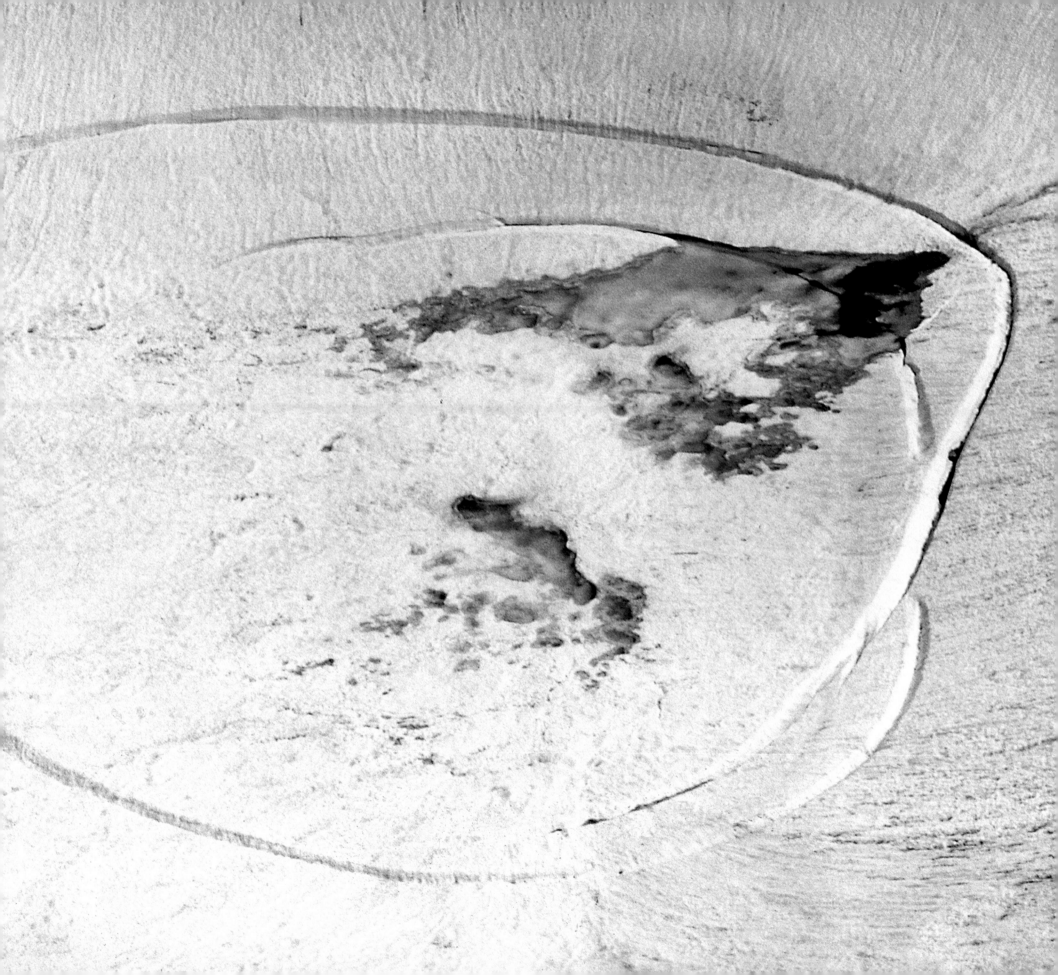

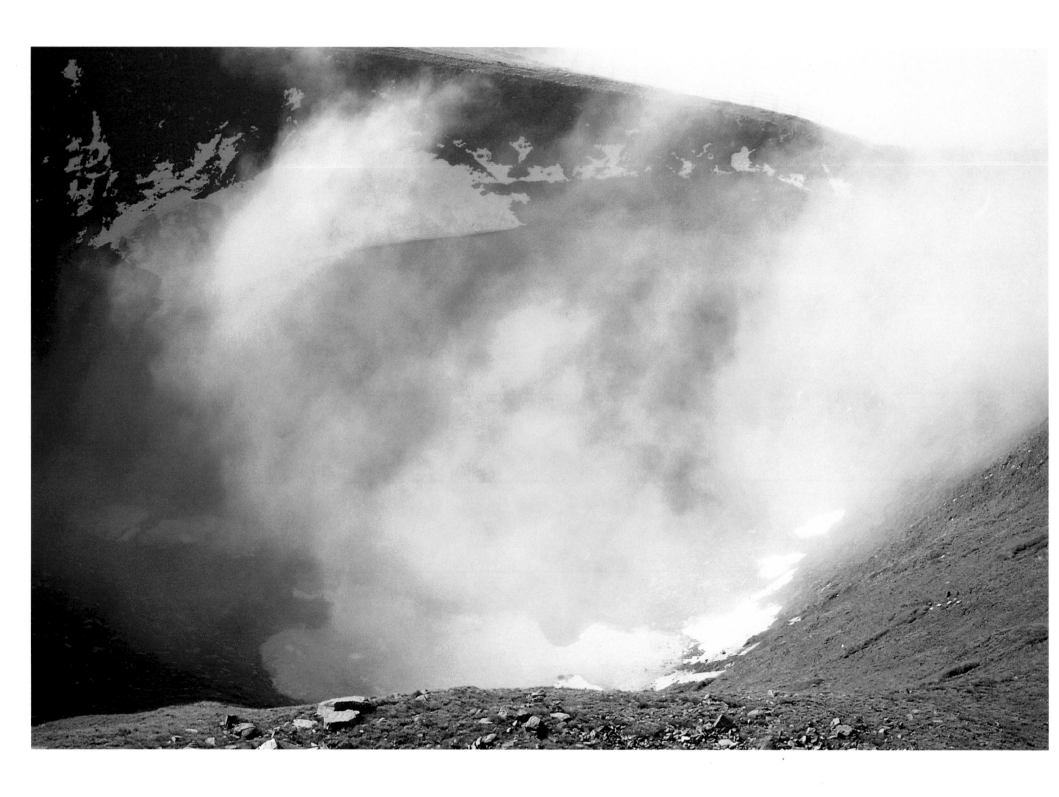

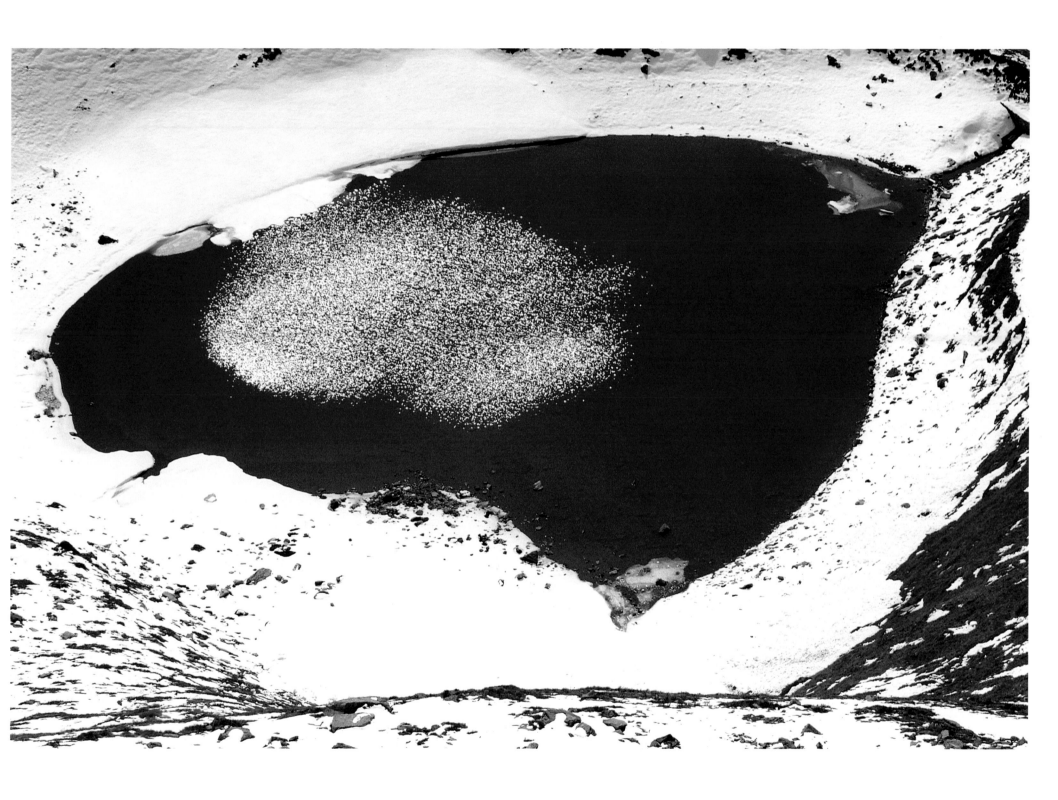

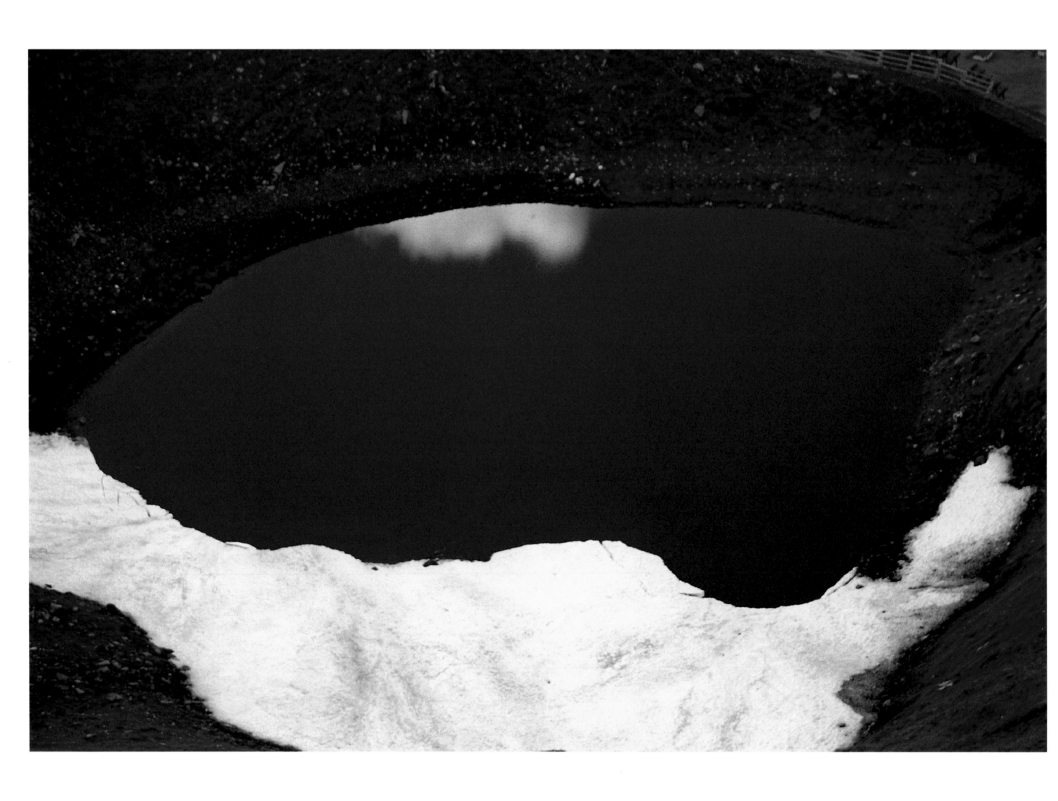

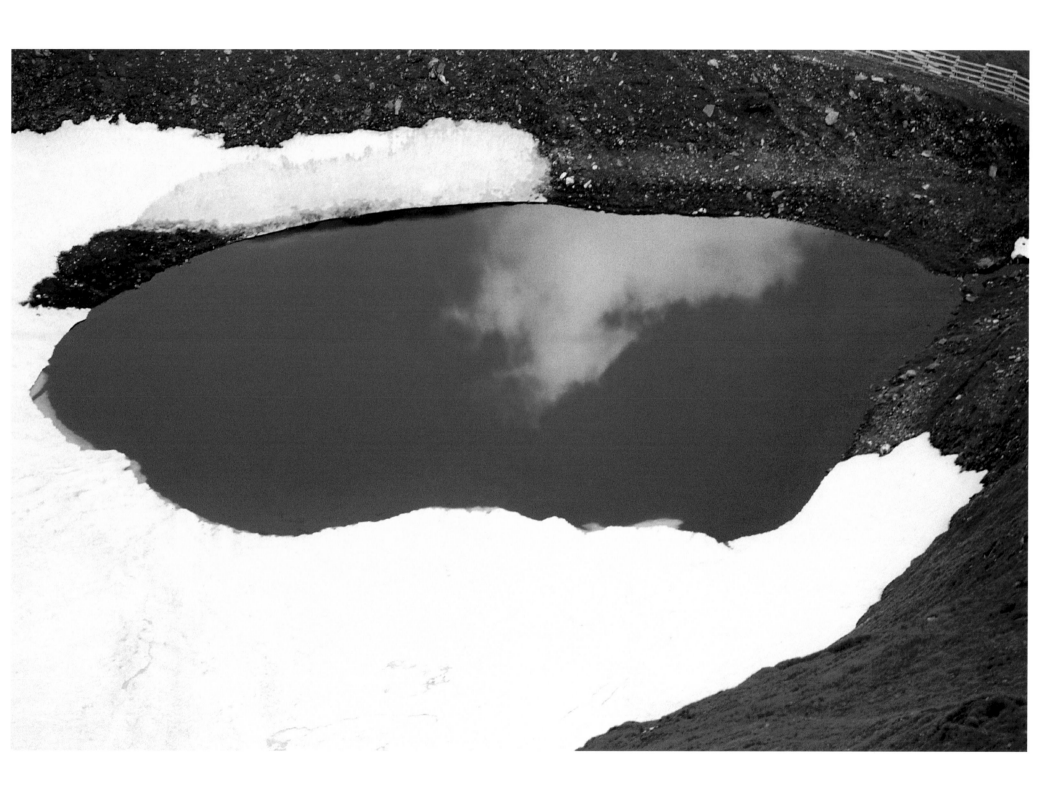

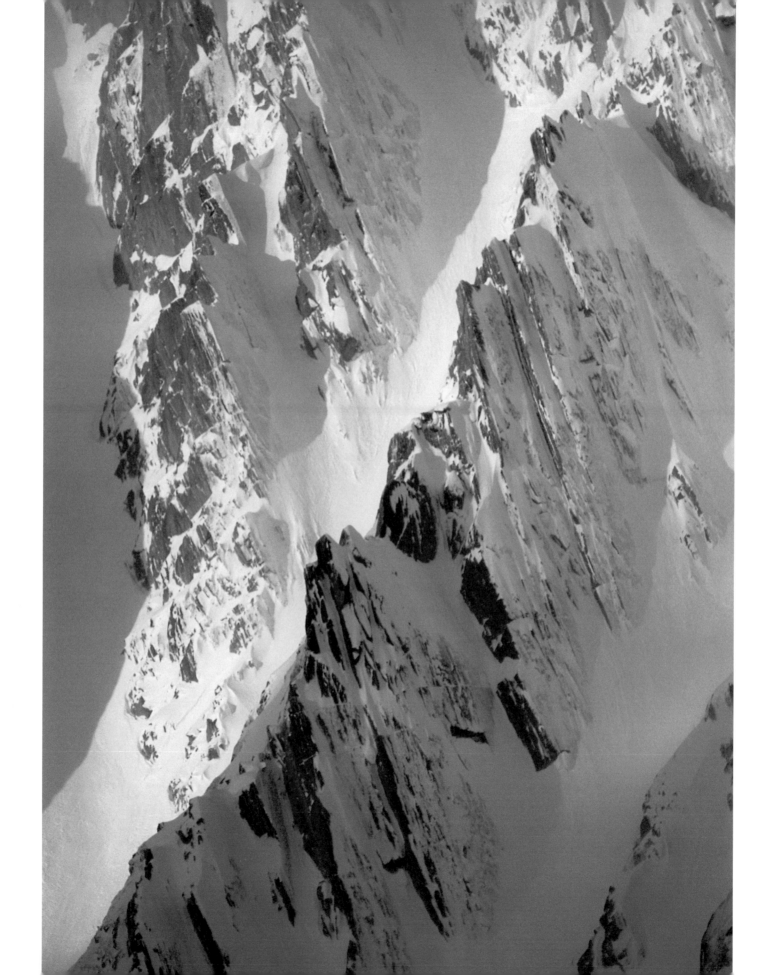

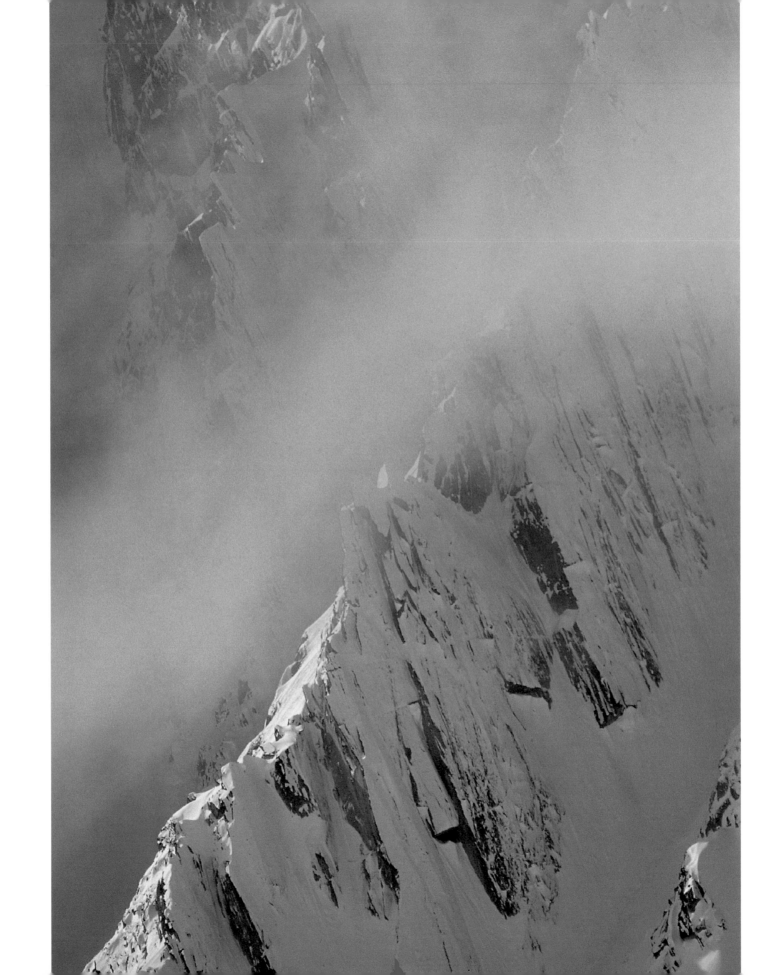

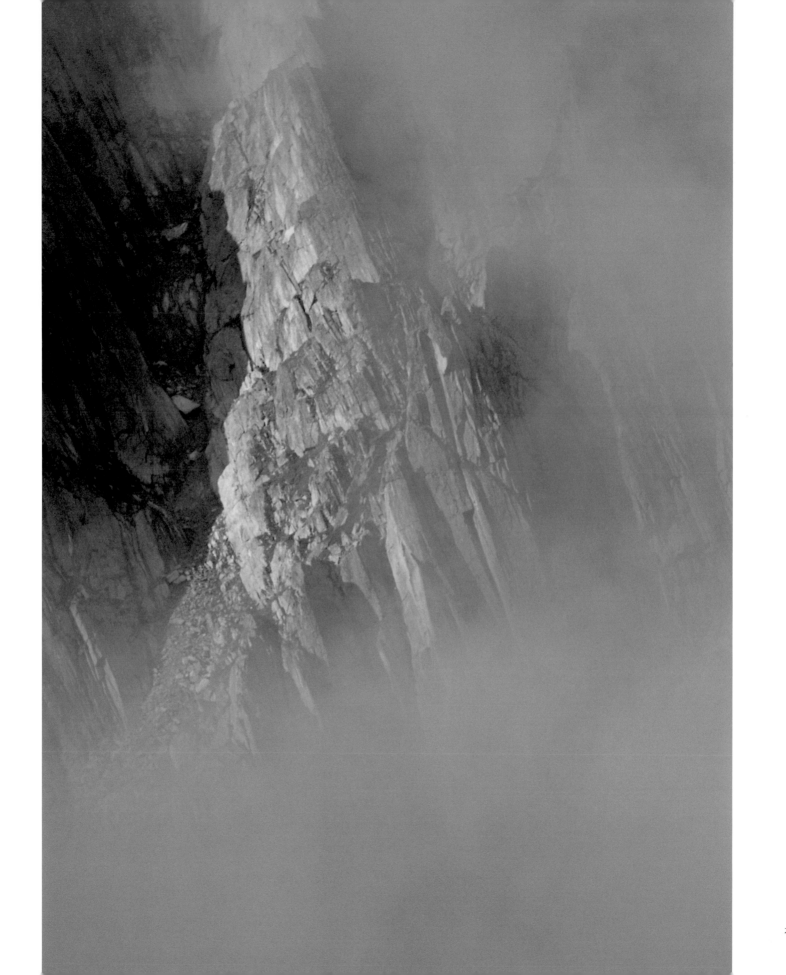

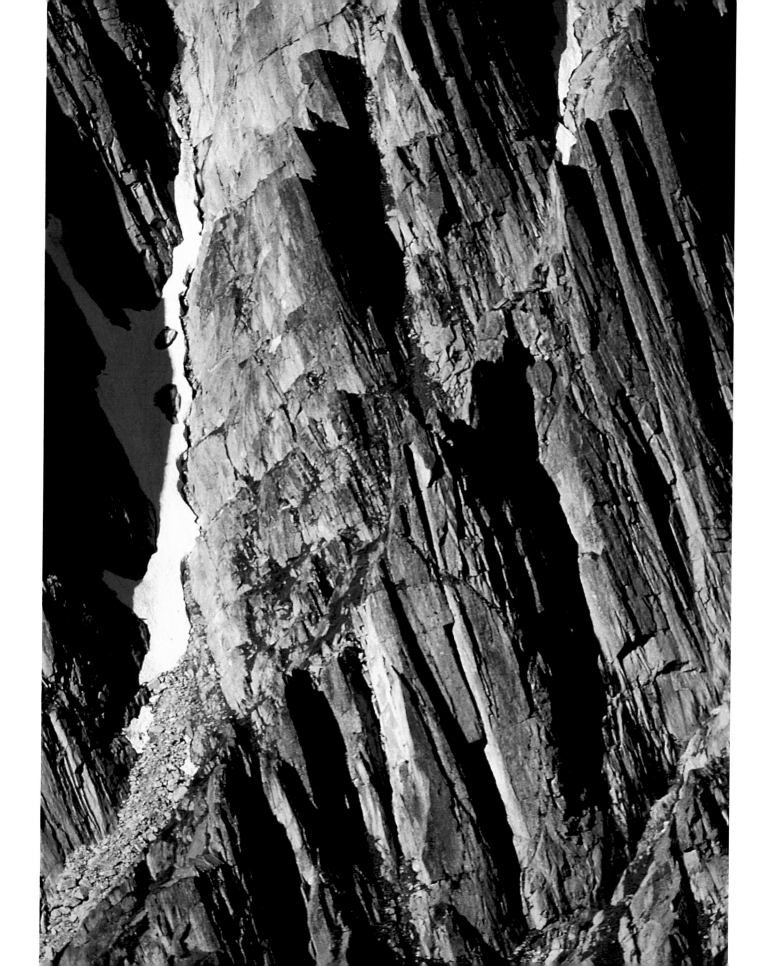

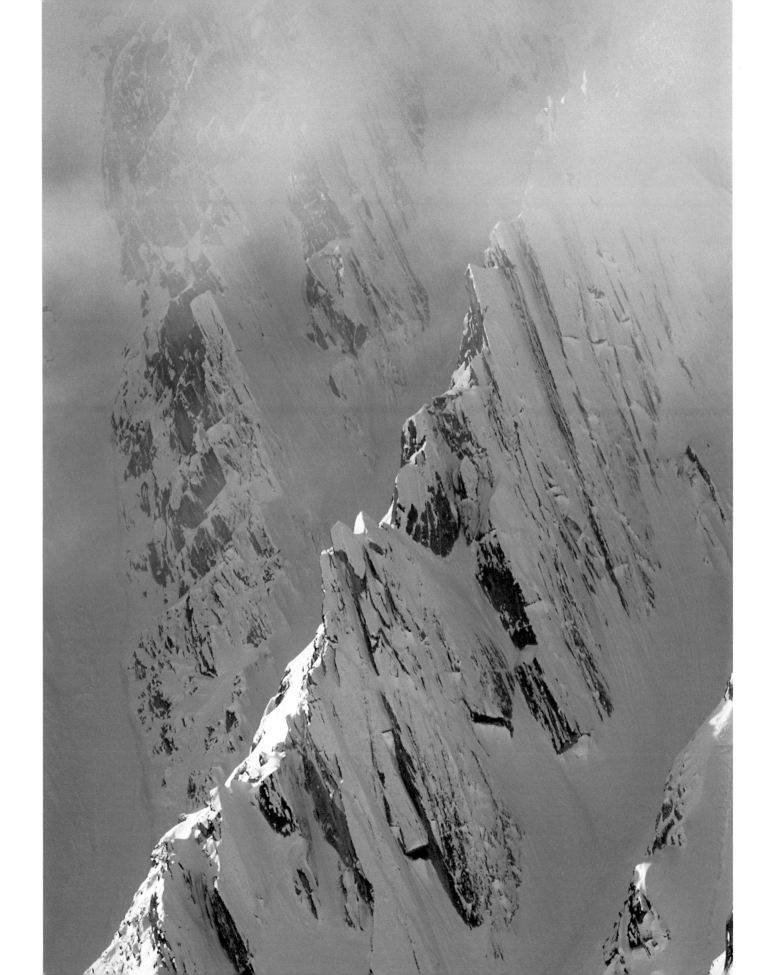

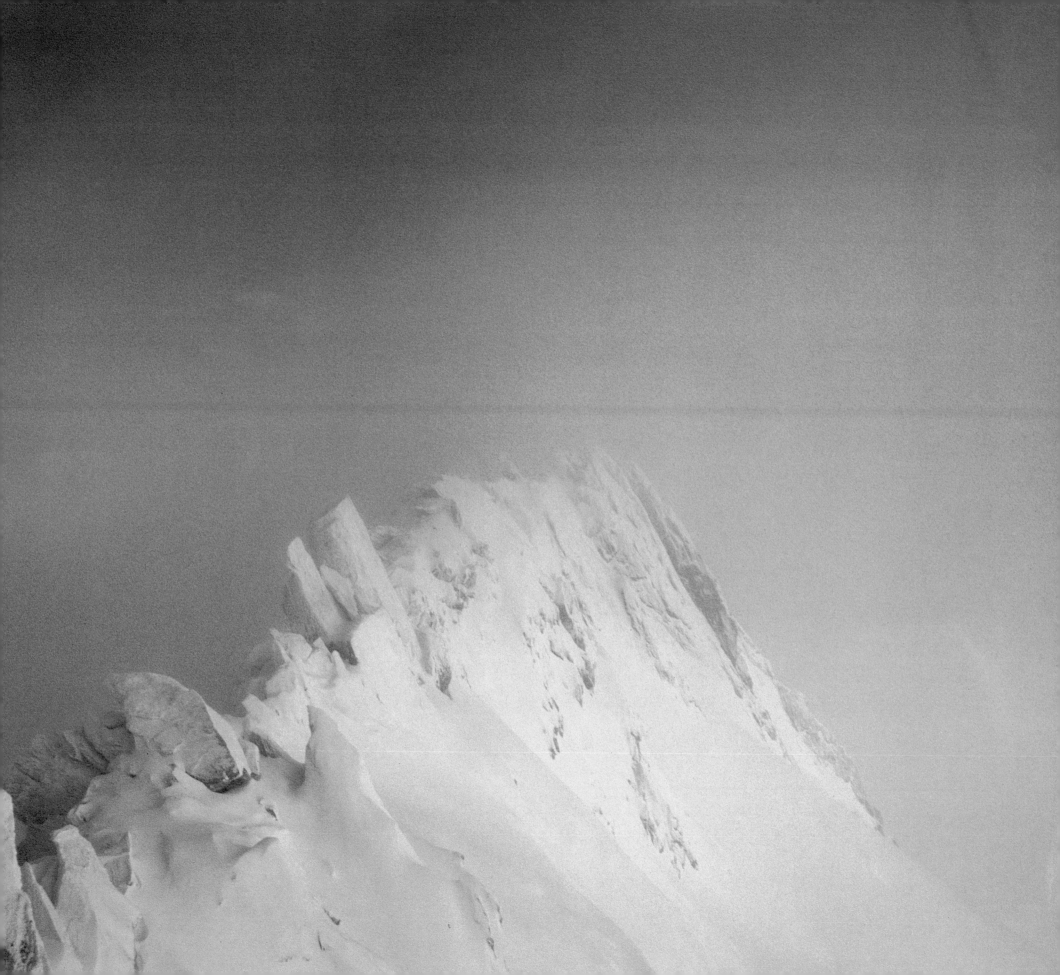

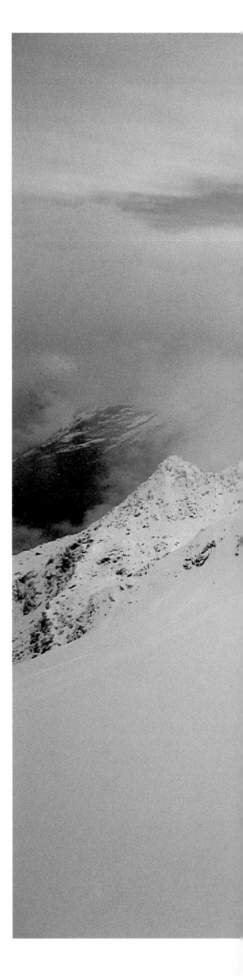

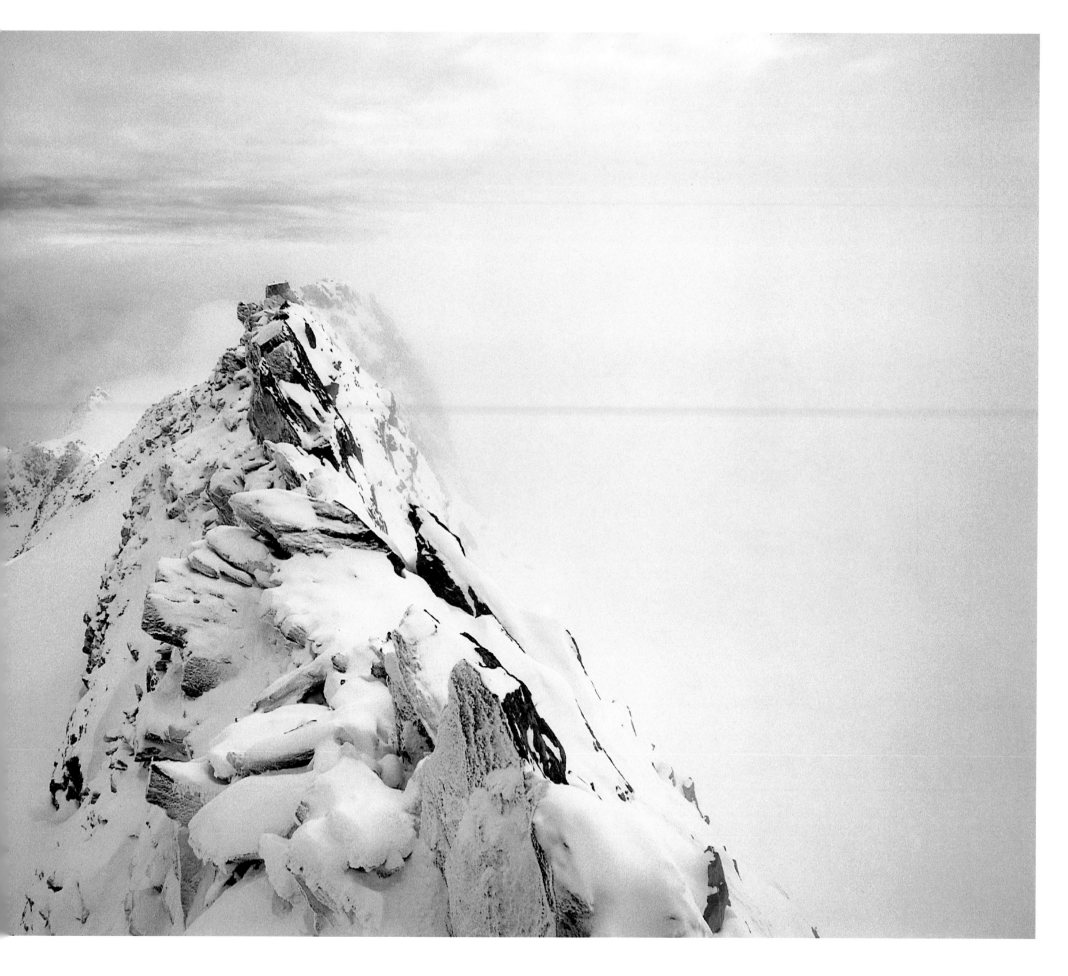

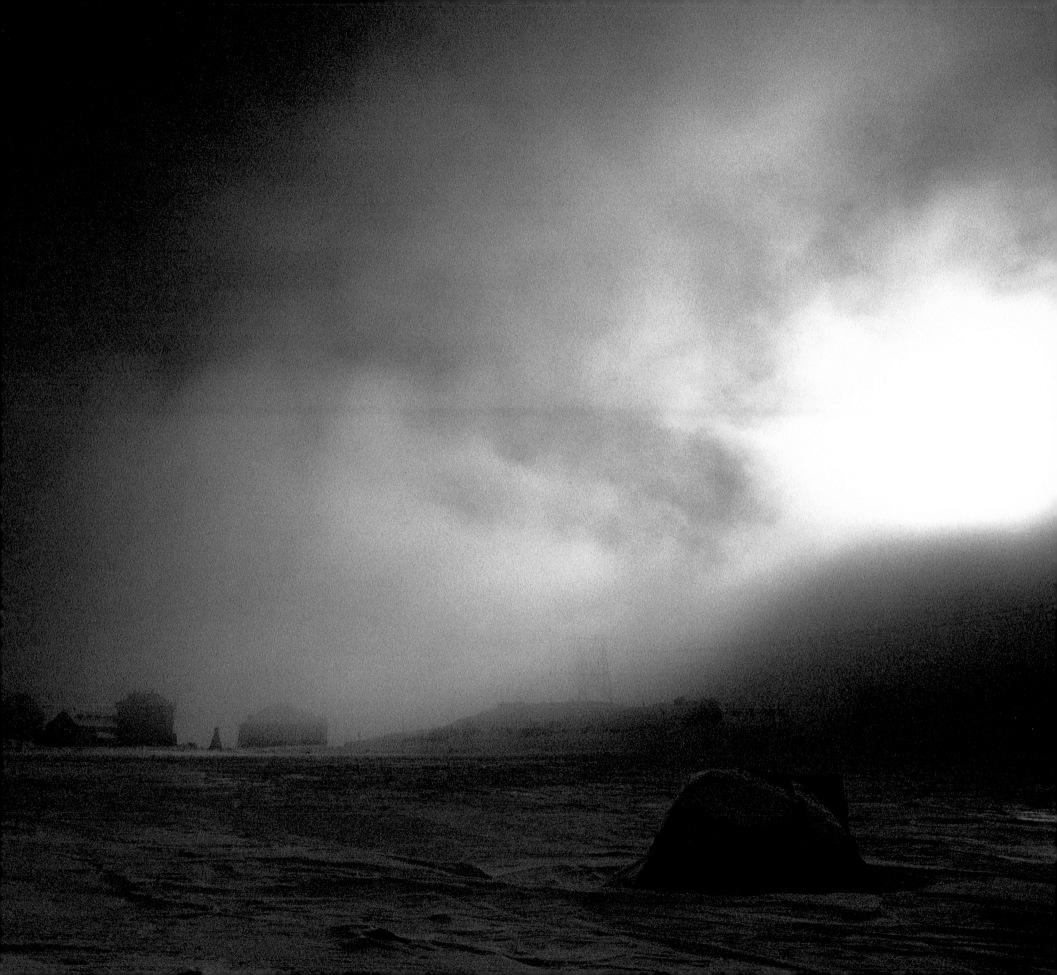

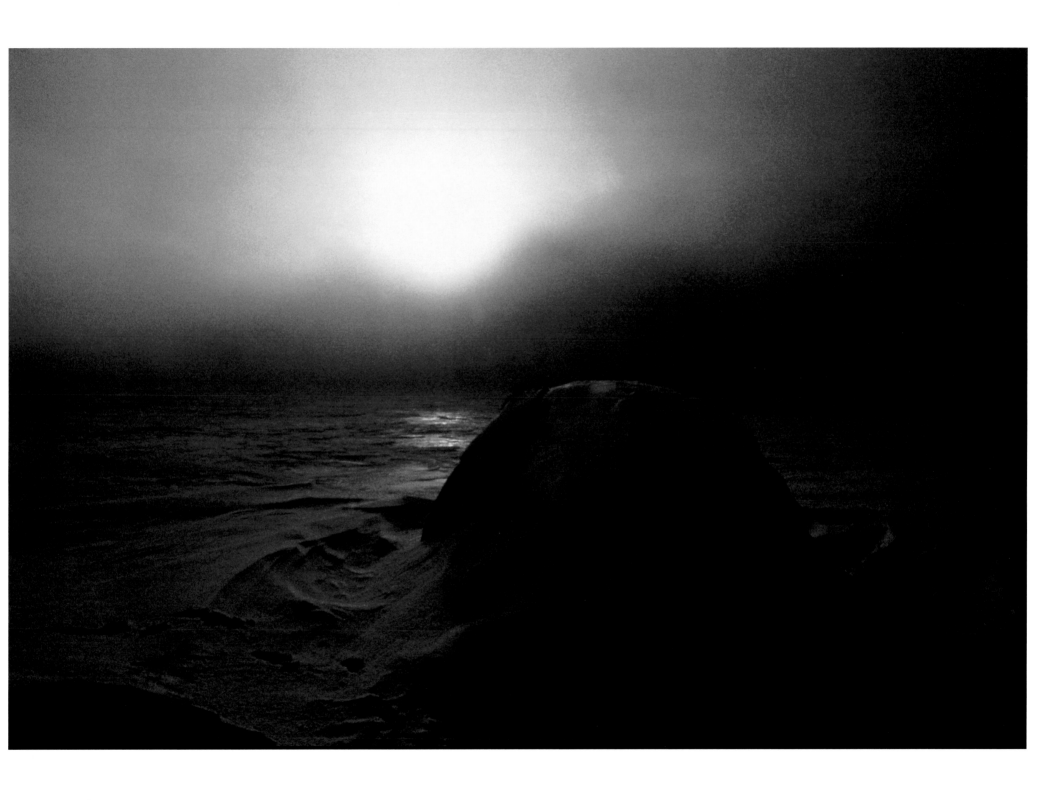

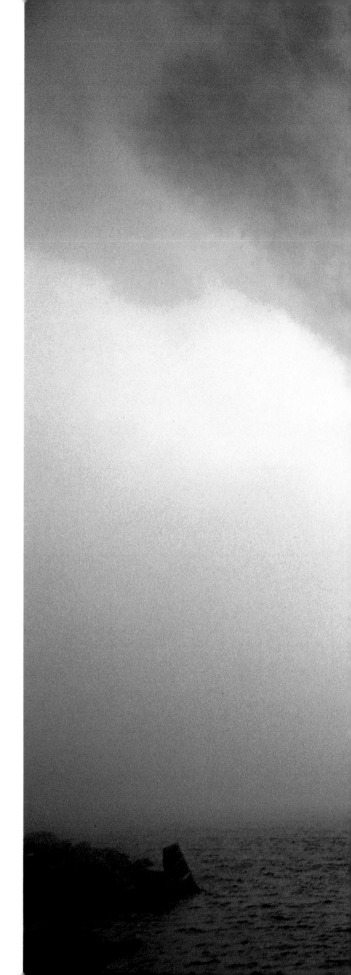

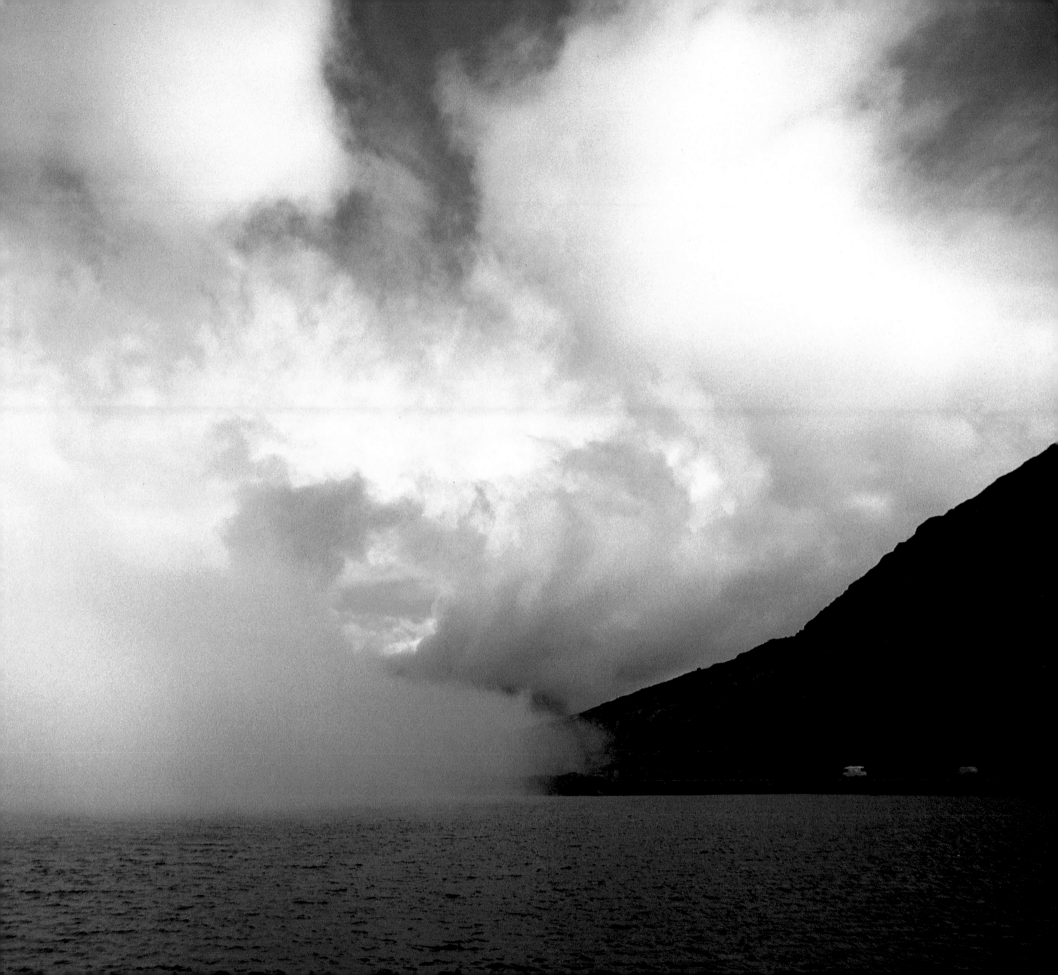

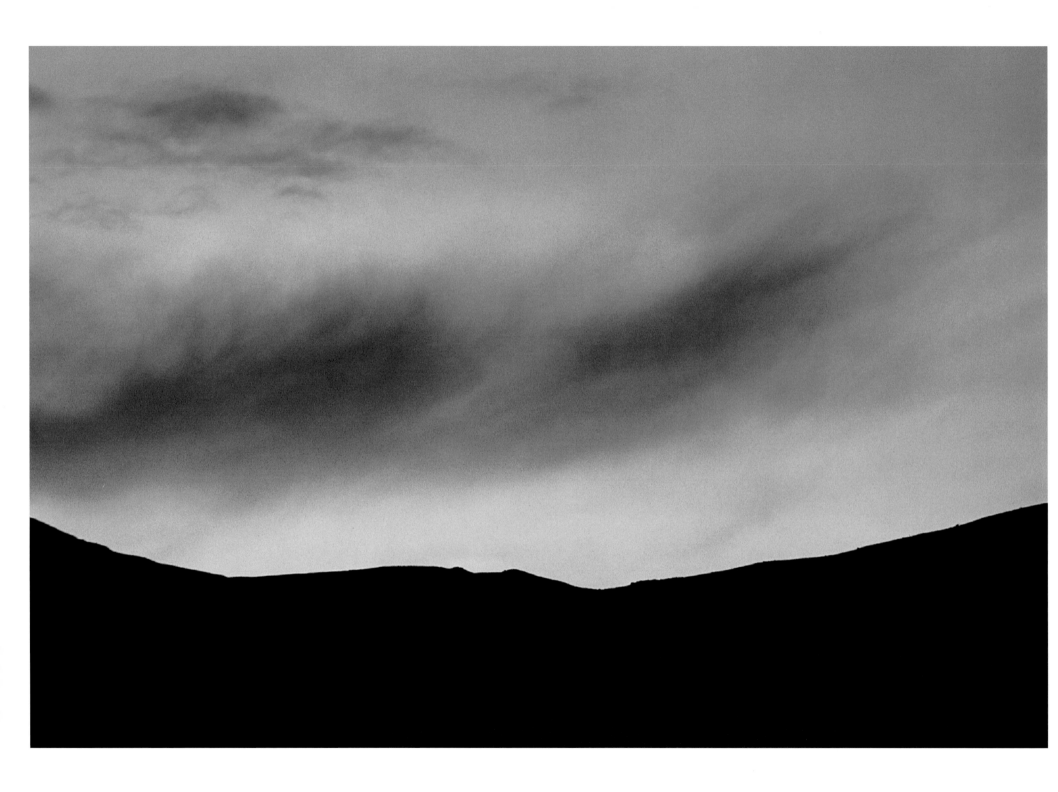

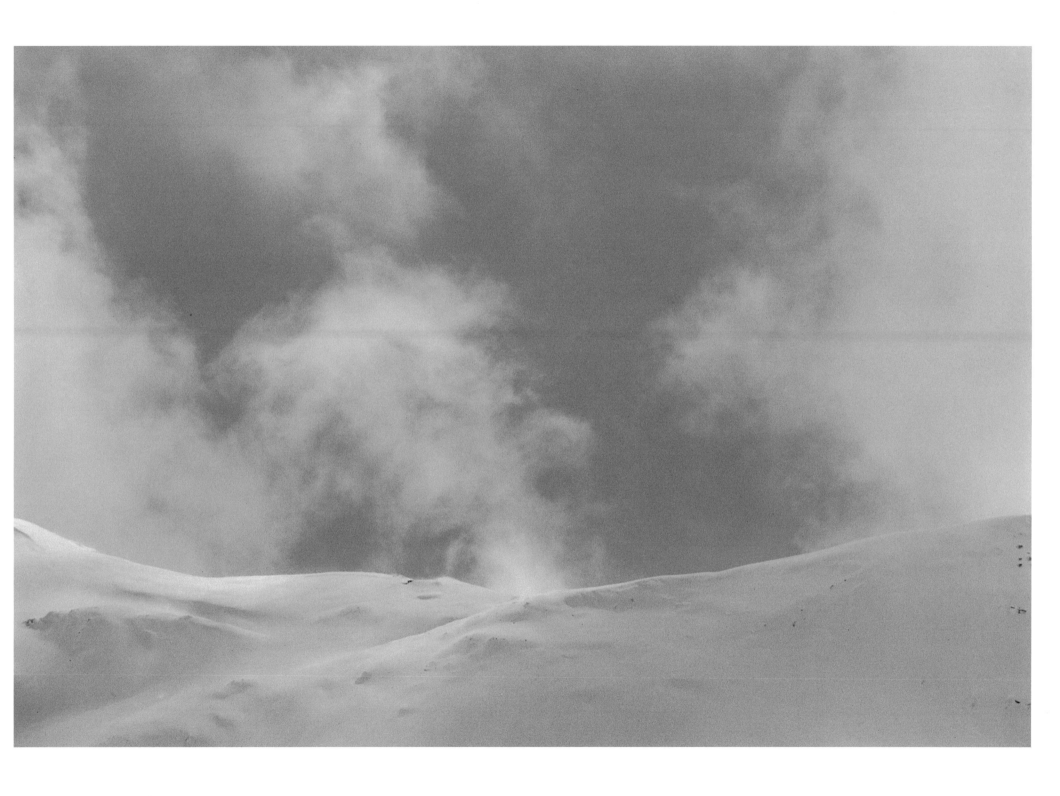

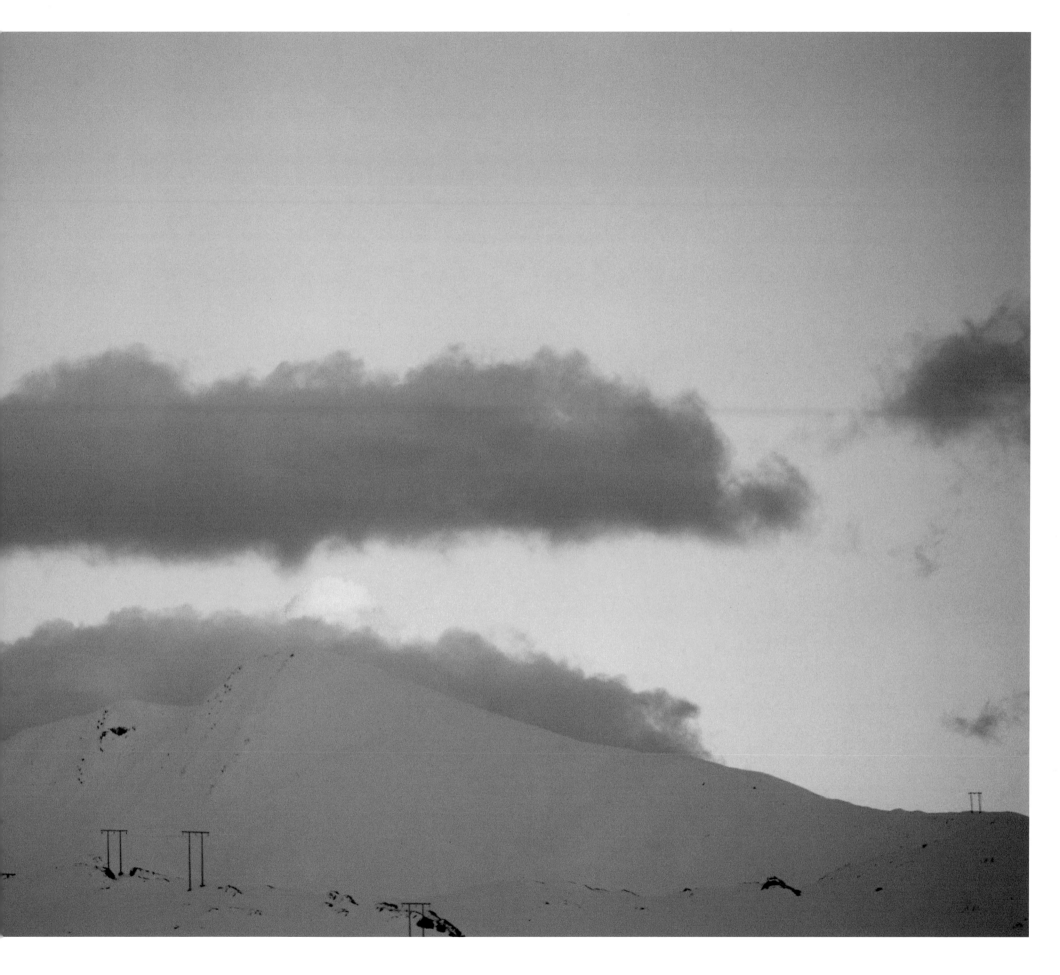

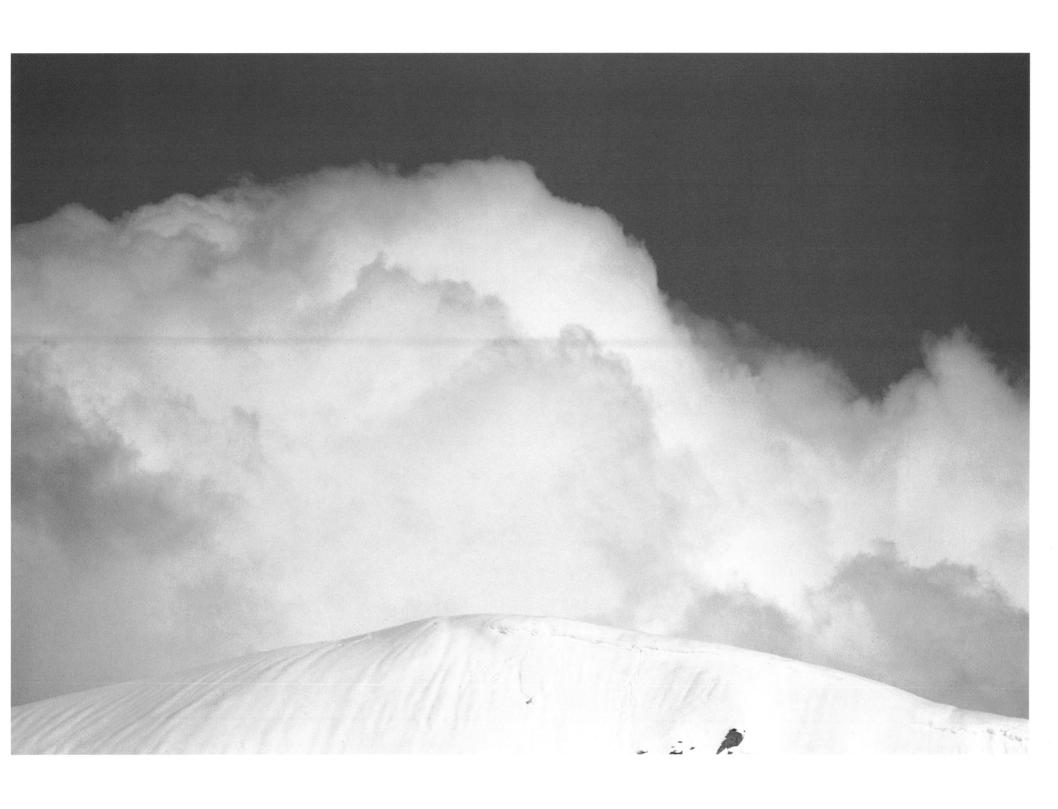

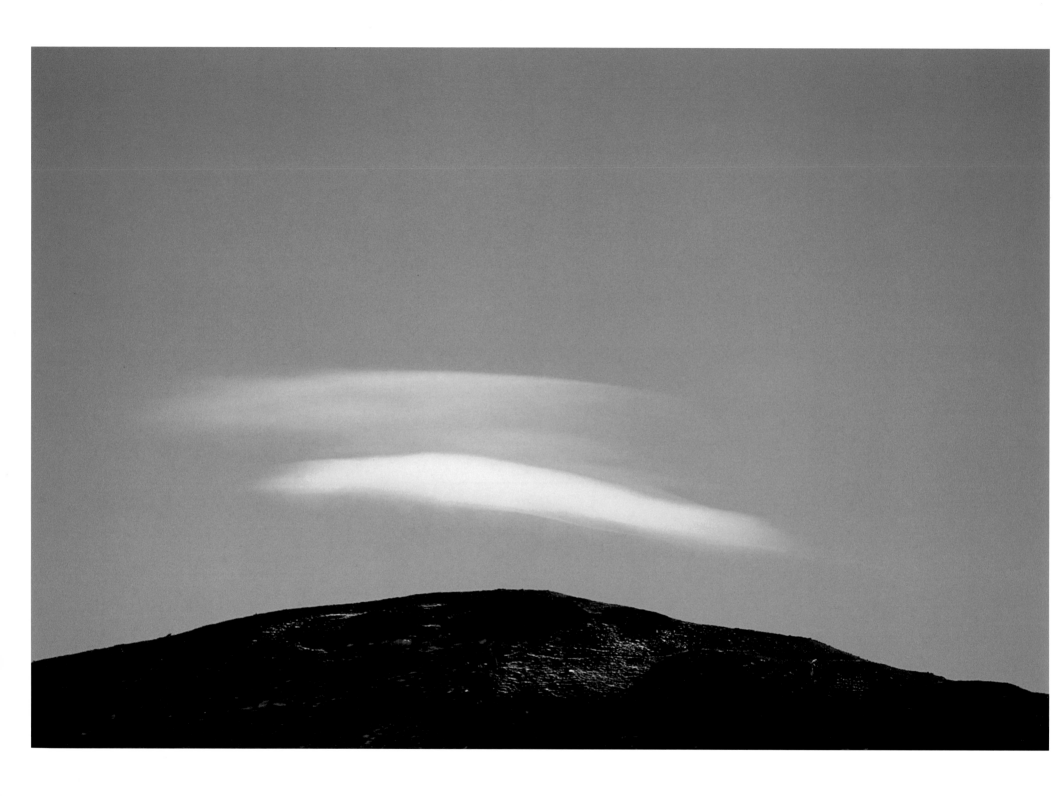

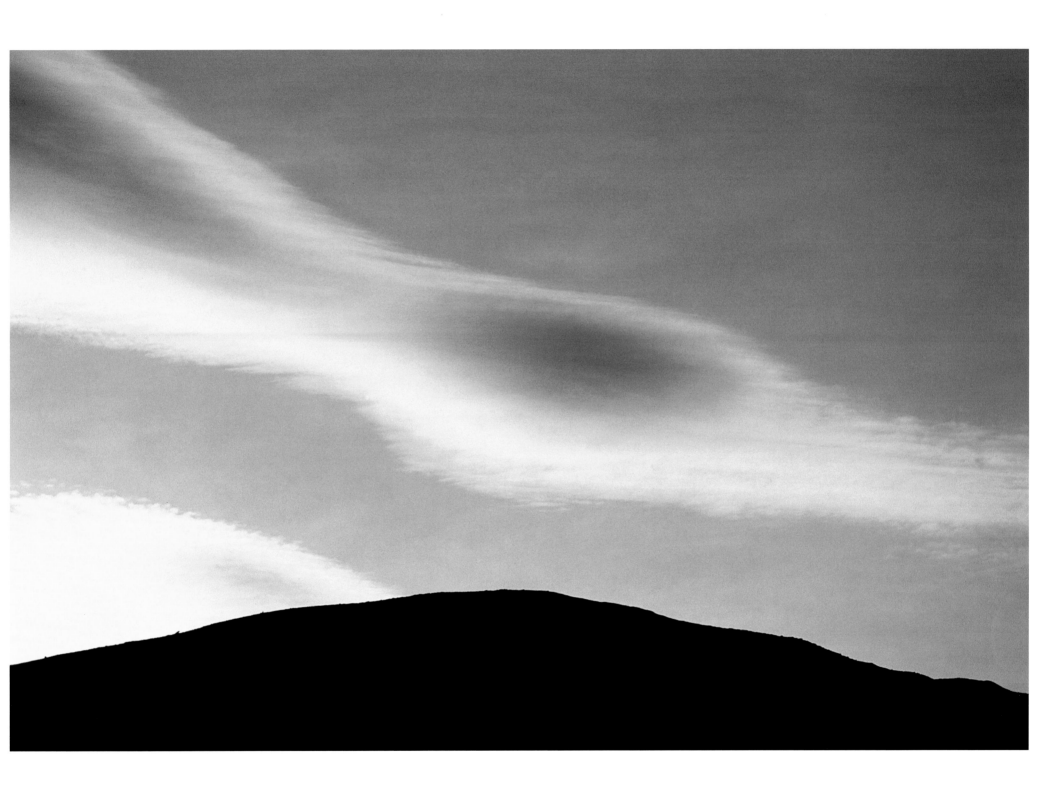

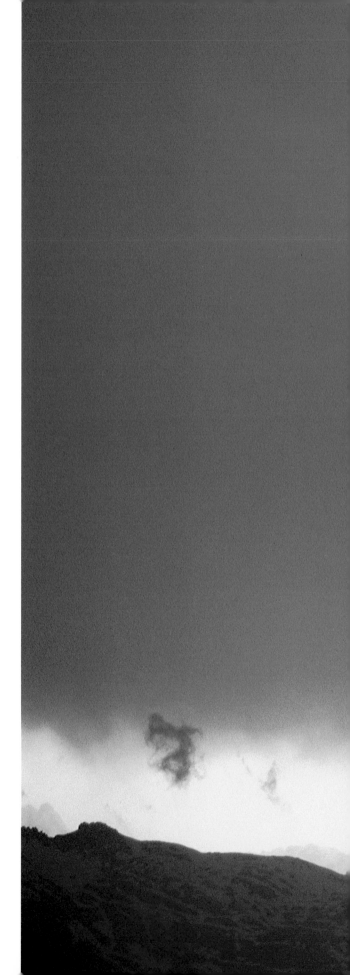

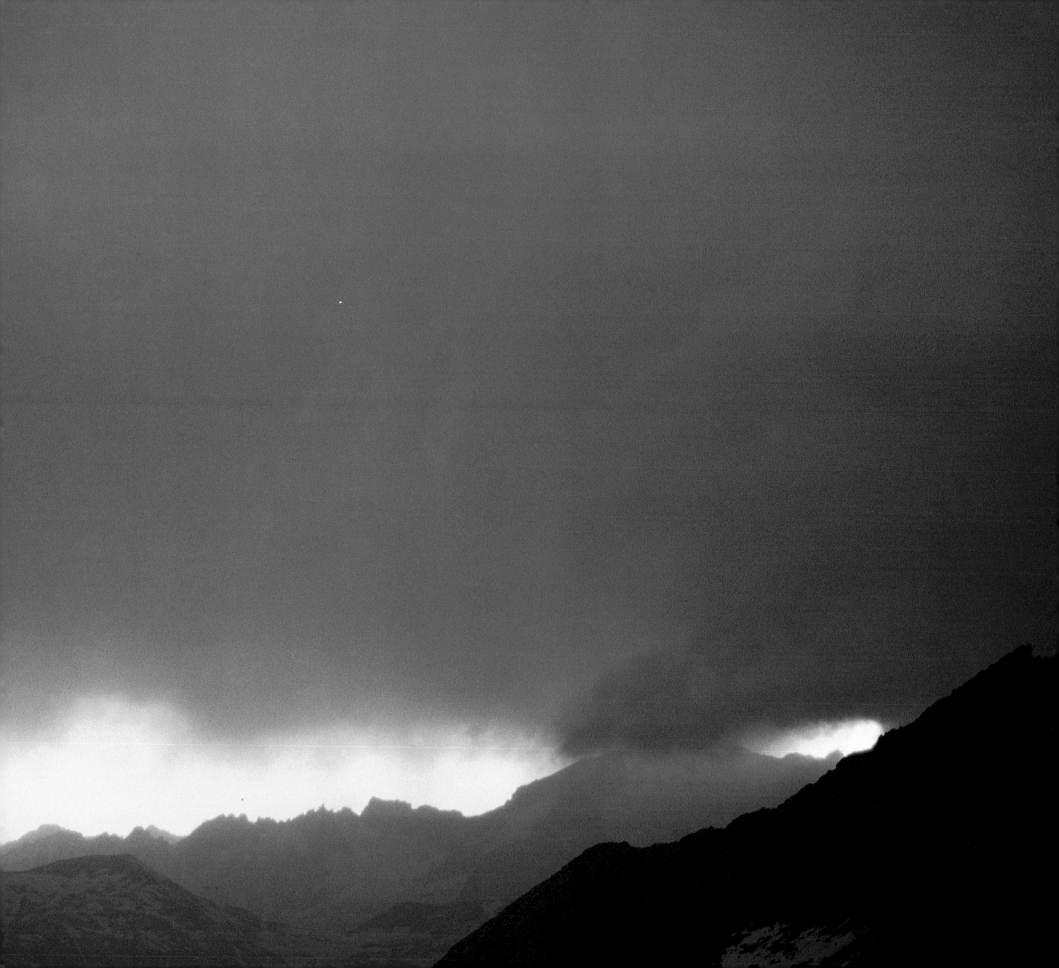

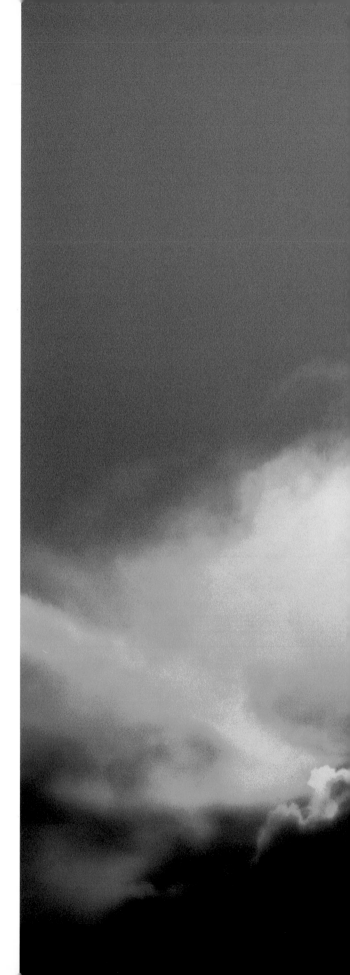

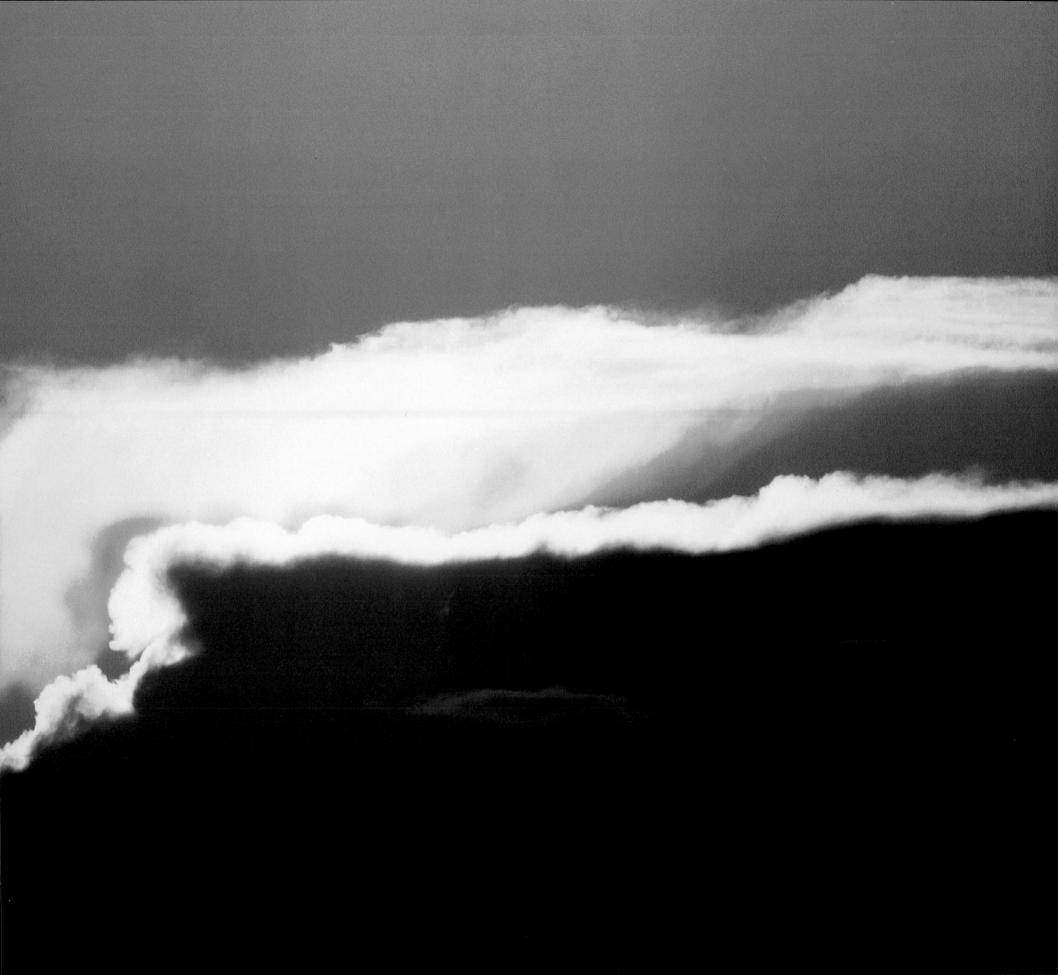

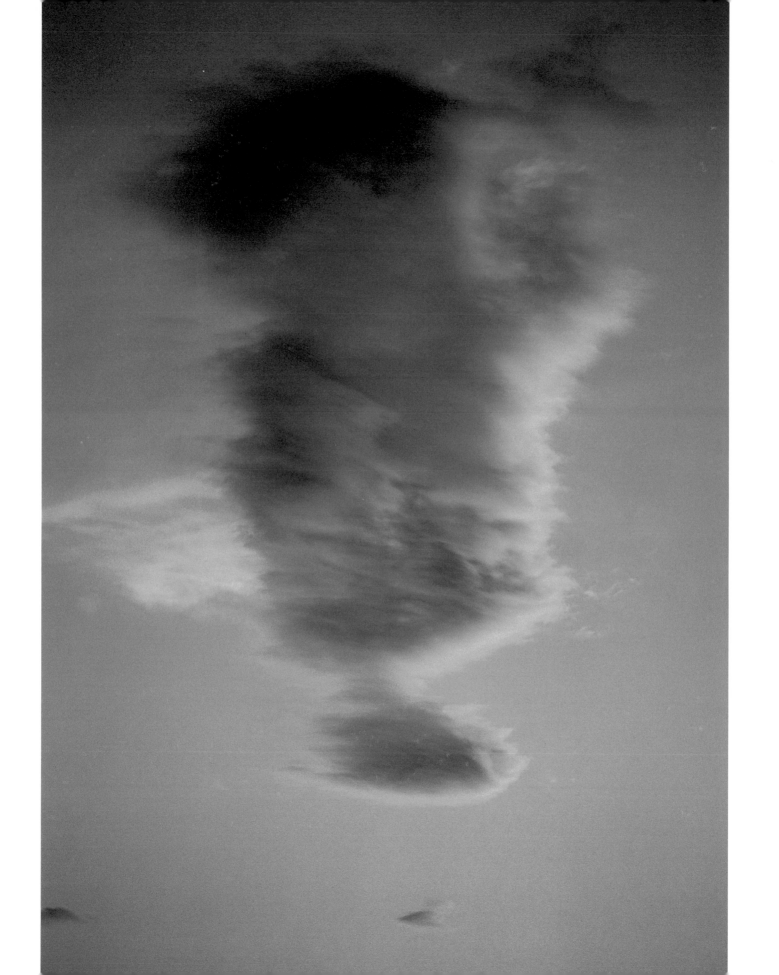

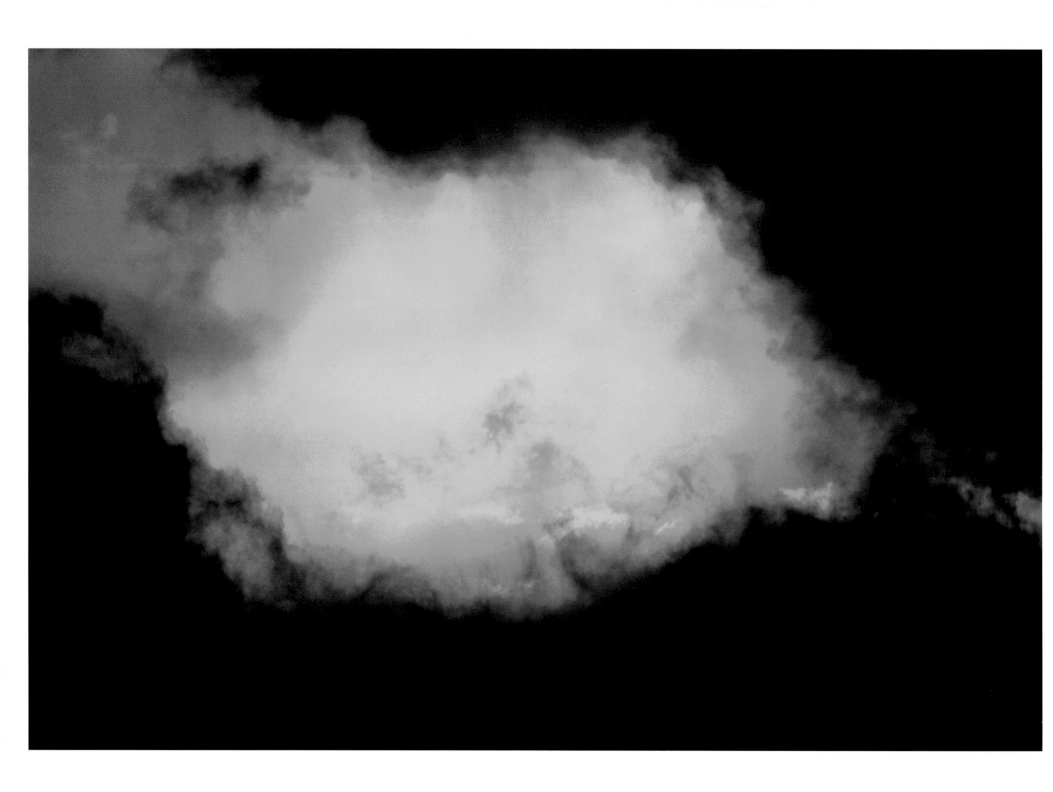

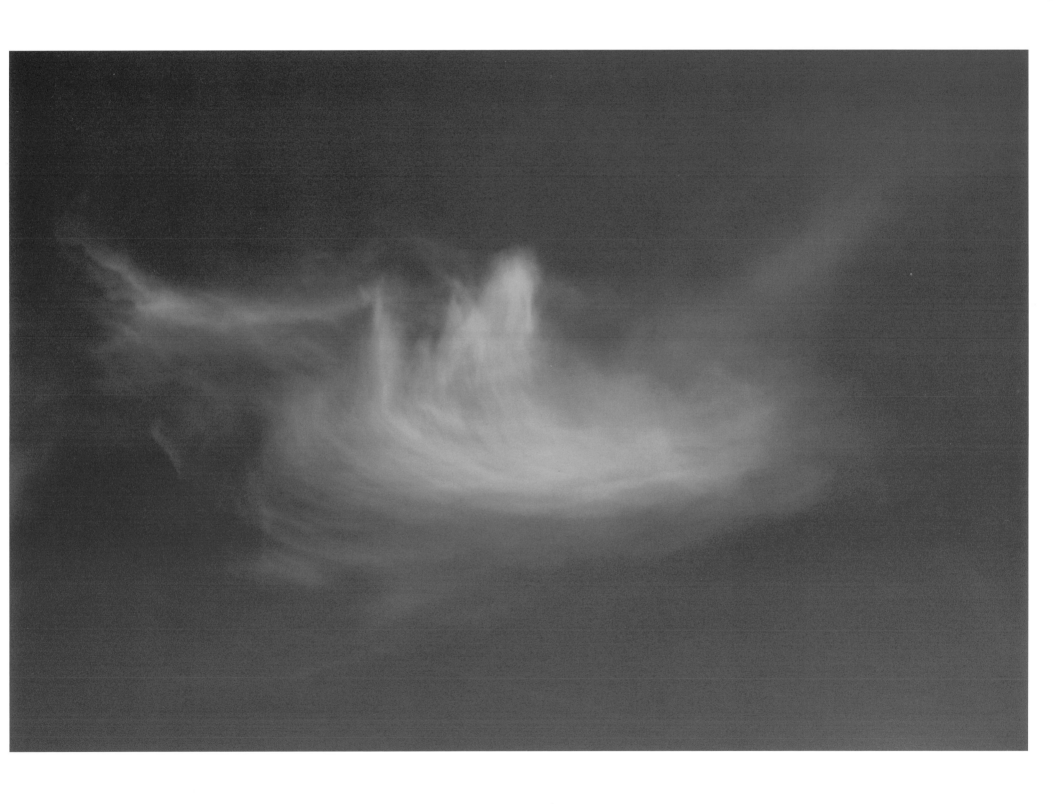

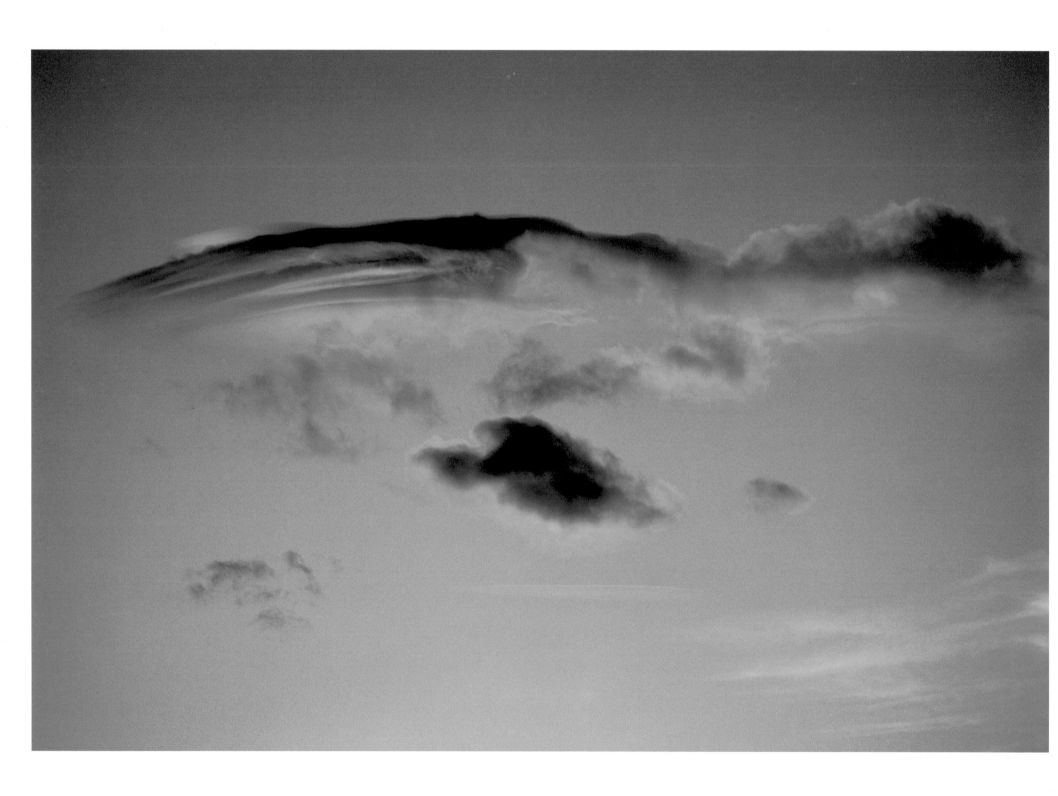

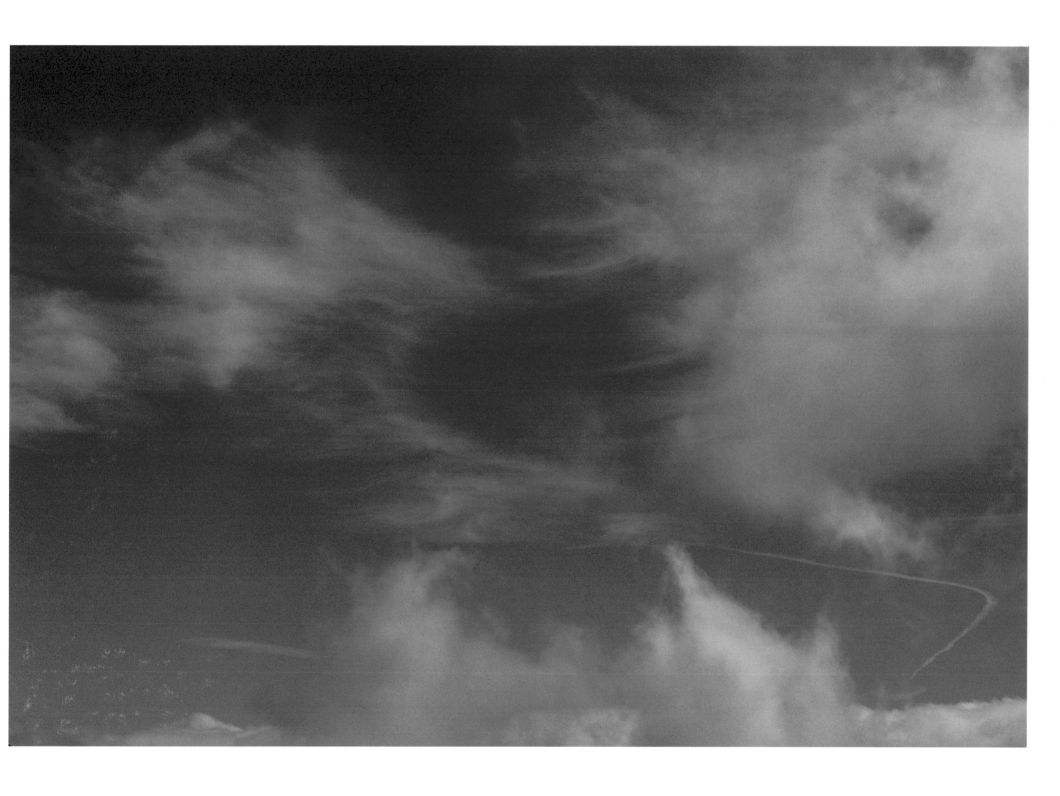

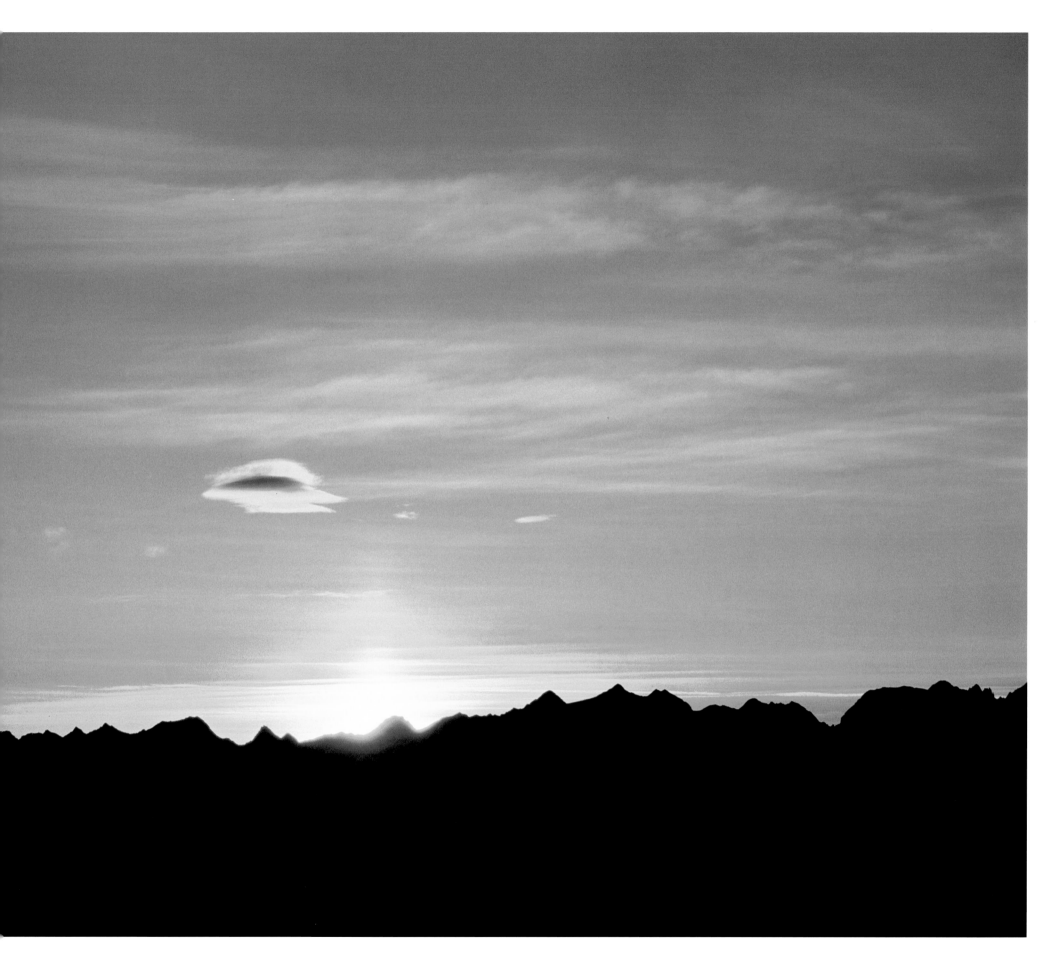

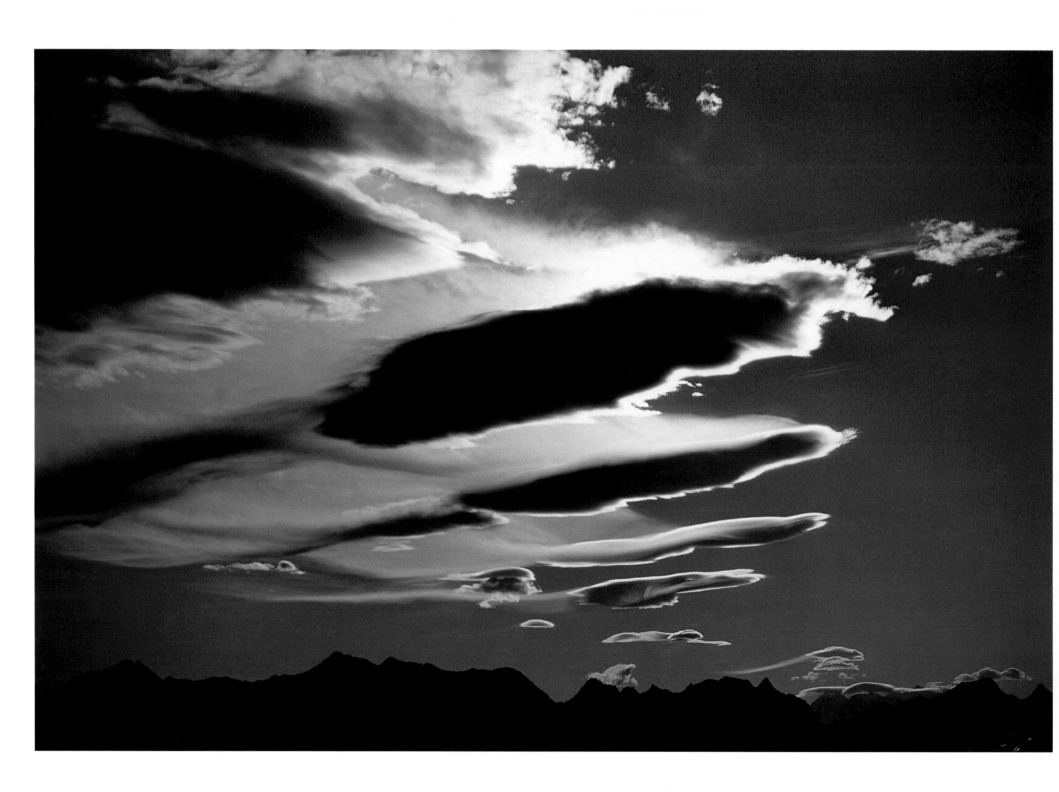

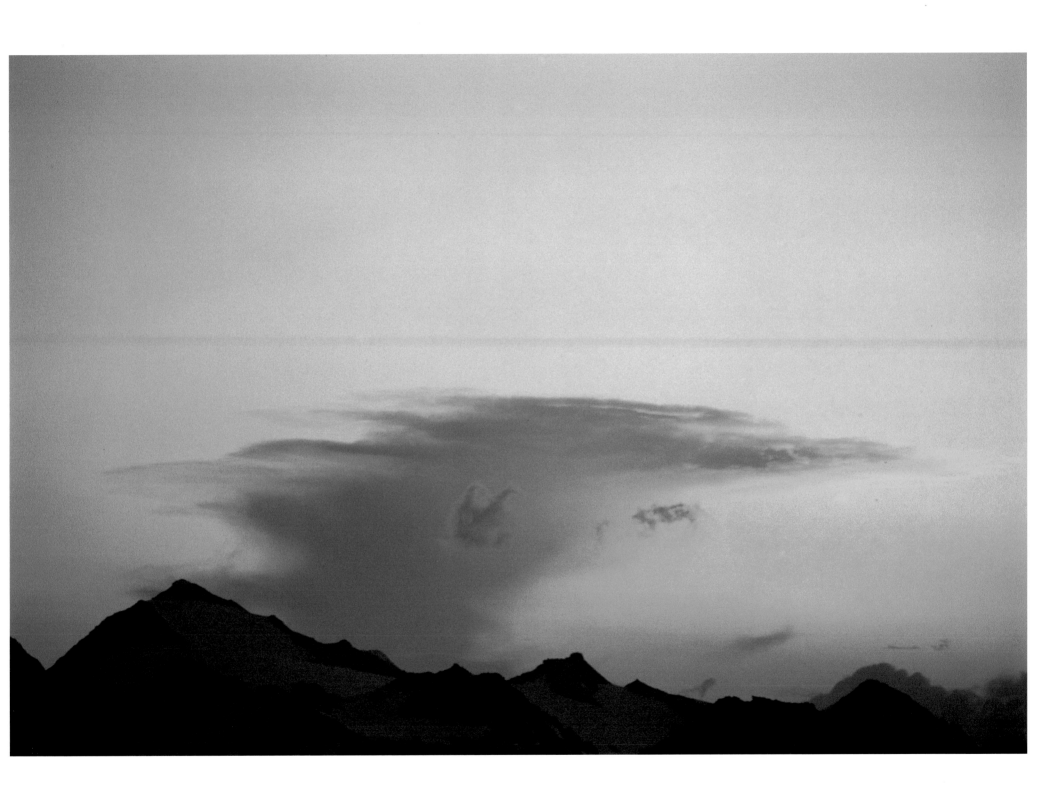

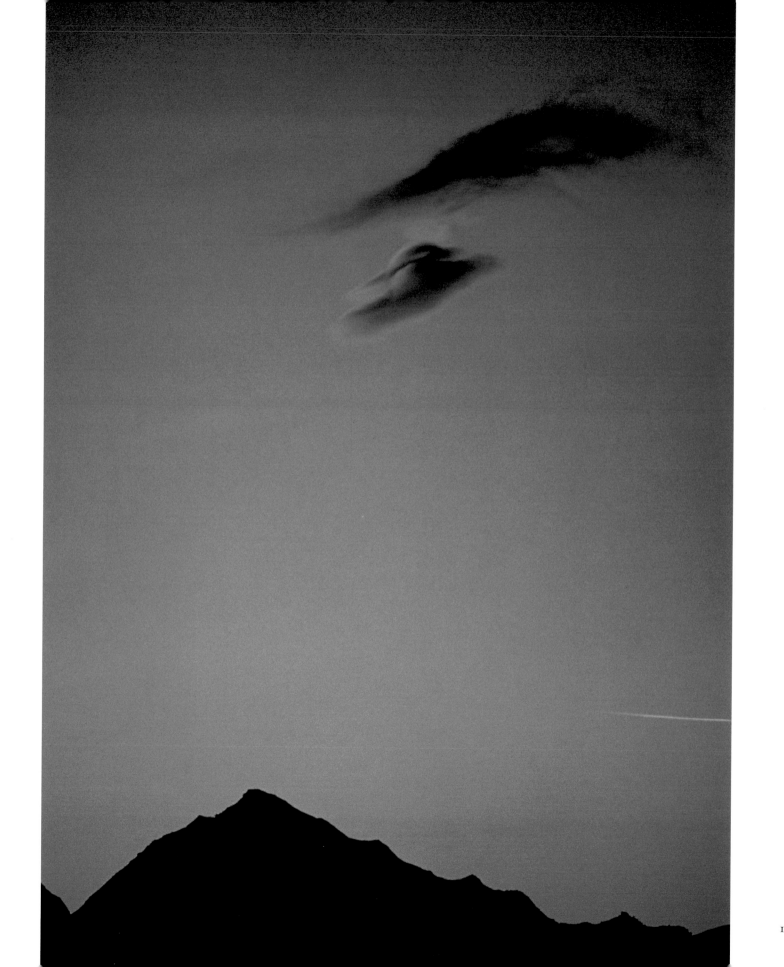

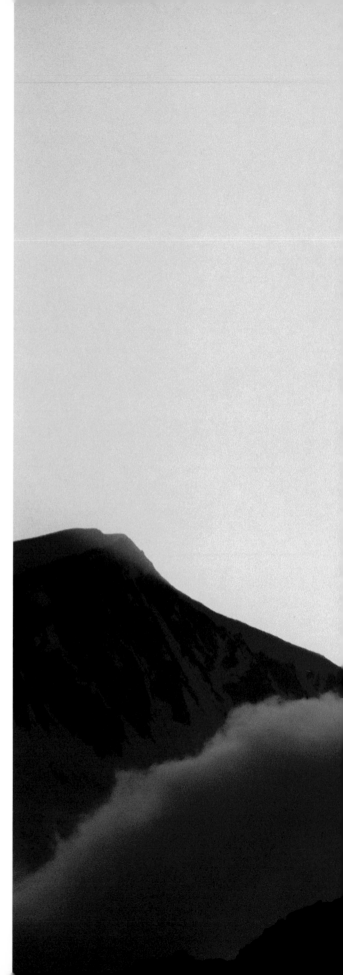

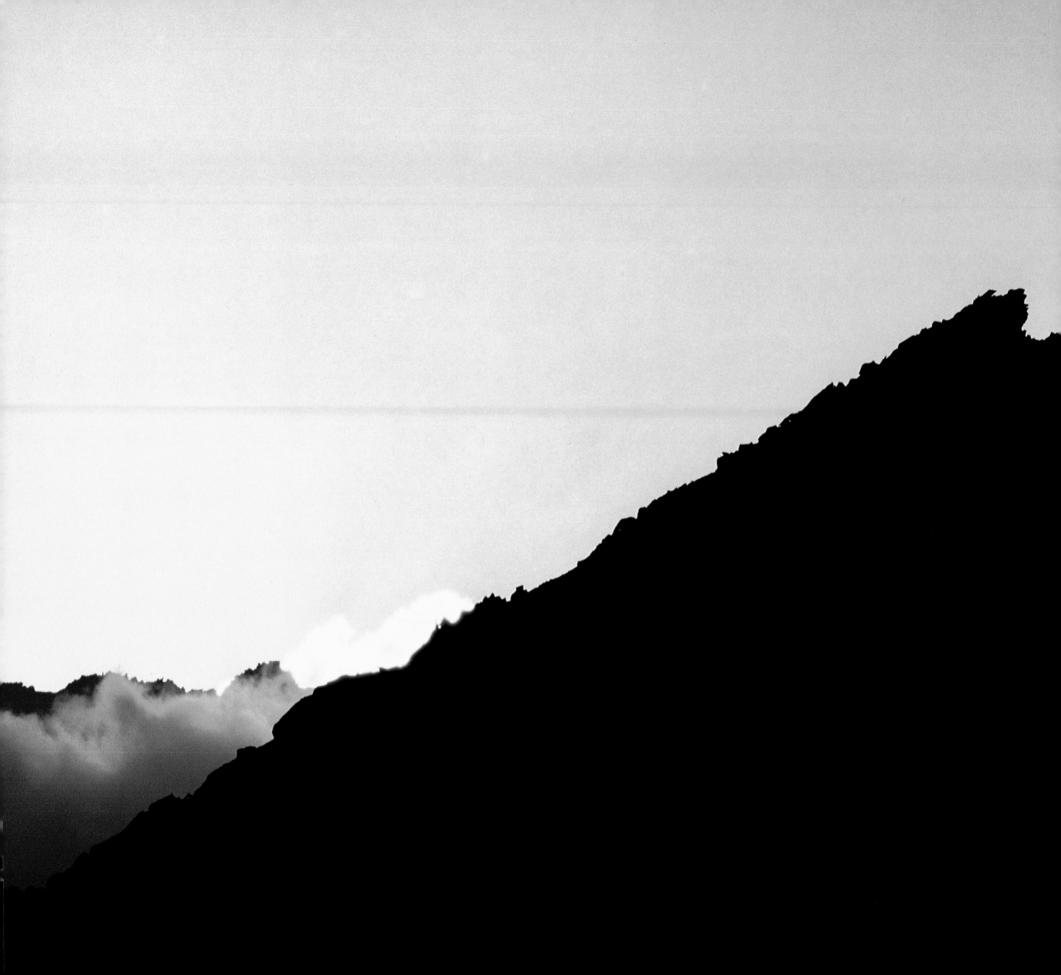

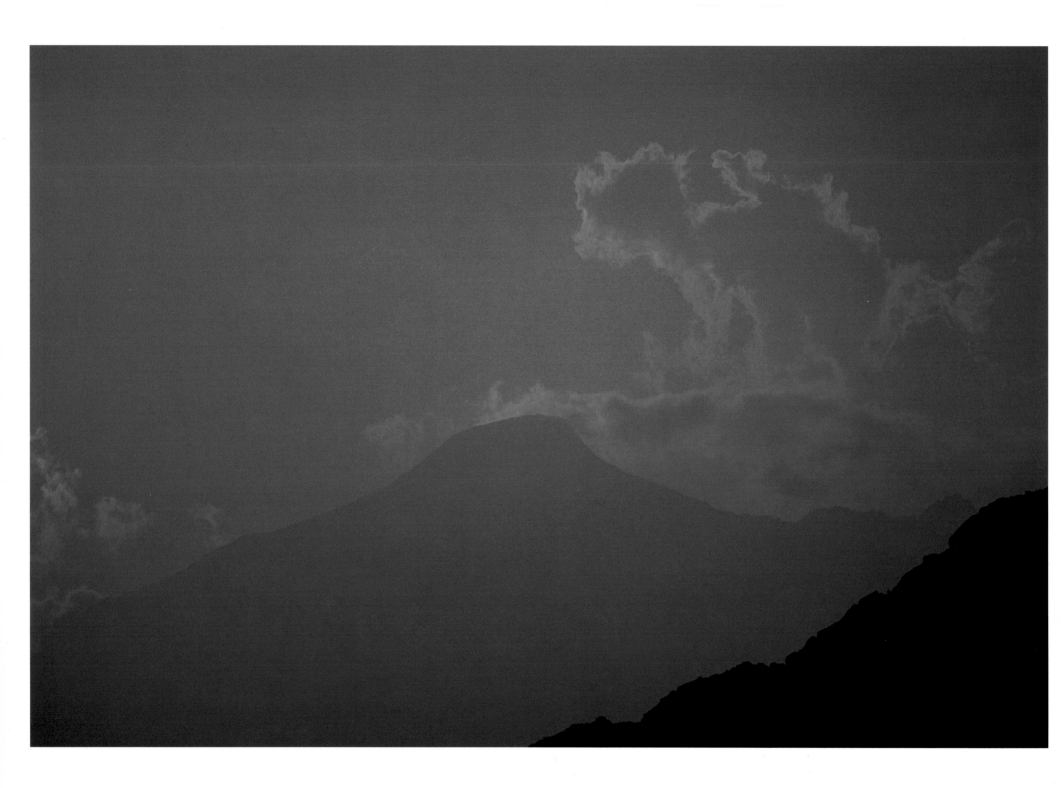

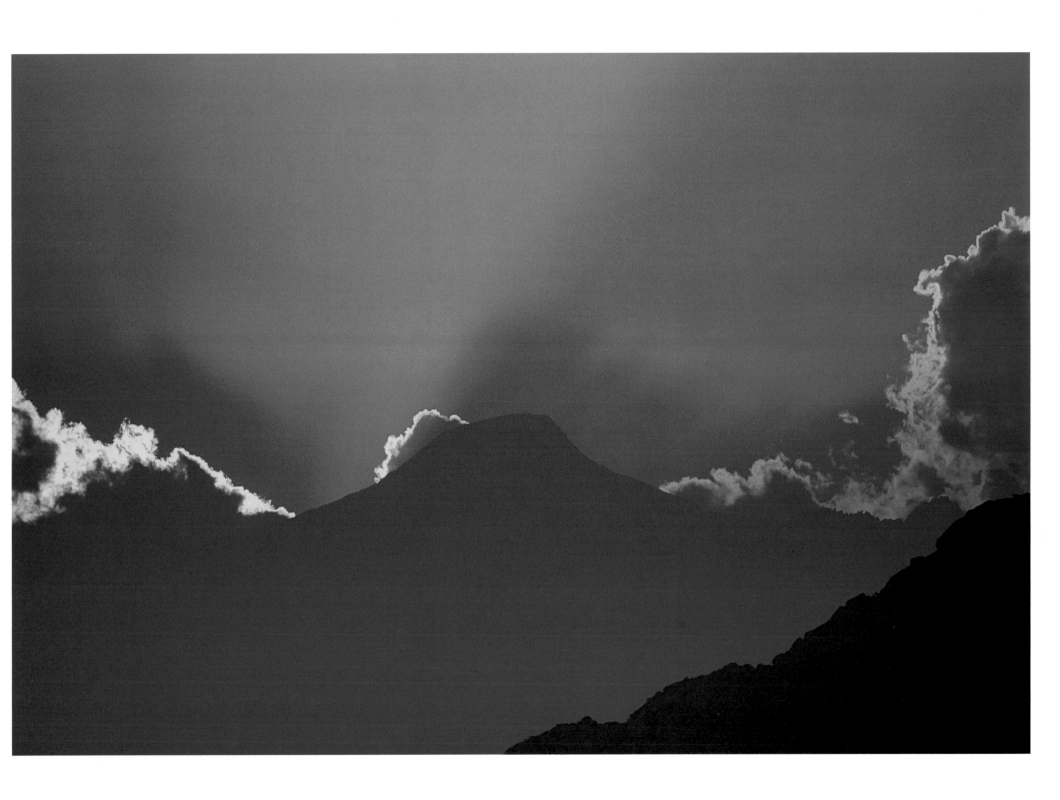

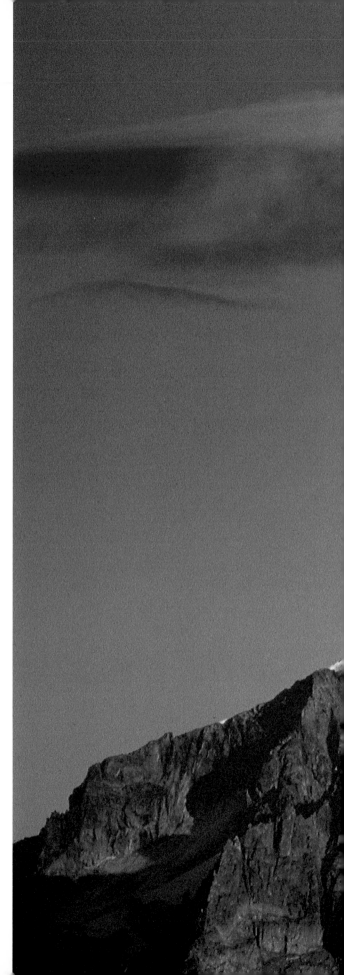

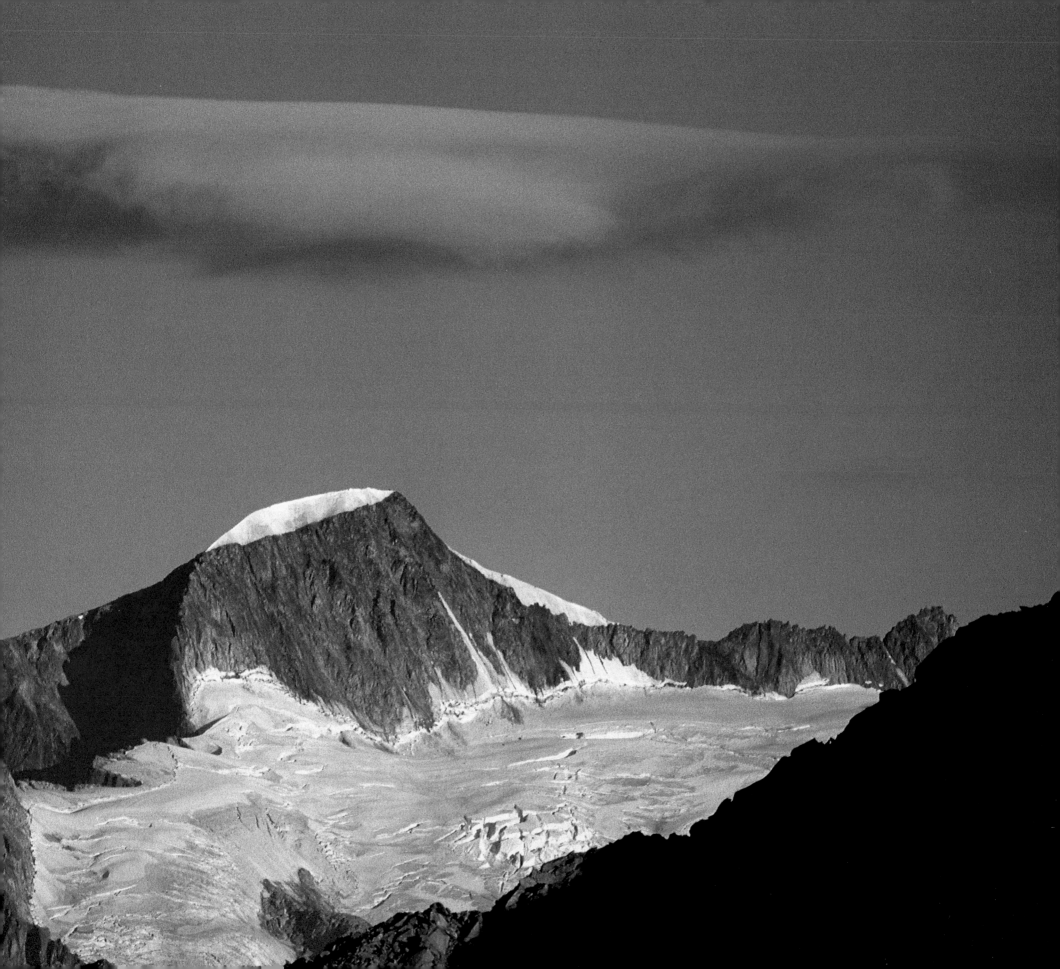

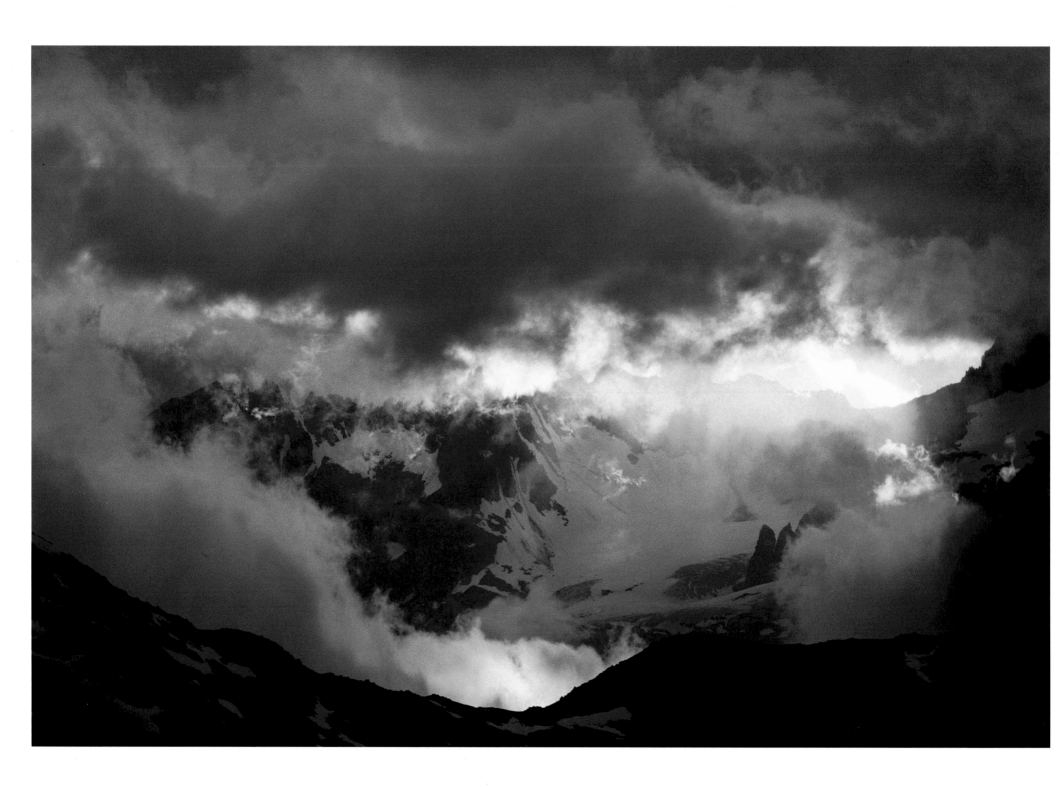

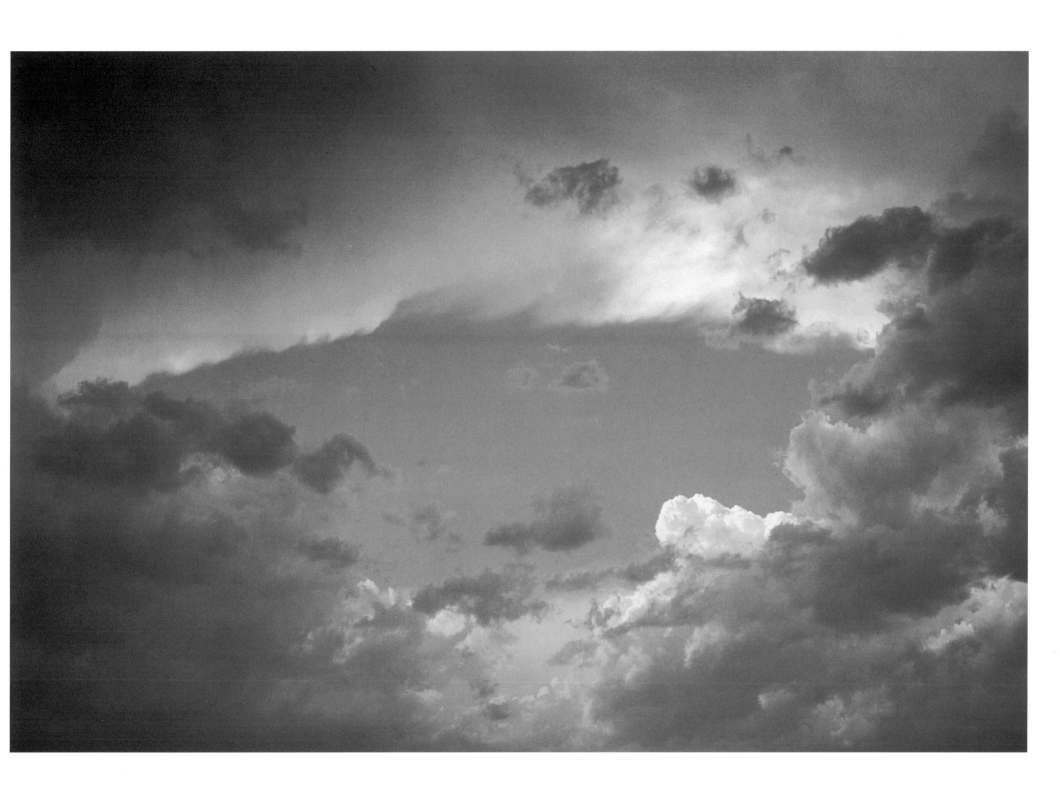

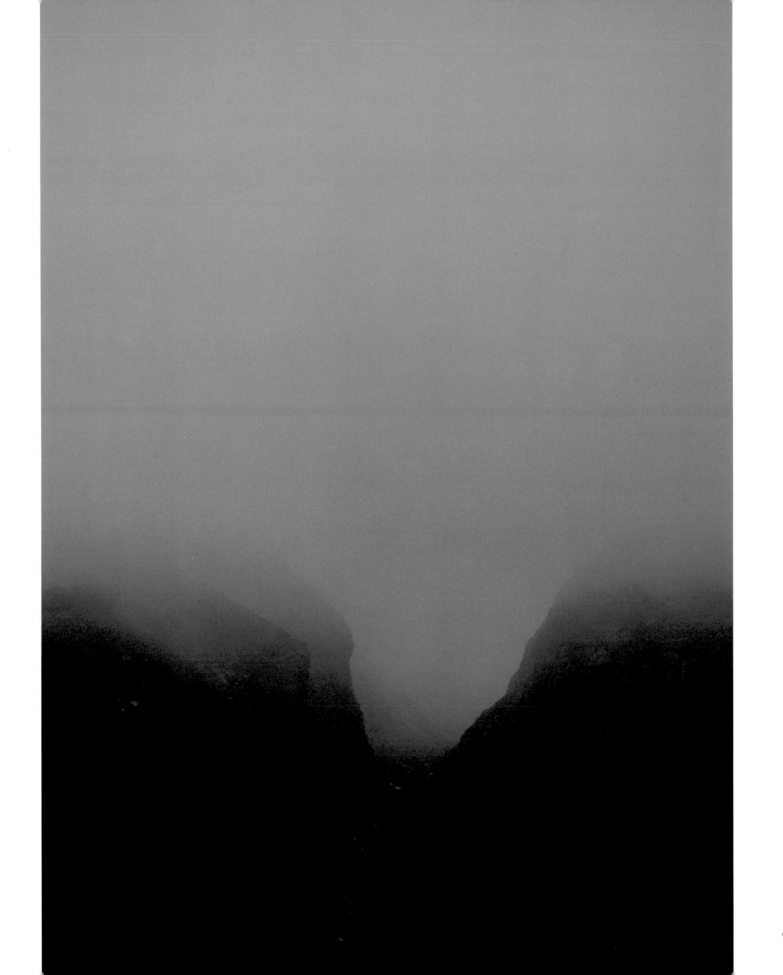

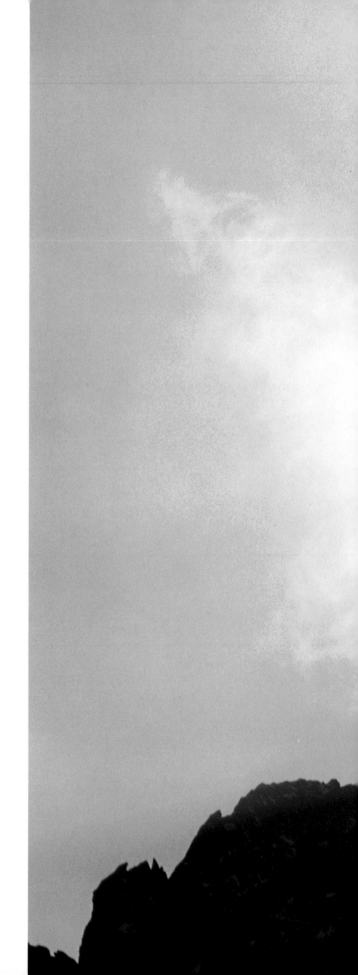

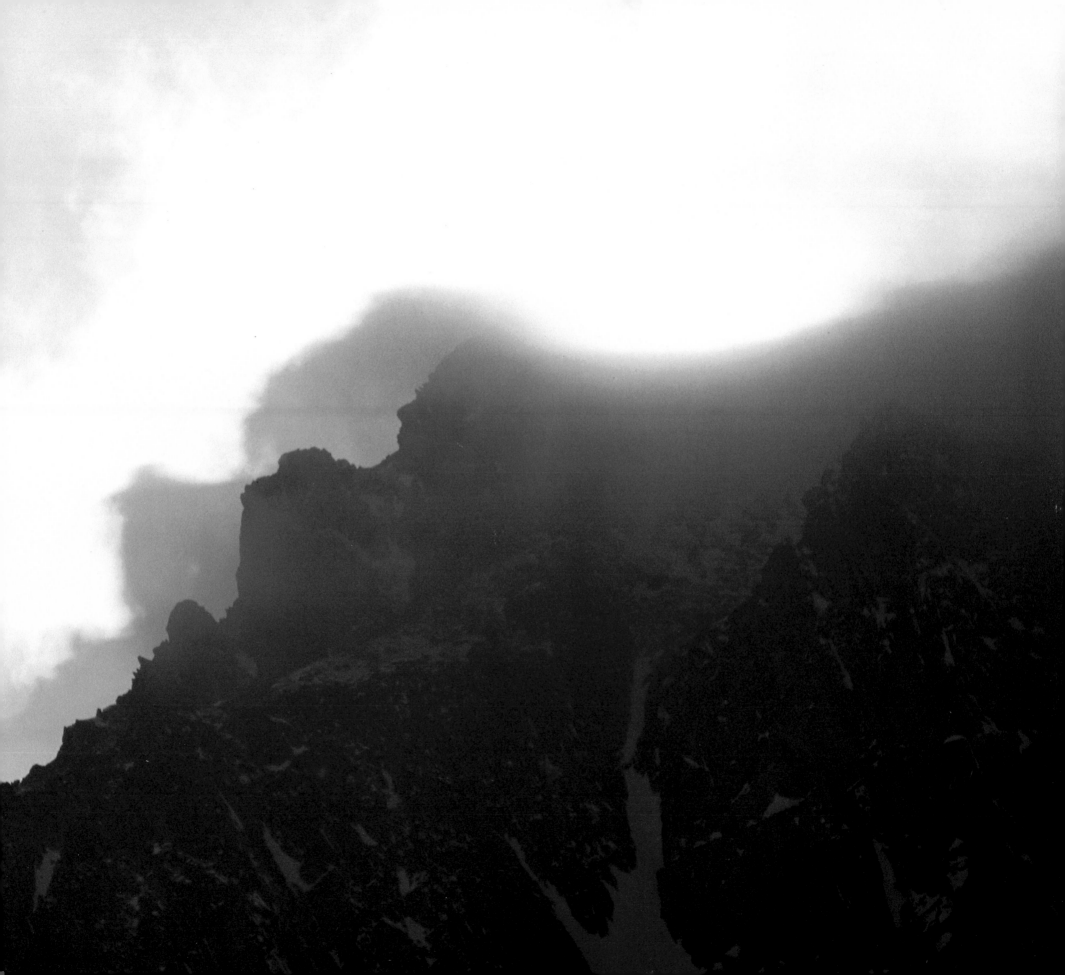

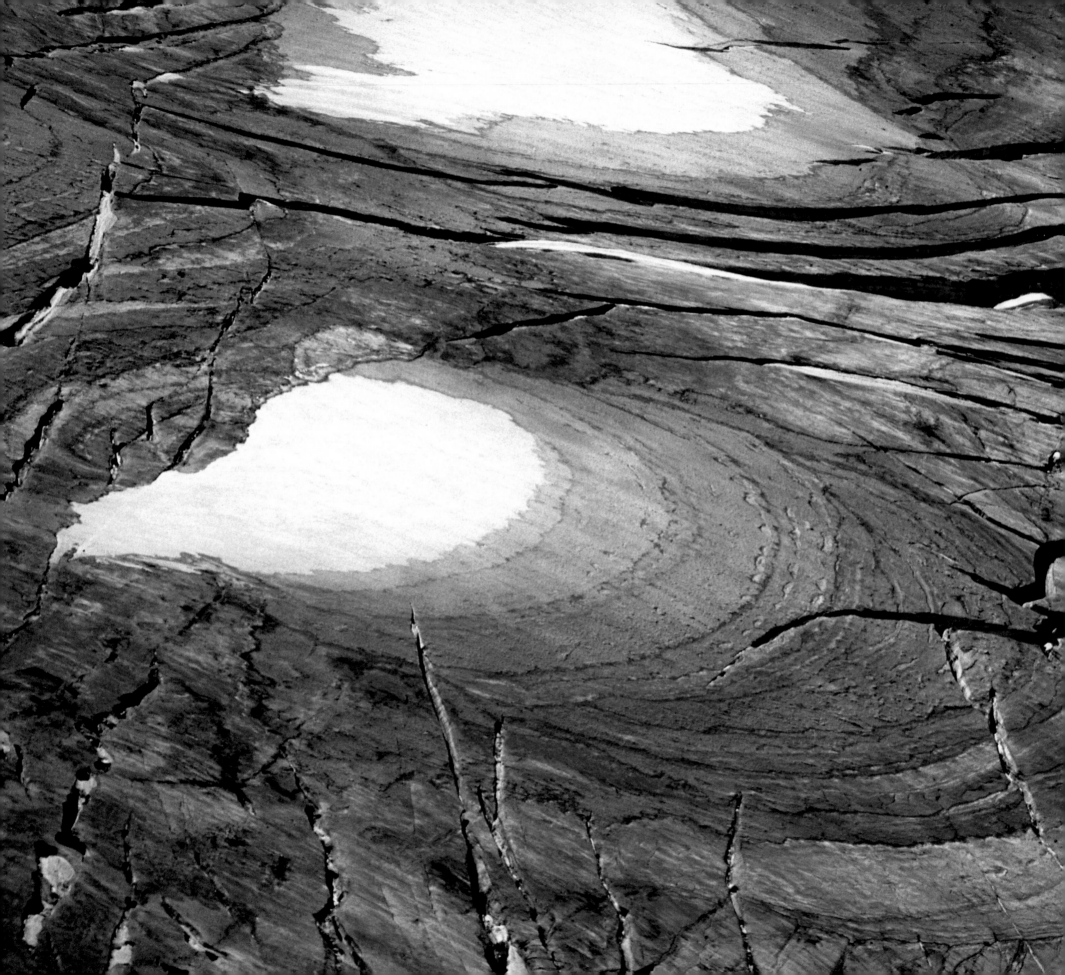

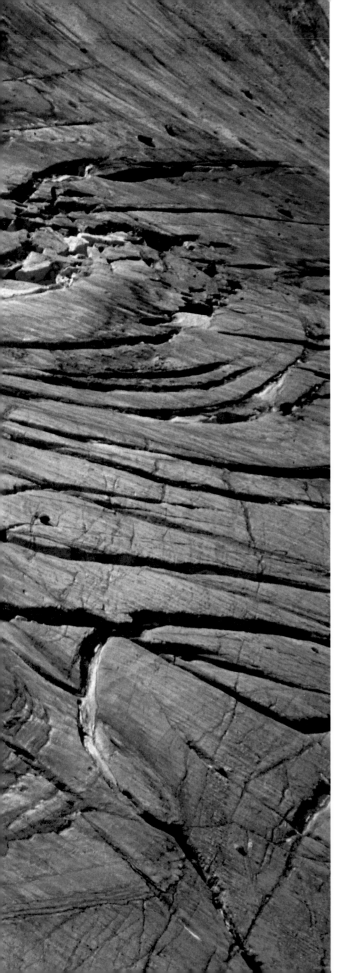

There are landscapes that have a distinct personality. They exert a magical attraction and yet still elude our grasp. Neither physical effort, nor historical and cartographic surveys can plumb the mysteries of this fascination.

In childhood we make our own curiously arbitrary pacts. Our limits are not set; the unknown seems known. The mountains of my childhood on the Swiss Vierwaldstättersee (Lake of the Four Cantons) had names and faces; they were my first partners in conversation; they were images that impressed themselves on my mind, never to fade. As mountains go, they do not rank among the giants, but they bore weighty names: Pilatus, Rigi. And behind them lurked the allure of another name that was to exert an even greater attraction: Gotthard. It is not the name of a mountain, nor of a specific or conspicuous outline against the horizon, but rather denotes a region that always attracted me more than any other, that governed me like magnetic north governs the needle of a compass.

Gotthard. The name does not describe an intact, or an ideal landscape. The Gotthard is criss-crossed by roads and military installations, by ventilation shafts coming up from the road tunnel, by humming, high-tension power lines — and in summer, by a steady stream of tourists. It is not a remote, untouched mountain landscape but rather the quintessential mountain pass: the most important pass in the Alps, because it is the shortest route, and the only one to cross the massif along a single pass.

The Roman emperors believed that the Gotthard was the highest mountain in the world, and it was not until the 18th century that this opinion was revised — by Goethe: 'The Gotthard is not the highest massif in Switzerland, and the Mont Blanc in Savoy surpasses it by far; yet the Gotthard holds the rank of royalty above all others, for it is here that all the other mountain chains converge and find support ... Thus we find ourselves at a crossing point from which mountains and rivers put out to all four cardinal points.'

This territory in the midst of the European Alps, redolent with history and myth, has become my partner and focal point in a prolonged spiritual quest. It has consistently held its position while mine has changed. The beginning was marked by a childhood dream of technical conquest as a locomotive engineer. Later, while preparing to study civil engineering in my teens, I drafted endless plans for the construction of a road tunnel, an idea that was soon to be realized by others. Then another change followed: the first attempts to take an entirely different approach, a softer, more gentle one — but also a less secure one, because there were no well-trodden paths to follow.

When I held a camera in my hands for the first time in 1983 in order to capture the purple sweep of the early morning skies over the Gotthard, I

sensed that photography could be a means of discovering the rhythm of this landscape and its skies. What began as intuition gradually developed into an agenda.

I have since spent weeks, months, entire seasons in this region. From more than 500 locations within an area of some 20 square kilometers (8 square miles), I have kept a record over the past fifteen years of rock formations, boulders, horizons, peaks, signs of civilization; I have registered them with the camera like a glider pilot flying around a marker; I have taken notes and recorded the time. Every photograph can be identified by the time when it was taken.

By the end of 1996 I had accumulated an inventory of over 180,000 shots taken from every conceivable vantage-point. But I could not possibly claim to have exhausted the visual potential of any one location. It is a process that meanders on—indefinitely.

Many of the sites are under a blanket of snow for up to eight months of the year, barely accessible and days apart, despite the short distances between them. The area is cut off from the rest of civilization from October to June. For over fifty years, a guard has been the only one to come here regularly, every two weeks to check the dam, and—when the forecast promises a few days of good weather—a few members of the garrison.

Even before I started studying the landscape in winter, I had toyed with the idea of staying up there and working with an automatic camera. I wanted to capture the movement of the clouds and the life of the horizon to the south. It took over a year to find suitable locations and an operative technology; the pilot phase took several months more. Finally I installed a station with an automatic camera north of the continental divide at an altitude of 3000 m (9,850 ft). The equipment was able to withstand snowstorms and rapid fluctuations in temperature of up to 100° C (212° F).

It was difficult to understand my obsession, and when asked what I was doing up there, I would say that I was engaged in meteorological re-search—a response plausible enough to satisfy everyone's curiosity.

The sky is an element that tells me what is essential with every new day. In cities it is no longer visible; skylines marked by feats of technology have replaced it; the sense of longing has been dismissed. Looking at the sky, the firmament, has always made me acutely aware of my own longings. It assures me that I am not an isolated being; that I am taking part.

Paracelsus calls the firmament the primeval image of writing.

Day follows day imperceptibly.
Cyclical time gently reveals the essence of the world
and exposes the traces of growth:
stones getting smoother in the wind, grass ageing,
signs of the patina of time.

From My Diary

14.07.85 — I am writing the exact time on the stickers for last month's series of photographs; suddenly there's a clap of thunder! A storm is gathering in the west. At 7 pm the sun was shining in a cloudless sky, it was still very hot, the horizon was in a haze, and now, at 7.45, the light is gone completely. A transition as abrupt as in the desert. From hot to very cold, cold enough to put a winter jacket over my T-shirt. A thunderstorm is brewing above Furka/Urseren, a branch scuttles south to the Bedretto valley. Pizzo Canariscio remains an island with raindrops falling in between. The sky gradually gets brighter in the west, a narrow reddish-yellow stripe between the Finsteraarhorn and Galenstock peaks. At ten-to-nine the sun sets to the left of Monte Prosa. A pink wing, a bank of clouds, is gathering again above Basodino, spreading from Maggia via Tenchia to the Leventina Valley. Balloon-shaped sacks make the skies look like the insides of intestines. The raindrops on the camera lens are no encouragement and I've run out of film. I run down to the hut and by the time I've climbed back up again with new supplies I'm pretty exhausted. The drama is overwhelming. Completely different skies. Yellowish above the Bedretto Valley (after the storm), a small fan of radiating light (one-sided on the left) behind Monte Prosa, gray with pale, reddish-yellow sacks of clouds in the backlit twilight above the Leventina.

For the first time I have observed a passing thunderstorm from a distance: the harbingers, rushing like arrows in all directions; in the background, a solid mass piling up (here with the sun shining on top of it in the distance), then everything turns gray, seconded by impish clouds. In the distance the skies become lighter as if the day were beginning all over again, as if it had all been a brief, magical interlude.

In Novalis I read: 'We dream of traveling through outer space; is outer space not within us?'

17.07.85 — Beautiful isolated clouds in the sky, just below 4000 m (13,000 ft). Stationary. The landscape at rest. Towards evening, shortly before 5.30, the wind transports the wail of factory sirens up into the mountains. Inconceivable, this form of time. How close the kinship between the sensation of time and the sensation of work.

21.07.85 — Radiant, almost autumnal light. I'm cold, although the sun's been shining all day. It's very, very windy. A woman passes by with a little girl. What is that all about, she wonders. If I knew, I wouldn't be standing here.

I note down: 'When you observe the shape of the sky, you can study time changing.'

22.07.85 – It seems to me that there's a moment in the course of a day when afternoon turns into evening. You can't see, but you can hear it; there's an almost imperceptible change in the sound of the landscape, it is carried by a growing stillness, like the light that becomes softer as it begins to lie down to rest.

23.07.85 – The sun is still two hands above the horizon. Only above the ridge between the Finsteraarhorn and Galenstock peaks are there cumulus clouds. 'Vapors for the sunset.' When I concentrate on listening to the softening light and the serenity of approaching dusk, I sometimes have the feeling that I can see my work growing, as if its shape were waving to me from afar: description and circumscription of the pivotal point.

24.07.85 – 10 pm. The moon above Bedretto. The earth's behavior, its appearance. It is all a question of the sky. Heat and cold alter the earth's cover. The longer I stay up here, the more I grow into the landscape. I no longer see it in all its details but rather as a greater whole.

Mircea Eliade: you do not quite know how this magnificent color has changed, you do not know what miracle will transpire when you look at the skies and your gaze travels up into the void of azure and sun.

26.07.85 – A group of hikers climbs up over the ridge. Their guide describes the peaks; the eyes of the hikers follow his hand. Then they all disappear from sight to take a break, absorbed in their rations. The afternoon is very hot, not at all conducive to thought and inspiration; time to be.

29.07.85 – Lightning in an atmosphere pregnant with snow. The fog has lifted in the lowlands, the cloud cover has an altitude of 2600 m (8,500 ft). The storm has blown over, it's still drizzling, the view has opened up, the air has been washed clean.

30.07.85 – Snow starts to fall towards evening.

31.07.85 – I am moving in a non-territory; it seems symbolic of the obstacle I have to conquer. A thousand meters (3,280 ft) beneath me, hundreds of surveillance cameras and signs are installed; the measuring stations in the Gotthard road tunnel have created a perfect, self-contained world. Every time I drive through the tunnel, I imagine the landscape overhead. At every mileage point, a different horizon above, a stone; at 2.7 kilometers (1.7 miles) driving south, I imagine a spring gushing out of a rock face up on top.

02.08.85 – What better proof of the infertility and uselessness of this terrain? It looks like an abandoned battlefield: thousands of shell fragments, used hand grenades, empty cartridges. The area is divided into military training sectors, grouped by number. Anyone who wants to enter the area has to check a list posted at the top of the pass to see if the zone is free.

06.08.85 – On the slope of the stone hut above the Canariscio again, back and forth. It's getting colder, it will freeze more often now. Always this uncertainty about my attempted exposure to the processes that mark this landscape without beginning or end.

12.08.85 – The entire area looks like the last stage before flight. I dream along the lines of the horizon where the earth lifts off.

16.08.85 – As much diversity as strict adherence to thematic unity will allow (Variations on a theme by Johann Sebastian Bach).

18.08.85 – Not single works, but layers: delimitation, definition of the space outside — the fantasies that are kindled in space, like the legends that inhabit the minds of the alpine farmers, isolated and alone for months on end. The entire project is a massif, a core out of which everything grows.

22.08.85 – Testing the new case for the automatic camera over on the Gemsstock at 3000 m (9,850 ft). When I took the measurements, I forgot to include the size of the window section. It's hard to work with the cutting wheel; I'll probably have to use a blowtorch. Besides, everything's crackling, a thunderstorm is brewing in the south, there's so much electricity in the air that my hair is standing on end.

23.08.85 – Meeting with the men from the Fondazione; they own the buildings on the pass. There are no provisions for power in winter; new installations will be required — for the water supply as well. News like that worries me; the idea that something might not function; I feel insecure, like that constricted feeling you get when you have an infection.

26.08.85 – My colleague from the main town in the valley: 'What's the point of staying up there all winter?' I don't want to answer or think about it.

28.08.85 – I read: 'I keep changing. I'm someone else from one moment to the next. I'm present — like a cloud.' Is a cloud a member of the sky?

29.08.85 – Another meeting to discuss the power supply. The whole affair is taking on overwhelming proportions. The heaters — designed for the summer season! — consume so much electricity that it will cost us 100 francs a day.

31.08.85 – I imagine daily life in winter, moving everything up there, and begin to wonder whether I've bitten off more than I can chew. The

grand idea, and then all the little chores. Gabriela and I will move into the Gotthard Hospice at the beginning of October. Bags and baggage, plus two dogs.

01.09.85 – Gotthard — not a name but an idea. The origin of a country's history, international traffic route, military center. Ancient, venerable images that still fire a people's imagination. I no longer see the images our grandfathers saw. Instead, new, soft, fragile possibilities groping their way out of the earth (or the sky?).

I read: 'Aren't all the places of childhood sacred places because the people they "belong" to imbue them with an aura of individual singularity?' That's where shrines come from. And that's why we recall the places of our childhood, because they are associated with events that make them unique and lend them a mythical seal that sets them off from the rest of the world.

04.09.85 – Sometimes a sensation, a drive, but helplessness as well. The way these images look after everything has been checked out and all that is left is the sensation, the longing (but certainty, too).

08.09.85 – Thick fog, with some rain in between, brief respites, sun on Sorescia, then more fog and rain. I reached the Canariscio at 11.30. Fog and rain, it clears just long enough to get a glimpse of the lake.

14.09.85 – The chimney sweep has inspected the chimney. It seems to be in working order. We can use the 18th-century soapstone stove. No one has spent the winter up here since 1945, no one has used the stove since then. Hardly anyone is left who can remember what it was like in those days, with the oxen pulling the snowplows and people crossing the pass throughout the winter. That has all been forgotten. We can't offer accommodation: it's against the law.

27.09.85 – A quiet evening. I have found a new location — above a scree slope of arrow-shaped gneiss. In the west the horizon radiates a pale yellow, the rest of the sky is gray and unlit.

03.10.85 – It feels like winter outside although there's very little snow. Strong winds.

08.10.85 – Snow coats the horizon, a perfectly straight line following the contour lines of the topography. The mountains lose their names; they acquire volume, develop faces.

22.10.85 – The last people have left; the buildings are empty. The pass has not been closed yet: there is still the occasional car and sometimes a huge trailer truck — probably transporting dangerous chemicals not allowed through the tunnel. Not until the winter has settled in will the limits be revealed, the point of no return unmistakably defined.

30.10.85 – It is dark outside, the wind is howling, the snow swirling into Japanese drawings in front of the windows — landscapes and clouds in the panes.

02.11.85 – Last night's storm left a huge snowdrift piled up in front of the house. It reaches up to the first floor, but there's practically no snow at all along the west side. This is my first encounter with the wind in winter, though I've felt its force in summer countless times on the Canariscio.

Not a single car all morning, they must have closed the pass. I tried to install the wind gauge again. Not much snow on the ground; the wind carries it away as fast as it falls. The wind, sharp needles blowing in my face, makes it very hard to work. It took me all day.

09.11.85 – Fernando Pessoa: 'What we see is not what we see but rather what we are.'

15.11.85 – Glorious weather: the day has gone by again in a flash.

20.11.85 – Waiting for the helicopter to bring supplies (including fresh food). It's snowing and there's a ceiling over the lowlands. They won't be able to make it. The wind gauge is working now, but not the compass.

24.11.85 – The fog is still thick in the morning. For the first time the snow has not been blown away by the wind: about 20 cm (8 in of fresh snow). Lines and contours are beginning to fade. The path to the Canariscio has vanished; the stone posts along the road keep getting shorter.

In the evening we struggle up to the top of the pass. Some 300 m (980 ft) beyond it, we discover the tracks of a skier who climbed up from the north and seems to have turned back again.

I read: 'In their dealings with matter, people are incapable of experiencing the numinous; at best they can approach it aesthetically; to them, matter is primarily a "natural phenomenon". In the modern age, art is practically the only medium in which aesthetic deference to nature has survived.'

25.11.85 – Glorious weather. I make the rounds on skis. The sun already disappears behind Fibbia by 2.30.

26.11.85 – Completely cloudless in the morning. The guards from the garrison can drive their Pinzgauers on the street. Elio brings the mail.

Clouds approach rapidly from the north, gray skies, the first gusts of wind. Light snowfall in the evening. The moon will soon be full. The light bounces off the snow at night and make the mountains look gigantic.

01.12.85 – The weather is beautiful again, very warm, it's 16° C (60° F) around 1 pm (as warm as in Athens and Rome, according to the radio). The snow starts melting.

18.12.85 – The storms finally begin to let up. I can see again. But despite the supposed depth of snow, we still don't have very much. The wind keeps blowing it away. Won't it ever really be winter? We're still waiting; it's as if there were less snow up here than down in the valley.

12.01.86 – For the first time it really starts snowing. The wind piles up huge snowdrifts.

13.01.86 – Snow today, too, non-stop all day long with gale-force winds: up to 110 km/h (70 mph). We can't open the front door any more, it's been wedged in by snowdrifts.

More work on the slides. I've reached mid-August.

17.01.86 – The wind finally lets up. We can go out to take a first look on skis. The drifts are entirely different from the ones in December: strange shapes, yards high. The wind molds the snow; I discover exquisite, smoothly polished formations. The wind as an agent — I'd never thought about it like that before. A short tour takes a whole day and I've reached only a fraction of my locations.

28.01.86 – Only by working on the slides are positions gradually defined. I crop pictures again. How long it takes to arrive at the right position, the right framing that will last for years!

08.02.86 – Beautiful weather again. Around 1 pm a patrol from the garrison arrives from Bolla. They've got mail for us: 35 developed films, at last. At 4.30, when they're ready to drive down into the valley again, I give them 25 films to be developed. In the evening I start on the new series. A change in color arouses my curiosity. Is there something moving in this field?

09.02.86 – The coldest night so far: 20 below (4° F). It's around zero (32° F) in the house and minus ten (14° F) in the unheated rooms on the north side.

15.02.86 – A storm is raging outside; snow is blowing in through the cracks in the walls. Since the wind is coming from the south this time, the snowdrifts and swirls are much more distinct. Gale-force winds again, over 100 km/h (60 mph).

23.02.86 – In a letter to a friend: 'Standing still in time is the order of things.'

28.02.86 – Overcast and snowing. Several avalanches have already slid down into the valley; fifty people have been evacuated. All quiet up here. Short walk around outside. Huge snowdrifts.

The snowstorms blind us in order to teach us how to walk, to walk with eyes downcast, literally following in the footsteps of the person in front. There are no paths, only traces of wind on the snow.

03.03.86 – The wind has died down. It is snowing and snowing. Real winter.

04.03.86 – The skis sink a couple of feet into the snow. It's increasingly difficult to reach the locations. The two dogs, Zeus and Hera, are finding it hard to make any headway at all. They plow through the snow like floundering fish.

08.03.86 – We're waiting for a helicopter that is supposed to deliver the mail. We try to stamp down a clearing, see the machine circling overhead, but the fog rising from the south is getting thicker, the helicopter disappears right over our heads, impossible to land.

15.03.86 – I'm outside of time; human time has lost its meaning. Time has solidified. It has turned into a physical experience that depends on variations in weather conditions. The day consists only of what happens between heaven and earth — and my activities between the two. The slides cumulate, becoming a kind of agenda, except that it contains no appointments, names, or subjects to be discussed — only the ceaselessly changing qualities of space.

02.04.86 – Staying in the mountains is my way of 'stopping the world'.

18.04.86 – We have been immersed in white for fifteen days. The wind pushes the snowflakes across our line of vision — horizontally. Are the flecks of snow falling or are they flying?

Making the rounds outside is no longer possible. We can't open the door; it's wedged shut by the snow. We let the dogs out through the first-floor windows. They love it; they romp around in the snow until they look like polar bears.

23.04.86 – The wind has set a new record: 179 km/h (111 mph).

29.04.86 – Pessoa: 'Sometimes I look at a stone. I do not think about whether it feels. I do not call it my brother. But I love it because it is a stone, I love it because it does not feel anything, I love it because it is not related to me. Another time I listen to the wind and think that it is worth coming into the world if only to listen to the wind.'

02.05.86 – Cyclical time gently reveals the essence of the world and exposes the traces of growth: stones getting smoother in the wind, grass ageing, signs of the patina of time.

03.05.86 – Foggy masses of cold air are rising up over the pass from the north. They have already absorbed the sun by 8 am. The wind is cold. By midnight the stars are out again.

27.05.86 – Out of the blue there's a knock on my study door. I jump. A Portuguese is standing outside; he wants to move in. My time is up. The employees of the restaurant in the Hospice have come back to prepare for the summer season. The rooms I've been using all winter will again be the lodgings for people from Austria and Germany, Switzerland, Portugal and Spain. They will install their satellite dishes and video recorders for the next four months. Until the snows return.

03.06.96 – 11 am. The pass has been opened to traffic again. People wearing summer shoes are astonished by the masses of snow and squeal in delight when they squeeze the snowballs they've made between their fingers.

It is time for us to move on. The idea 'Gotthard' endures.